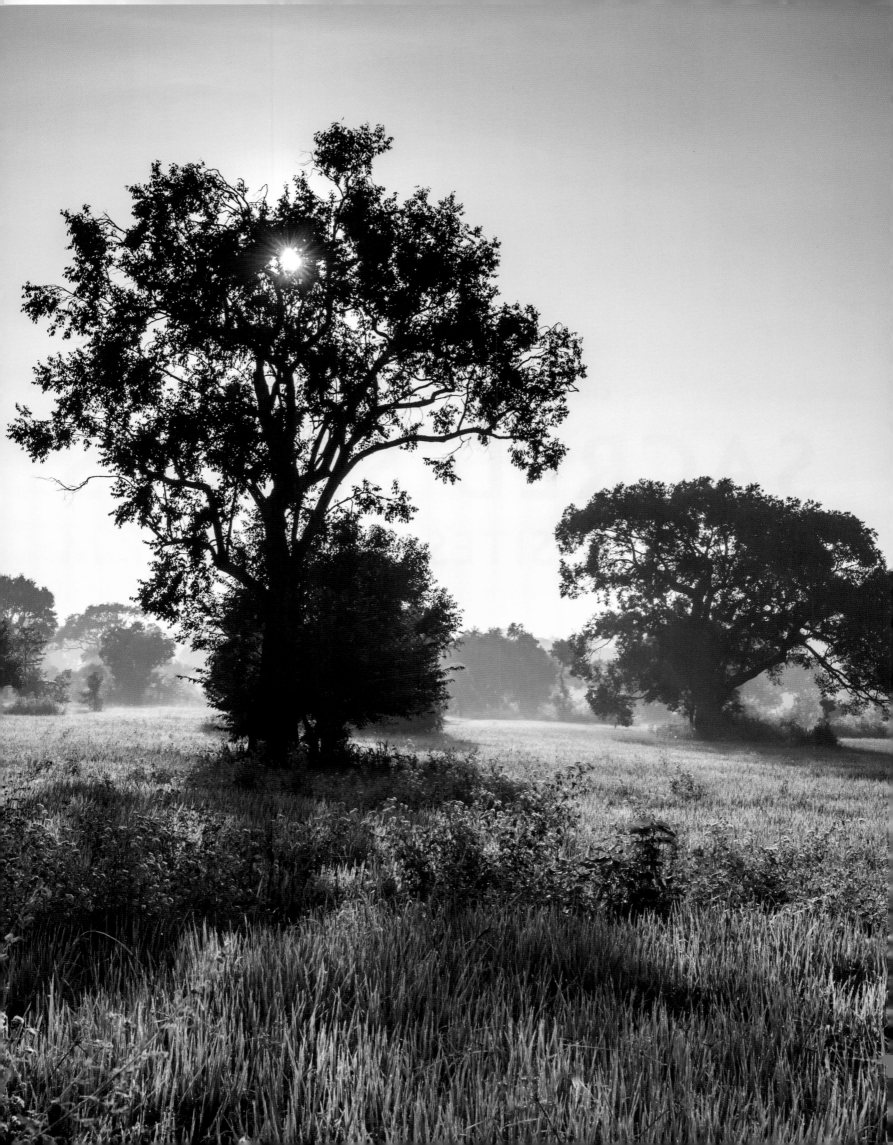

CONTENTS

FOREWORD

It is shortly before sunset at Griddhakuta, also known as Vulture Peak, near Rajgir. To be fair, the mountain is actually more of a hill surrounded by many other ridges. Nevertheless, with an elevation of 1,270 feet (380 meters), it is still quite striking. Amid a colorful group of monks and lay Buddhists, I sit on the ground in front of the foundation of what is said to have once served as Buddha's dwelling. Vulture Peak was one of his favorite places where he meditated and gave teachings. The First Buddhist council, which recorded Buddha's teachings after his death, met not far from here at Saptaparni Cave on an adjacent hill.

I take in the colorful confusion around me. The mood is relaxed, some pilgrims are picnicking, I hear laughter, and the monks have prepared a small altar with a sculpture of Buddha and candles for the light offerings. As yet nothing indicates that, before long, a solemn ceremony is about to take place to mark the sunset. Soon, however, restlessness sets in, times are compared, and everyone stares at the hazy sky. No one wants to miss the moment when the sun disappears behind the horizon. And suddenly the moment is upon us. A reverent silence falls, the monks begin to murmur sutras, and the pilgrims begin to sing in chorus—I feel the chill of goose bumps sweep over me. Here, for the first time, I experience the shiver that certain places give us, something that allows us as modern humans to tap into a place of power. I embrace this feeling that has overwhelmed me so unexpectedly, hoping to hold onto it for as long as possible. But just then, one of the

4

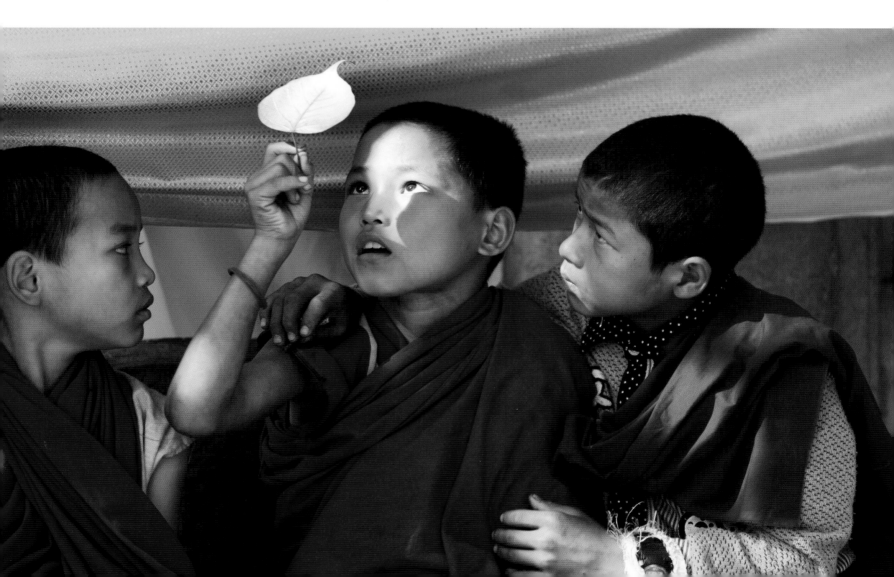

pilgrims approaches me, beaming, and gestures for me to follow him. He leads me to the altar, and buoyed by the enthusiastic approval of the other pilgrims, I am invited to light one of the candles as a light offering. Light offerings are a symbol of Buddha, and the lighting of a candle symbolizes the desire to attain Buddhahood. As I gaze at the candle, I am filled with a deep joy at having been invited to take part in this ritual.

This unforgettable experience awakened in me the desire to create a book about the sacred places of Buddhism. Back home again, I started by reading a thoughtful work about the Dharma. After I was done, I realized that it is impossible to gain a true understanding of Buddhism and its holy places through books. But what if you can't travel to the places where Buddhism is a part of everyday life? A statement by the ancient Buddha promised a solution: Images are the language of the imagination and are able to move the hearts of viewers and enlighten their minds. Buddha had a disciple named Maudgalyāyana who possessed the special gift of being able to translate the teachings into vivid imagery. Thus Buddha entrusted him with the task of putting core elements of Buddhism into a pictorial form.

In Christoph Mohr, I found a photographer who was willing to take on the challenge of photographically reinterpreting the teachings and the life of the ancient Buddha from a contemporary perspective. The photographs are intended to engage the imagination, to give readers a sense of Buddhism, to convey the spiritual life and the spiritualism of Buddhist countries themselves, and to thus take readers on a visual journey into the world of Buddhism. It is our hope that the photographs in this volume will have an impact similar to the images created by Maudgalyāyana in his time.

From that point on, we traveled through India, Sri Lanka, Southeast Asia, and Eastern Asia, following in the footsteps of Buddha and the countless Buddhist scholars who helped spread Buddhism in Asia. On our journey, we wanted to see how sacred sites and Buddhist life manifested themselves in the different schools of Theravada, Mahayana, and Vajrayana, as well as how Buddhism was even able to take root in these countries in the first place. Again and again, we found ourselves overcome by moments of emotion like the one I had experienced for the first time on Vulture Peak, and usually in quite unexpected places: in the unfathomable silence at the ocean-like Namtso in Tibet; in the midst of peaceful crowds of pilgrims from all world religions on Adam's Peak; and among the endlessly friendly and open people at the Shwedagon Pagoda in Yangon.

According to a Tibetan proverb, "Those who do not climb the difficult crag will also not reach the magnificent meadow." This proverb perfectly describes how the sacred places of Buddhism need to be experienced, felt, and sometimes hiked on strenuous pilgrim trails. This book hopes to serve as inspiration for you to start this journey in your imagination—and perhaps even spur you on to continue it someday in person.

5

Sacred sites for an
EXTRAORDINARY LIFE

The first tentative rays of the rising sun infuse the faint haze over Bodh Gaya with pink, hinting at another hot day. The languid morning calm is broken only by the occasional ringing of a bell, accompanied by the rhythmical beating of a gong. Together, these announce the "sound of emptiness" in one of the numerous temples.

Dawn belongs to the pilgrims, who take advantage of the cool morning hours to make their way to the Mahabodhi Temple, which reaches majestically up into the sky. The air vibrates with the shuffling footsteps of hundreds of Buddhist monks from all over the world, the whirring of evenly spinning prayer wheels of a group of Tibetan monks, and the sonorous chanting of the sutras. This is when you can feel the spirit of Buddha most keenly in this sacred place.

What makes a place holy?

I am on a journey in search of sacred Buddhist sites in an effort to answer for myself the question of what actually makes a place holy. Is it a structure, a place where a particular event occurred, or is it simply a special natural phenomenon? In our modern world, the value of a place is nearly always reduced to its utility. Many spiritual locations have become mere tourist attractions—entertainment archeology that you photograph and check off a list. The situation is completely different in many parts of Asia, where numerous regions and even some large cities have retained their sacred aura to this day. In the eyes of the people who live in the Himalayas in particular, nature is populated by countless gods and spirits, Buddhas and bodhisattvas, and saints and ascetics. For those who reside in the region known as the roof of the world, the entire landscape serves as a reminder, as a place in which they embed their myths and their religious, social, and moral ideas.

Perhaps it is the experience of feeling a shiver in certain places that still allows us, as modern people, to tap into a spiritual site. Sometimes even a rock that stands out among a multitude of other rocks is enough, because its shape holds a certain symbolism. But regardless of whether it is a rock, a tree, or a body of water, the object is seen as a receptacle for a force beyond itself. As such, it can become a place of power, a junction between the physical and spiritual worlds, and thus a sacred place.

Swept up in the stream of pilgrims, I can feel excitement in the air as I approach the large Bodhi tree in front of the Mahabodhi Temple. As we arrive at the massive Bodhi fig tree, awe settles over the crowd of pilgrims. The spirit of Buddha is tangible here. This is one of the gateways to the spiritual world. Religious history was written under the predecessor of this tree, whose mighty, far-reaching branches shade eight stupas on a terrace and protect them from the scorching sun. This is the place where Siddhartha Gautama, the founder of Buddhism, attained enlightenment. For inattentive visitors, these may seem to be only a few shrines among so many here, but in fact these eight stupas are stone memorials of important stations, both real and legendary, in the life of Buddha. Taking advantage of a free space, I sit down in the shade and take a moment to picture his life in my mind.

Born into an aristocratic family in Kapilavastu (symbolized by a round stupa with the lotus leaf steps), Siddhartha Gautama was isolated from the outside world and grew up in aristocratic splendor. On four outings, he was confronted with the reality of life, consisting of birth, old age, and death, along with an encounter with a monk. As a result, he renounced his previous life to devote himself entirely to a religious quest. As an ascetic, he joined the company of five other ascetics. He lived as a hermit in the forest, eventually seeking his path in meditation. Finally, sitting under the Bodhi tree in what is now Bodh Gaya, he saw through the law of reincarnation as a consequence of earthly deeds and realized the way to stop the cycle of rebirths. Siddhartha Gautama had become Buddha, the awakened one. The square stupa with the four steps tells of this groundbreaking event.

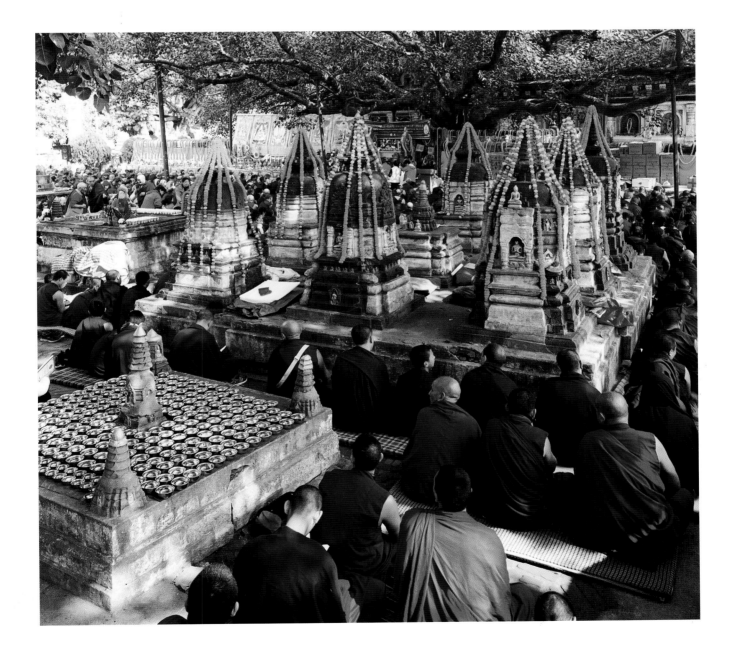

He could have left it at that, but the certainty of having recognized and thus eliminated the source of suffering turned the seeker into a guide—and yet one who initially did not want to pass on his own experience. According to legend, it was the god Brahma Sahampati who convinced him to spread his teachings. As a result, Buddha set out for Sarnath near Benares, where he sought the five ascetics who he hoped would understand his teachings. He met up with his former companions at the Isipatana Deer Park, where he gave his first sermon and set in motion the wheel of his teachings. This important event is symbolized by the square stupa of many doors.

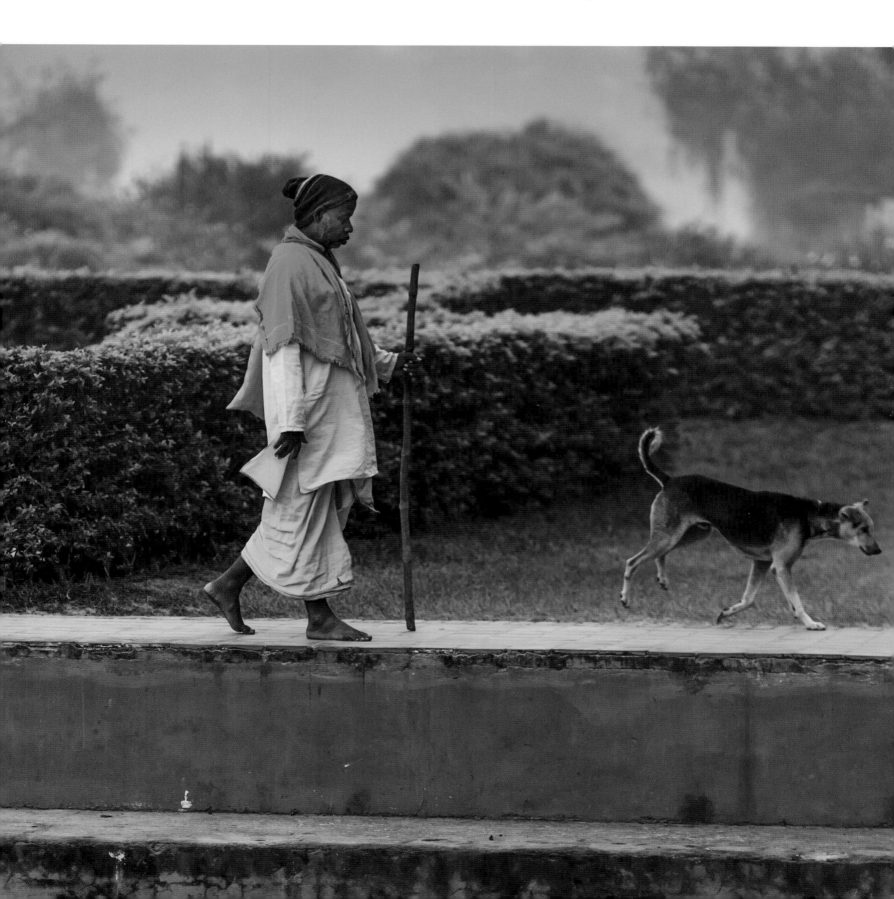

Meanwhile, in the shade of the tree, numerous monks have settled around the central group of stupas and among the other stupa clusters, waiting for the morning recitations to begin. Stupas—also referred to as chorten or pagodas, depending on the region—can be found wherever Buddhism has taken root. At first glance, they appear to be mysterious hill- or tower-shaped structures with a prominent spire. Some are only a few centimeters high, while others, such as at Bodh Gaya, are monumental structures. Regardless of the size, however, a stupa primarily serves as a representation of Buddha's spirit, the ultimate symbol of enlightenment, and almost like the very presence of the Buddha himself. Paying respect to a stupa means opening your own mind to the qualities of Buddha and thereby drawing closer to them.

Unfortunately, where there is success, envy is never far behind. Rival yogis and Mara, a diabolical demon, soon challenged Buddha; this is memorialized in a square stupa with a projection. Buddha described miracles as dangerous and confusing and believed that they did not serve as evidence of the truth of a doctrine. Challenged by his opponents, Buddha performed various miracles over the course of 15 days. These included the Twin Miracle at Shravasti, where he floated in the air, emitting fire from his shoulders and streams of water from his feet. He concluded by creating a duplicate of himself and engaging in a conversation with him. To this day, these events continue to be commemorated in Tibet on the "Great Day of Miraculous Manifestations" (Chotrul Duchen) on the first full moon day according to the Tibetan lunar calendar.

The first rays of sun have now found their way to the temple and are bathing it in warm morning light. You can feel the growing heat, but it is forgotten when faced with Buddha's life. My gaze falls upon the square stupa with the four steps, a symbol for Buddha's descent from heaven in Sankasya. This event is related to the death of Buddha's mother, Maya. She was reborn in the realm of demigods, where Buddha visited her and shared his teachings. Buddha was soon desperately missed by his human followers. In his honor, the gods festively staged his longed-for return: On a bejeweled triple ladder, the most exalted of the gods accompanied him down to earth—and for that moment, the overwhelming splendor of the otherwise invisible higher spheres became apparent even to humankind. In Tibet, the Buddhist festival of Lhabab Düchen celebrates the descent of Buddha from Tusita heaven, and the Buddhist holy day Pavarana is celebrated in countries where Theravada Buddhism is practiced.

Around the age of 70, Buddha faced one of his greatest tests when Devadatta, who was both his cousin and brother-in-law, wanted to take over the leadership of the order from him. Buddha refused the proposal, thus creating a dangerous enemy for himself. Devadatta launched three assassination attempts in Rajagriha, but all of them failed. These events are commemorated by the octagonal stupa, a symbol of unity and a reminder that all beings hostile to Buddha and the monastic community will be defeated and unity restored.

As the morning recitation begins, I take another look at the round, three-tiered stupa that represents Buddha's agreement in Vaishali to prolong his life by three months. The nearly 80-year-old Buddha spent a rainy season in Vaishali, where he became very sick. Cared for by his faithful servant Ananda, however, he overcame his illness through force of will. Last but not least, I admire the bell-shaped stupa without steps that represents Buddha's passing into parinirvana at Kushinagar. Having taken this moment to look back at Buddha's life, I am ready to begin my adventure in search of the sacred sites of Buddhism in Asia.

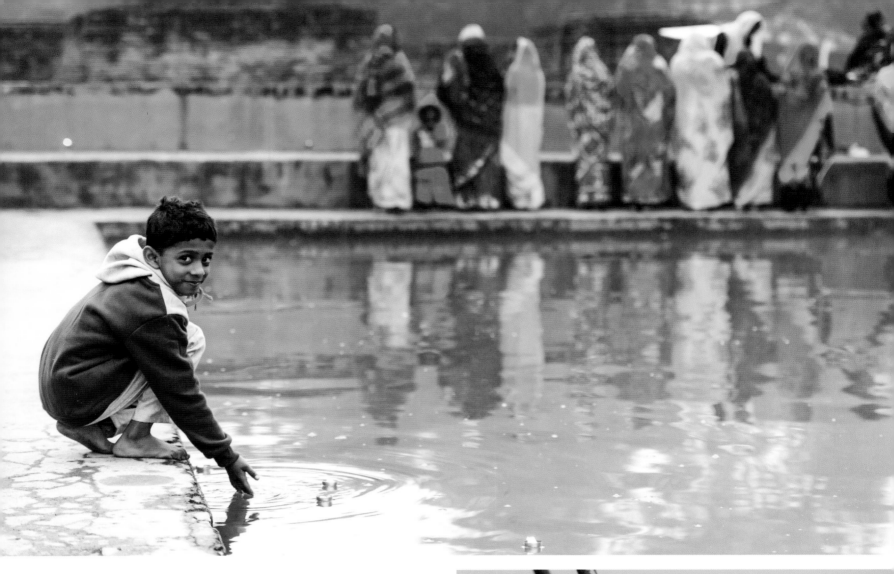

It is said that Siddhartha's mother stood under a Sal tree and gave birth to him near this pond in Lumbini. In the year 248 B.C.E., Emperor Ashoka had a stone pillar with a carved relief placed at the site of Siddhartha's birth to commemorate the event. The ancient Chhath festival honoring Surya, the sun deity, and his sister Chhathi Maiya still takes place here to this day. With offerings of flowers, the two deities are thanked for the life they make possible.

Ashoka Pillar ✿ The Sacred Garden ✿ Lumbini ✿ Nepal ✿ Sacred sites for an extraordinary life

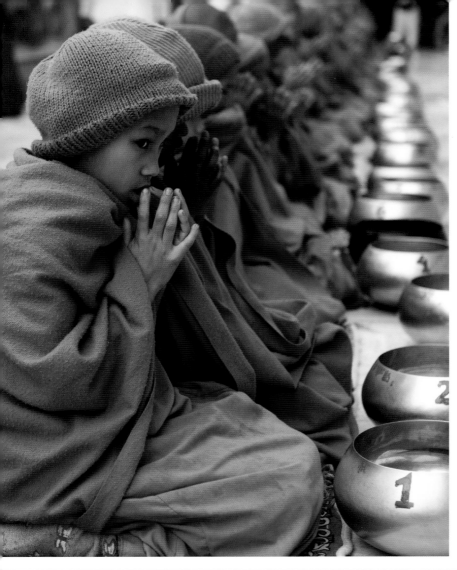

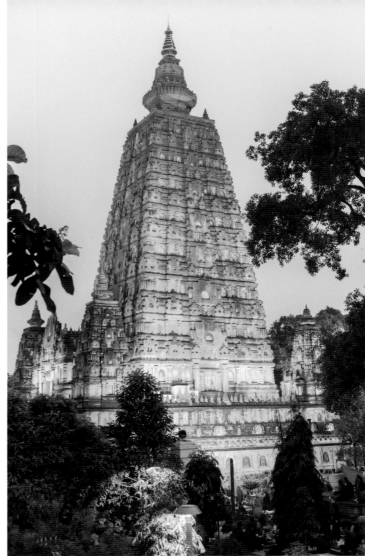

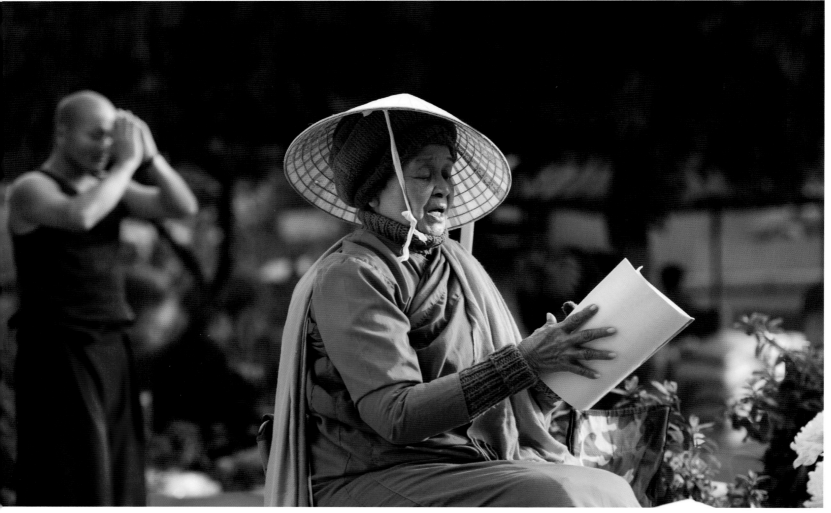

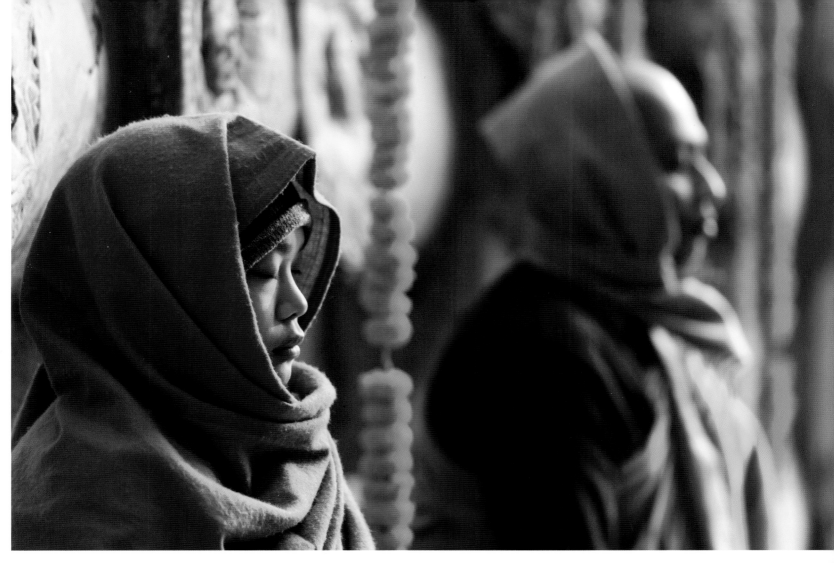

For young novices, a trip to the Mahabodhi Temple in Bodh Gaya is more like an exciting field trip. Only later will they really become aware that it was at this place that Siddhartha achieved enlightenment and became Buddha. Pilgrims from around the world meditate in front of the temple, which was built as a massive stupa. With a little luck, they may even be able to listen to the teachings of the Dalai Lama during one of his regular visits.

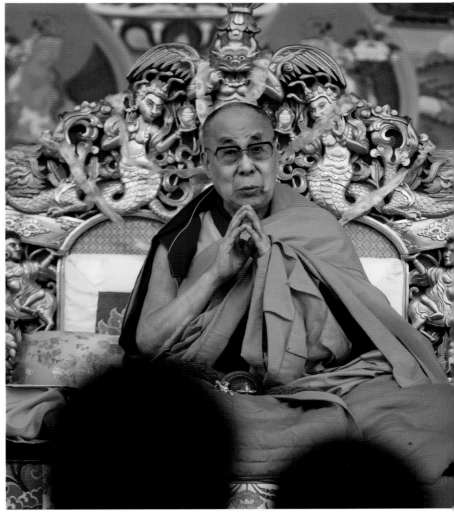

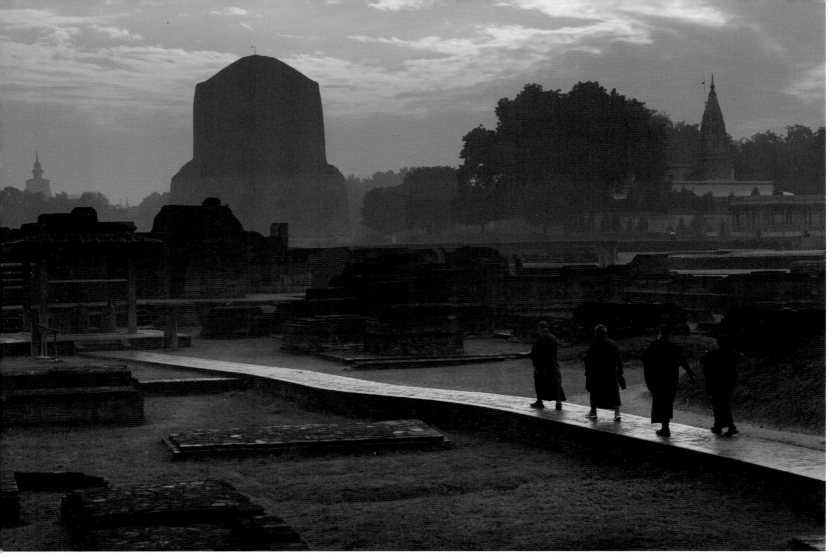

Siddhartha's path to Buddhahood was difficult and full of hardship. He followed various gurus, became a forest hermit, and finally an ascetic. Following his enlightenment in Bodh Gaya, he walked to Benares on the Ganges. Once there, he gave his first sermon at the nearby Isipatana Deer Park in Sarnath to five of his companions from the time he was an ascetic—and with that, he set in motion the wheel of his teachings. The mighty Dhamekh Stupa in the picture above is a reminder of this.

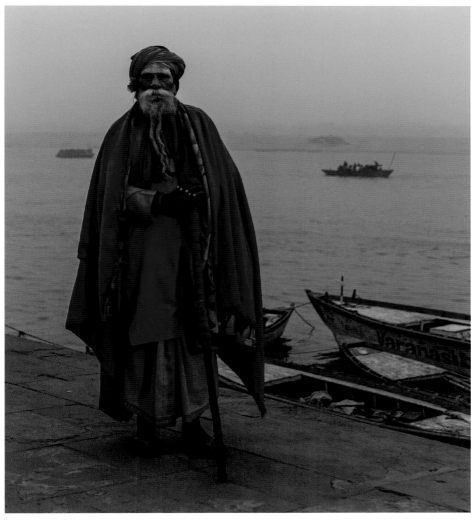

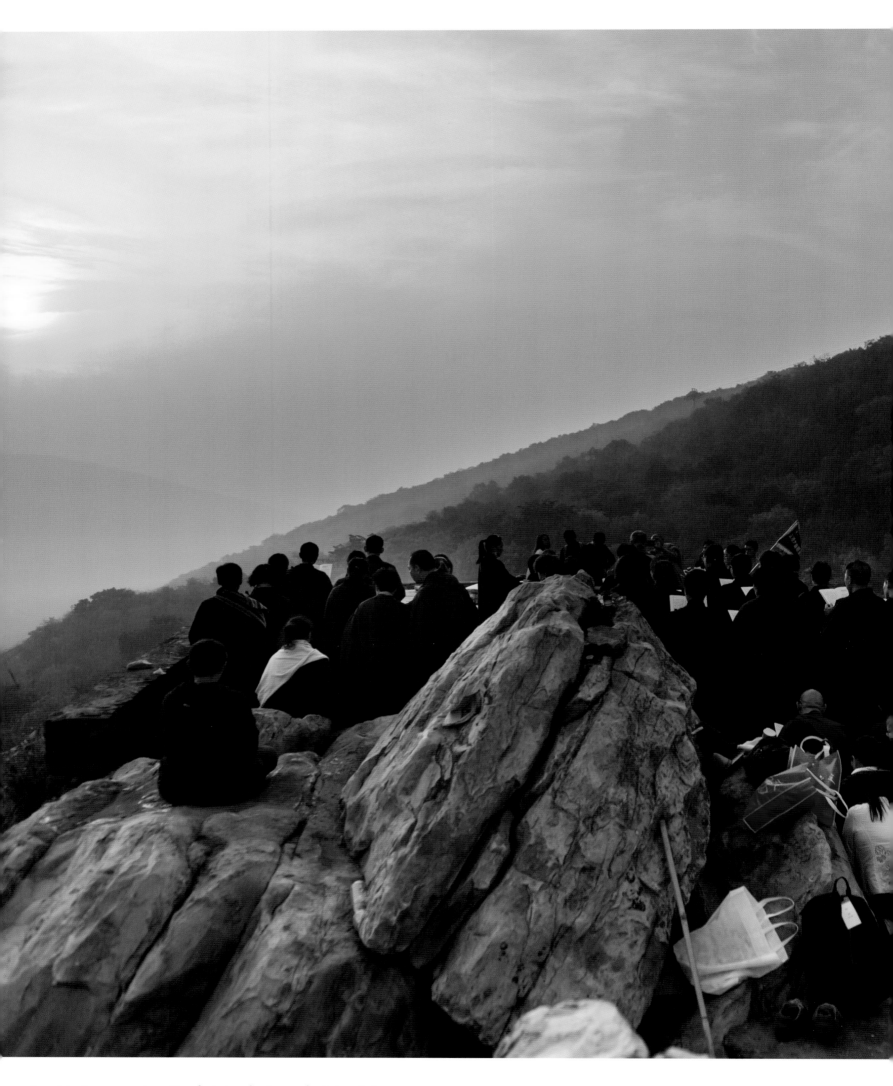

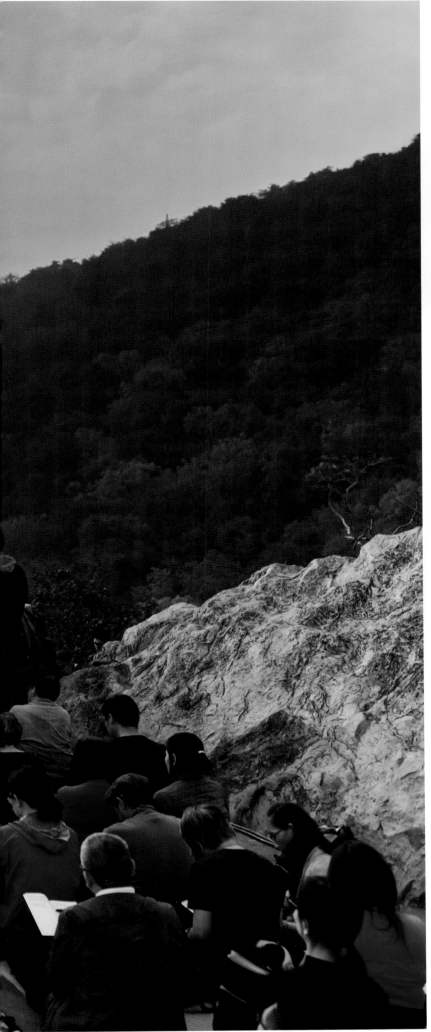

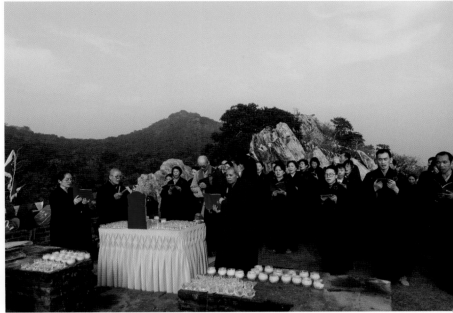

This double-page spread:

Rajagriha (now Rajgir), the ancient capital of the kingdom of Magadha, was one of the first places where Buddha gave teachings. He converted the ruler there and meditated several times on nearby Vulture Peak. This is also the place where Bodhisattva Avalokiteshvara is said to have revealed the Heart Sutra, which is of significance for Mahayana Buddhism. As a result, this mountain has remained an important destination for pilgrims to this day.

Next double-page spread:

In Shravasti, Buddha spent a majority of the rainy seasons, which were so vital with respect to strengthening the monastic order. The land for the Jetavana temple had been given to him by the merchant Anathapindika, in whose honor a stupa was built. The Gandhakuti stupa, gilded for festive occasions, stands in front of the ruins of the hut where Buddha used to stay during the rainy seasons. The sculpture of the reclining Buddha in Kushinagar recalls his passing into parinirvana.

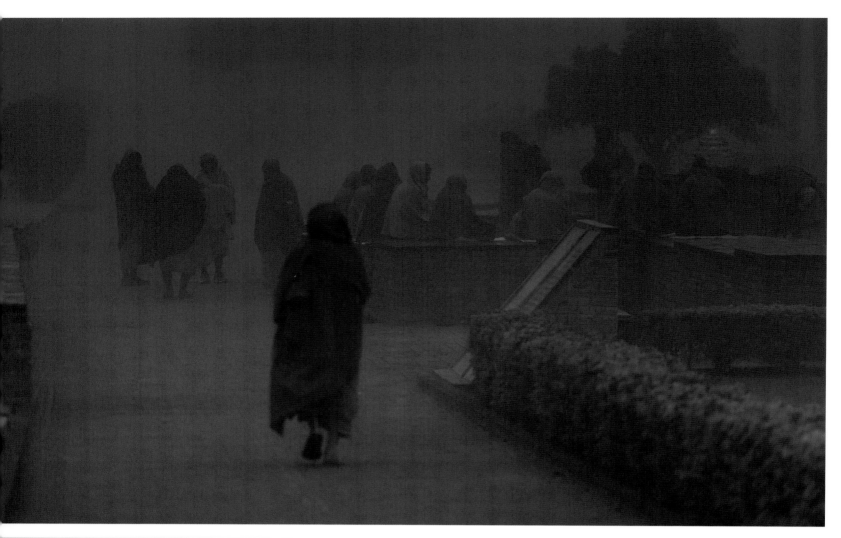

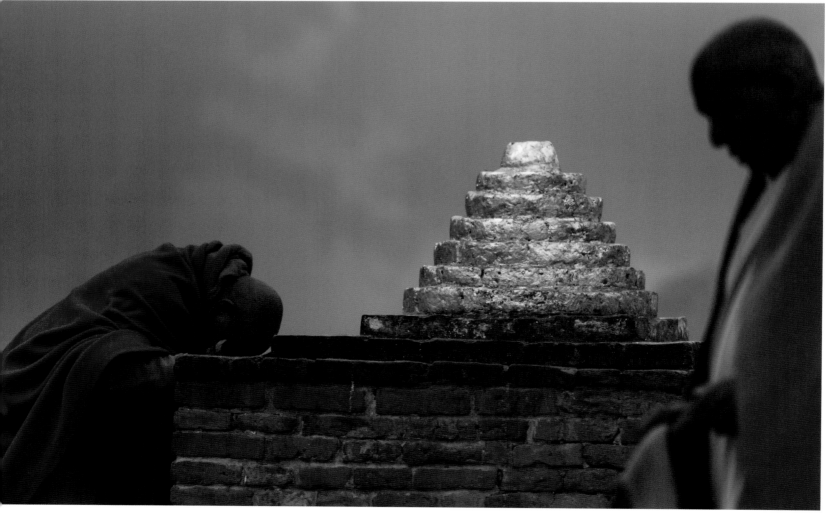

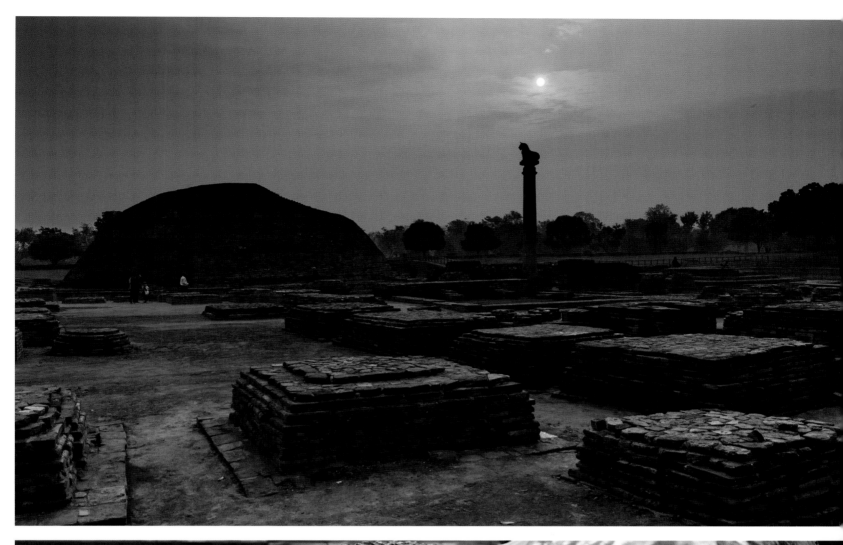

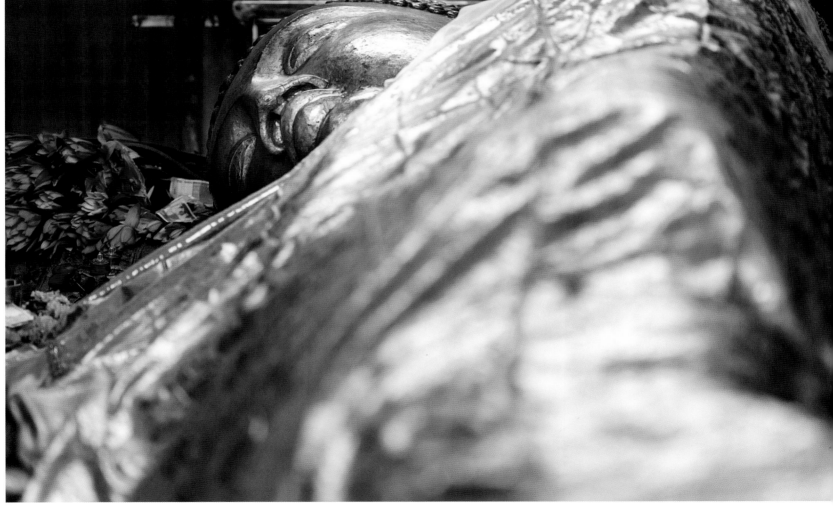

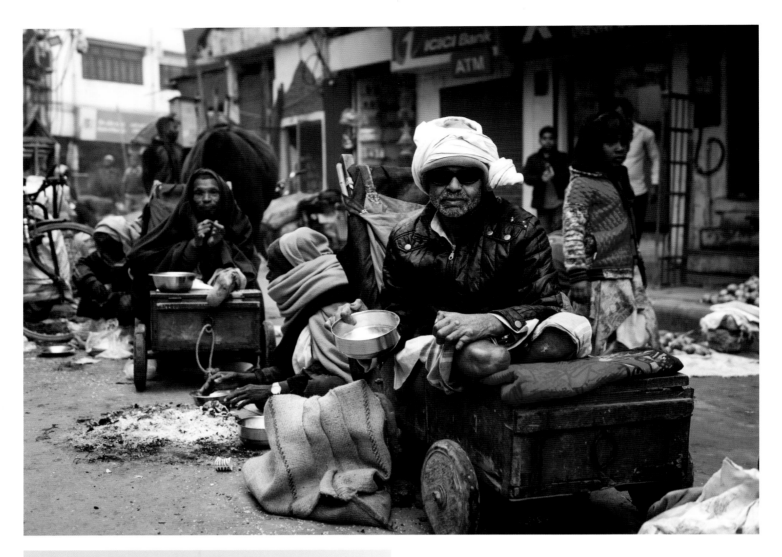

20

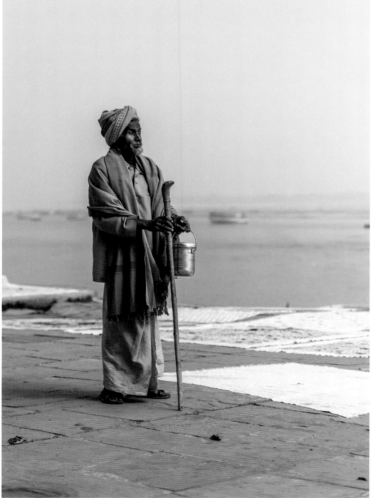

Siddhartha Gautama's father, Śuddhodana, was a leader of the Shakya republic in Kapilavastu, in what is today northern India. His mother, Maya, died just a few days after his birth. As a member of the warrior caste, his training in military skills began at an early age, though he displayed little enthusiasm. So little, in fact, that his future father-in-law even wanted some proof of suitability before giving his daughter Yasodhara in marriage to Siddhartha, who was only 16 years old.

Although Śuddhodana provided his son with a carefree life filled with pleasure, which was designed in no small part to discourage religious speculation, the young Siddhartha began to ponder the inevitability of old age, illness, and death. As a young man, according to dramatic legend, he made four trips that would change his life.

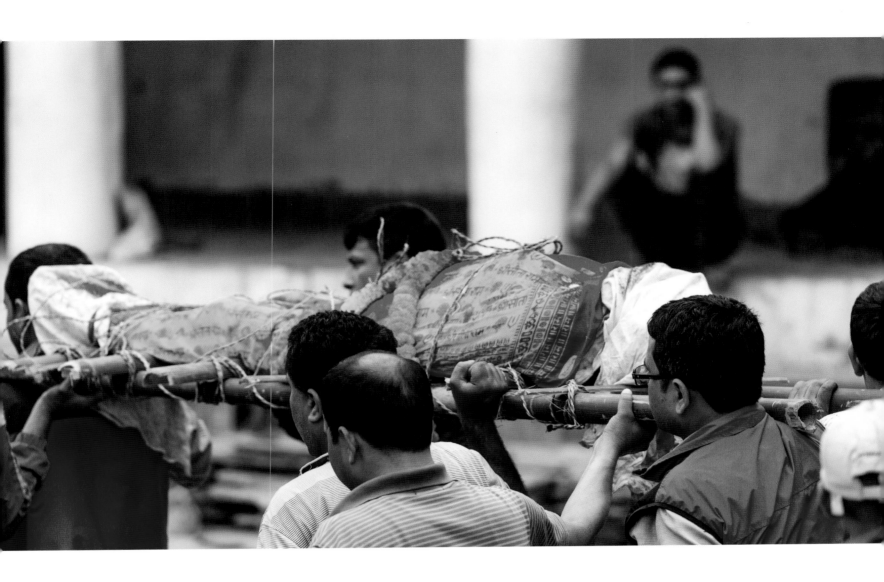

On his first trip, Siddhartha saw an old man walking
with a cane. At that moment he understood that no
living creature can escape old age.

During his second trip, Siddhartha met a sick man,
and he realized that health was not something
that could be taken for granted, but something that
could affect rich and poor people alike, regardless
of their caste.

On his third excursion, a funeral procession crossed
his path, and Siddhartha recognized that at some
point, every human being dies. The mourners
reminded him that the end of life is always a time of
suffering and filled with the pain of parting.

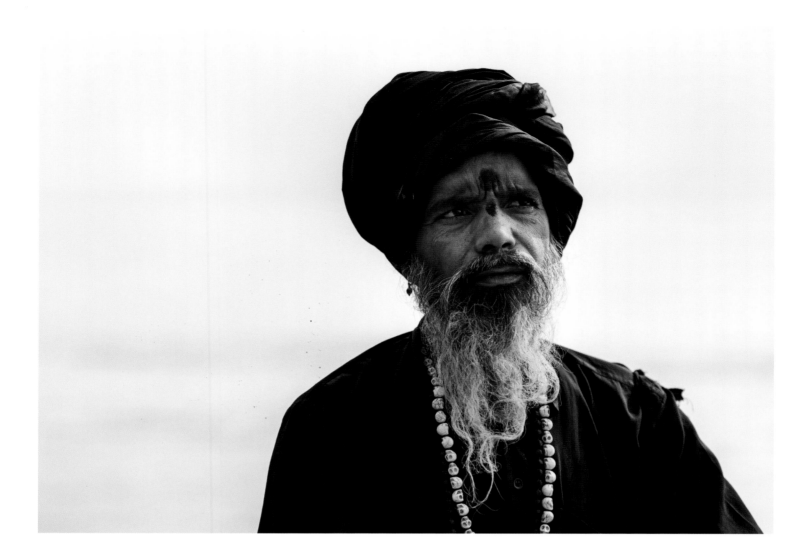

22

Siddhartha was deeply unsettled by the realization that life is finite and full of suffering, since he did not know what to do with the knowledge he had gained on his trips. Finally, on his fourth excursion, he saw a wandering monk and was deeply impressed by his composure and peaceful aura. He then decided to adopt this way of life, free of possessions and power, and without envy, greed, or hate.

Śuddhodana was said to have tried desperately, in tears, to change his son's mind. Siddhartha promised to stay if his father was able to free him from illness, old age, and death. Thus, at the age of 29, Siddhartha left his home to lead a life as a wandering mendicant monk, dedicating his life to the search for the true knowledge of all things.

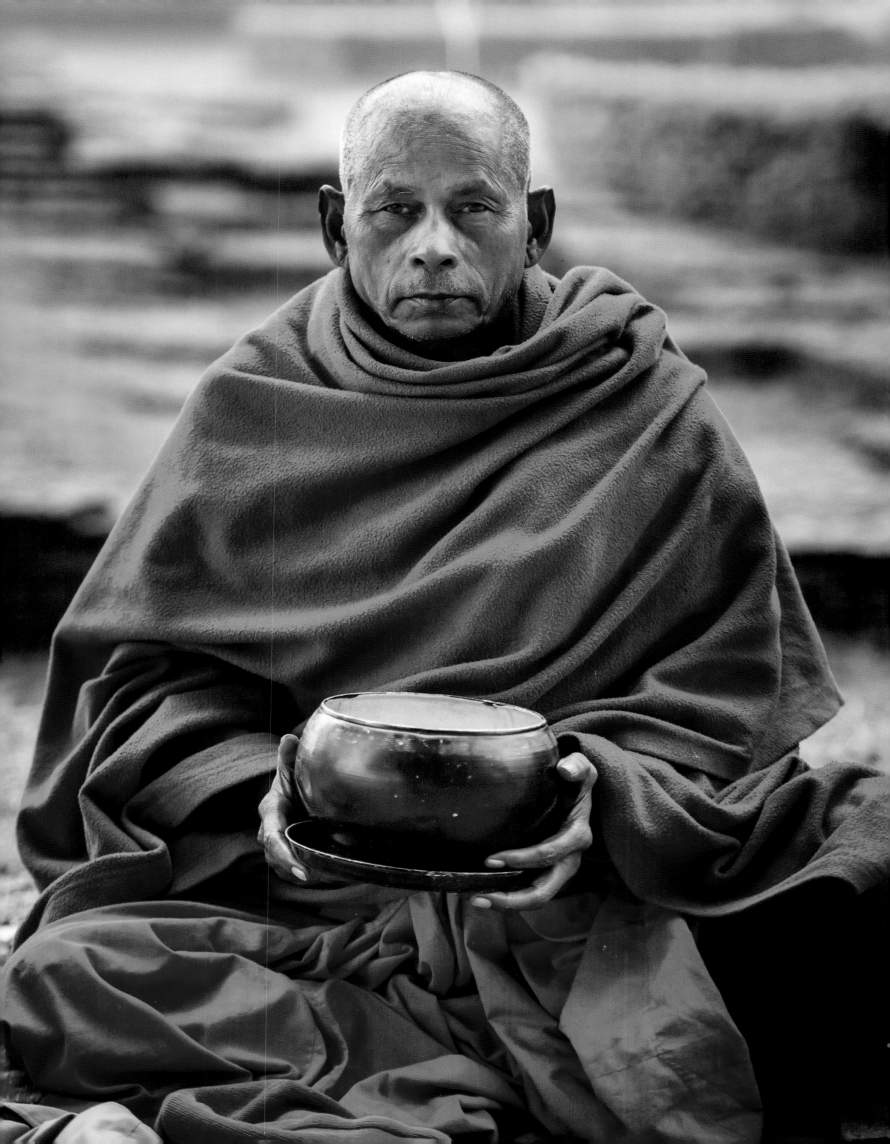

The cycle of
BECOMING

Together with Tashi, my Tibetan guide and interpreter, I am following in the footsteps of the great tantric master Padmasambhava, known as the one "born from a lotus." This is part of my quest to learn more about Buddhism's path to the roof of the world as well as about Tibet's omnipresent spirits and demons. In the middle of the vast, endless highlands, after hours of driving west, we reach the small Tradun Monastery situated on a hill just outside the town of Drongba. It is one of twelve monasteries that Songtsen Gampo, the first Dharma King who reigned from approximately 629 to 649, established in an effort to combat the demoness who was said to rest over Tibet and who wanted to prevent the spread of Buddhist teachings. It was not until more than 100 years later, however, that Padmasambhava—known to Tibetans as Guru Rinpoche—succeeded in paving the way for Tibet to become a Buddhist country.

Blinded by the glaring sun, it takes a moment for my eyes to adjust to the sudden darkness that surrounds me in the entrance area of the small temple. A monk appears unexpectedly from the darkness and informs us that we need to pay an entrance fee. After taking the money, he introduces himself as Champa, "the friendly one." Clad in a red robe, the monk looks at us expectantly and indicates that we are welcome to ask him questions. I ask him to tell us something about Buddhism, and he is visibly pleased at the request. He immediately leads us outside and points at a golden wheel flanked by two gazelles on the roof above the entrance: "The wheel of teaching, referred to as the *Dharmachakra*, is the symbol of Buddhism. Buddha started it turning when he gave his first sermon at the Isipatana Deer Park—represented by the two gazelles," he explains.

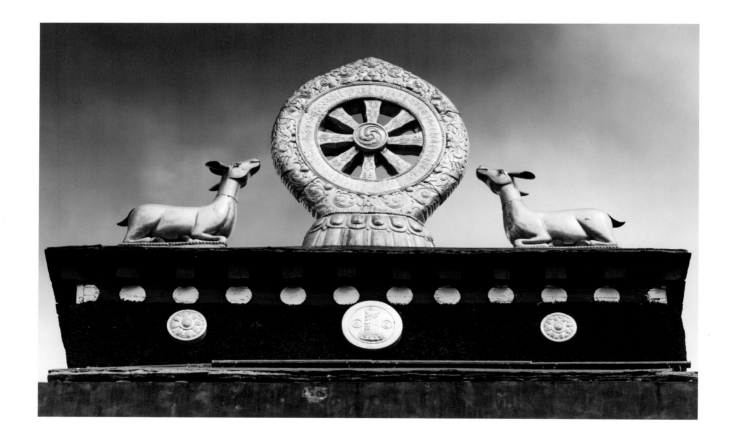

"His teaching was about the Four Noble Truths, namely the truth of suffering, the truth about the cause of the suffering, the truth about the end of suffering, and the truth about the path that leads to the end of suffering. For this, you need to follow the Noble Eightfold Path, which is a combination of insights, ethical codes, and meditative practices that promise to liberate you from the endless cycle of rebirths. This path is symbolized through the eight spokes in the wheel, while the gankyil symbol in the wheel hub, which is derived from the yin-yang symbol, represents the interconnectedness of suffering and release."

The Wheel of Life is a reminder that each of our actions has consequences.

Champa beckons us to follow him back to the entrance. There he gestures at an interesting mural to the left of the entrance and explains that it represents the Wheel of Life and can be found at the entrance of most temples in Tibet. This wheel, called the *Bhavachakra*, is a visual summary of what Buddhism stands for and a reminder that each of our actions has consequences. It serves as a mirror of self-knowledge and as an appeal to change our lives. Buddha himself had suggested that the Wheel of Life be placed at the entrance to each monastery and that a monk be appointed to explain to visitors the imagery, which went back to his disciple Maudgalyāyana. Champa makes it clear that he has dedicated himself to this task. Fortunately, time is not an issue today, and before we know it, we find ourselves in the midst of an exciting journey into the world of Buddhist symbolism and the teachings of Buddha.

The monk points to a fearsome figure with a bull's head, a chain of human heads, flaming hair, and a club, that is holding the Wheel of Life in its claws. "That is Chögyal or Yama, the god of death. In Buddhism, he is known as the judge of the dead," he explains. "You face him at the moment of your death." Yama is not, in fact, a personalized deity that you physically face, but rather more like a mirror that you look into at the moment of your death and in which you see your entire life passing by once again. You recognize all the deeds you have done, good and bad, and understand which spiritual consequences of your actions you will now reap.

Champa's index finger moves to the center of the image. "Here we see the second truth from Buddha's first sermon, the truth about the cause of suffering." I take a closer look. In the hub of the wheel, a rooster, a snake, and a pig are turning the Wheel of Life. They represent the "three root poisons" that corrupt us from within. They give rise to all the misery of life. The rooster is the symbol for greed, the snake for hatred, and the pig for delusion. All servitude and all suffering of humankind is rooted in these three mental attitudes. The three intertwined animals move together in a circle. This shows that these three fundamental evils are inextricably interconnected. Only by becoming aware of these three evils can we prevent them from controlling our lives. The objective is to overcome these three evils. Buddha describes the journey to this liberation as the Noble Eightfold Path, which consists of eight practices for living:

❀ Right view, in other words, understanding the causes of suffering and how to end it;

❀ Right intention, i.e. a sincere attitude and the willingness to put into practice
what has been understood and to live your life accordingly;

❀ Right speech, which means avoiding lies, gossip, and chatter;

❀ Right action, such as maintaining an honorable way of life, not killing, and not stealing;

❀ Right livelihood, such as having a "harmless" profession;

❀ Right effort, in other words doing good and avoiding evil;

❀ Right mindfulness, i.e. constant, sincere reflection on one's own actions; and

❀ Right meditation, in other words, maintaining a constant concentration in all we do.

Clearly in his element, Champa now runs his index finger once around the second ring of the Wheel of Life. "This ring," he explains, "illustrates how the law of karma works." The ring is divided vertically into a black and a white section. In the black area, tormented beings plummet downwards. In the white area, men and women in light-colored clothing move upwards and practice commendable deeds. The message of this ring is that we will inevitably reap the fruits of our karma, or of our "deliberate actions." Every action leads to a consequence that the person performing it will eventually experience themselves; the specific nature of this consequence is determined by the intention with which the act was committed. Intentions can vary depending on whether they are based on greed, hatred, and delusion, or on *metta* (mercy), generosity, and clarity of mind. Viewers are supposed to realize that they need to develop wholesome states of mind if they want to successfully tread the path of liberation.

Next come the six spokes of the wheel, which the monk explains to us in a clockwise direction. The six realms of life that fill up the spaces between the spokes stand for the truth of suffering. These sections can be understood as objective dimensions of experience into which you are literally reborn, or as symbols for the psychological states into which people may fall. He starts with the uppermost realm. In the realm of gods and pleasure, delusion causes pride and carelessness. Suffering exists in the illusion of the eternity of this happy state, because even this realm does not protect you from being reborn into lower realms of existence. This is followed by the realm of the demigods, who are driven by the misery of envy and thus live in a constant state of struggle and strife. Although you are not driven by envy and greed in the animal realm, you live there without vision, because your only goal is to satisfy basic needs. Hell can be understood as the objectification of hatred. In the realm of hell, beings at fault due to anger and hatred must suffer terrible ordeals of heat and cold. The realm of hungry ghosts reflects a spirit obsessed with greed. Hungry ghosts live in a realm of unsatisfied desires. No matter how much they may possess, they always believe that they still lack something. They find no joy in the things that they accumulate. In the human realm in the sixth section, beings are caught up in egoism and passions that bring you old age, sickness, and death. Being reborn as a human, however, is still the most favorable for liberation since humans are able to read and understand the holy scriptures and thus tread the path to liberation.

Finally Champa comes to the outermost ring. "This ring illustrates the doctrine of the twelve links of dependent origination in alternating dependence." I look a little perplexed. "It is the foundation of all Buddhist teachings and practices. Depicted here are the twelve factors of existence that determine the life of every human being and are passed through in the cycle of birth and death. Buddha put this teaching into a simple formula: "This is because that is. This is not because that is not. This arises because that arises. This passes away because that passes away. You might say that these are the Buddhist story of creation. Ignorance,

27

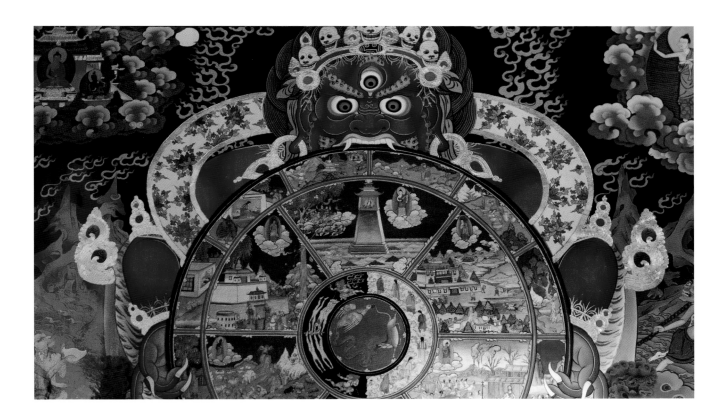

formations, consciousness, name and form, six senses, contact, sensation and feelings, craving, grasping the sensory world, becoming, birth, old age and death—these twelve scenes on the rim of the wheel follow each other in an endless cycle. Ignorance causes formations. Formations cause consciousness, etc. In addition, each link contains all the other links. None is conceivable without the others. The twelve links of cyclic conditionality show how deeply delusion controls people's actions."

My head is spinning trying to absorb all this; Champa regards us with satisfaction. "And where can the other two truths be found," I finally ask. The monk points to the moon, explaining "it represents the truth of the cessation of suffering. The Buddha pointing at the moon represents the truth of the path toward the end of suffering." Although I am still filled with questions, we still have a long way to go today. After a short tour of the monastery rooms, we say goodbye to Champa, who did such a wonderful job of explaining his faith to us.

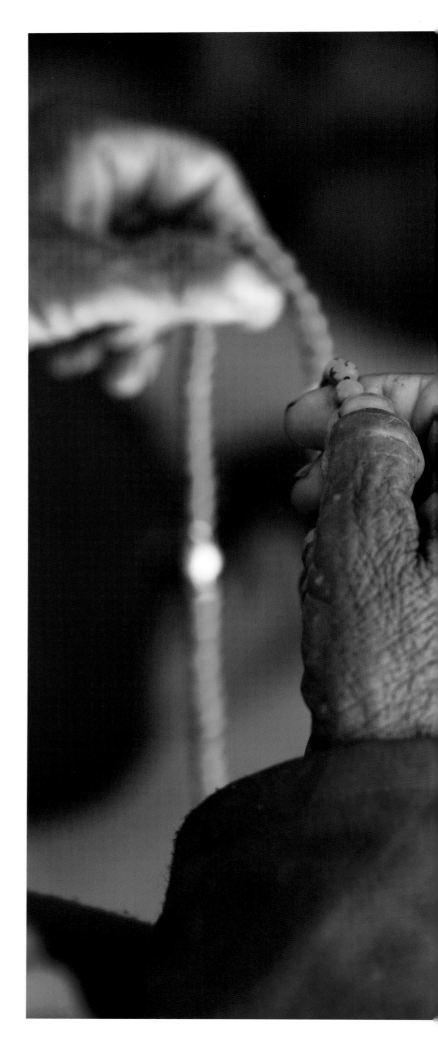

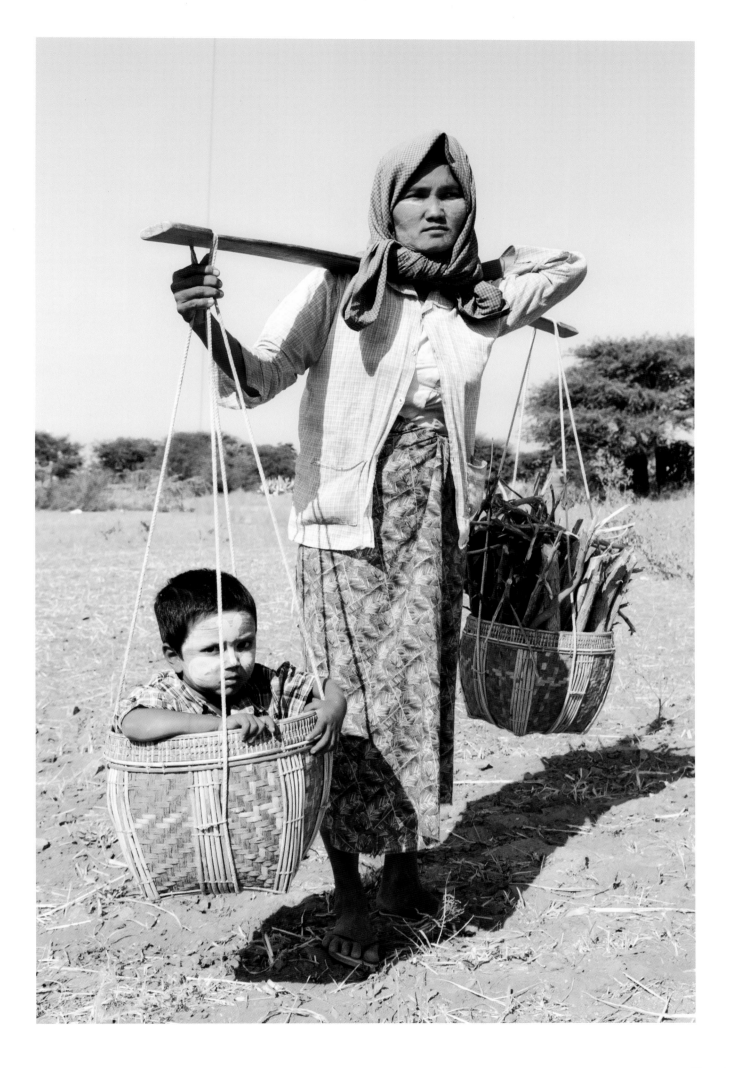

The cycle of becoming

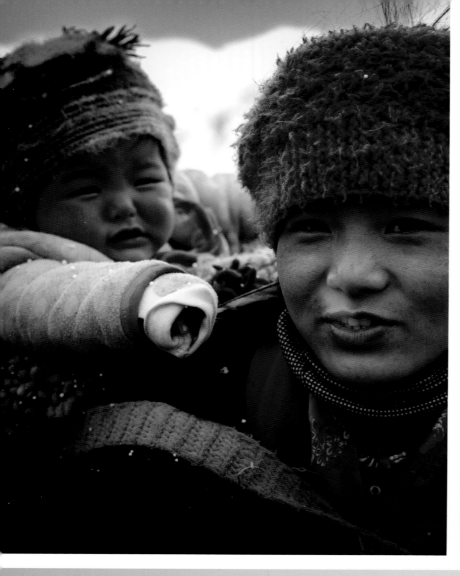
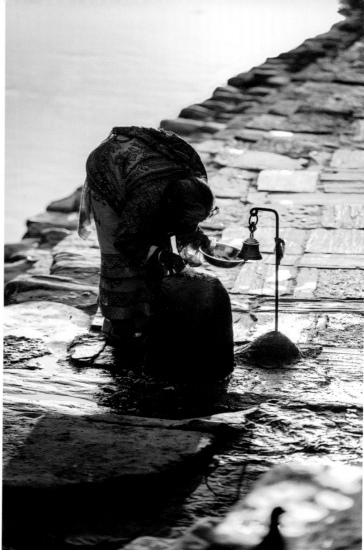
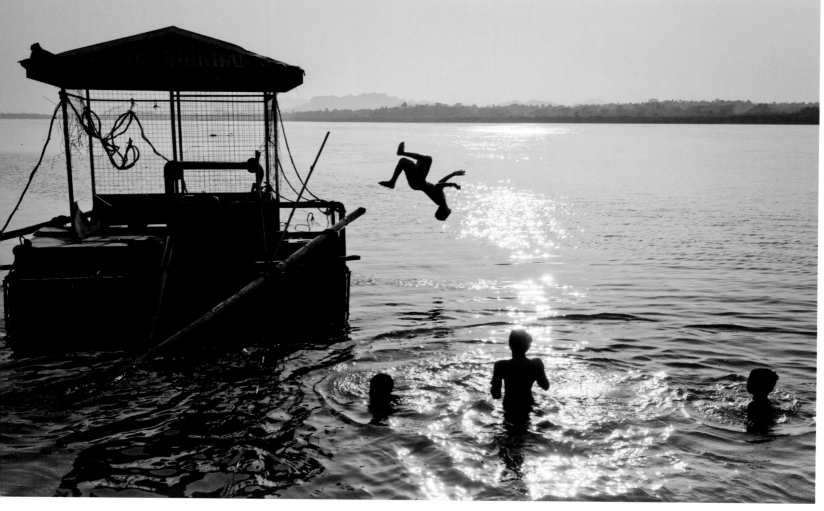

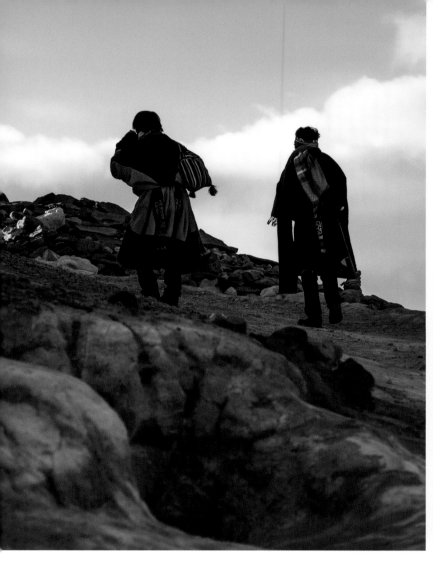

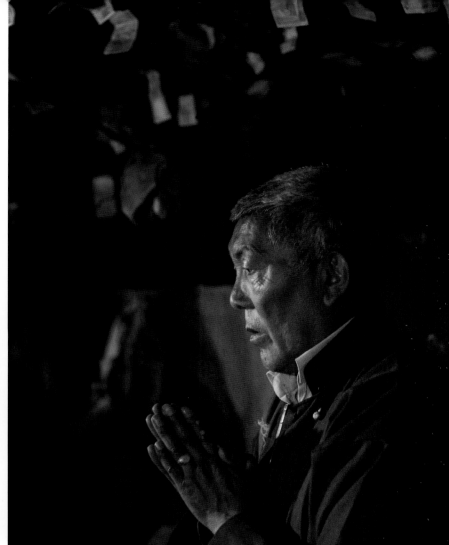

This and next double-page spread:
The noble truth of suffering maintains that suffering can be found not only in birth or old age, but even in a state of joy, which is never permanent. To overcome suffering, you have to follow the Noble Eightfold Path, which consists of practices conducive to salvation:

Right view

Right intention

Right speech

Right action

Right livelihood

Right effort

Right mindfulness

Right meditation

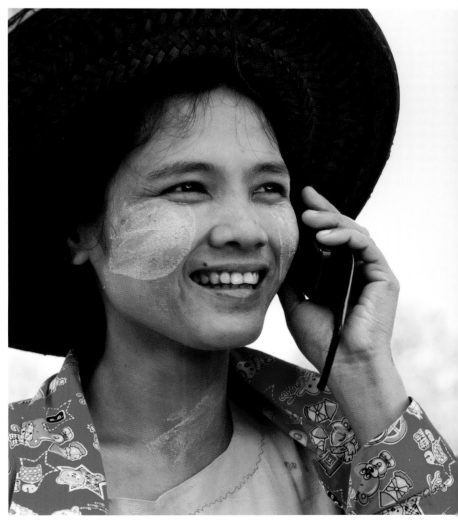

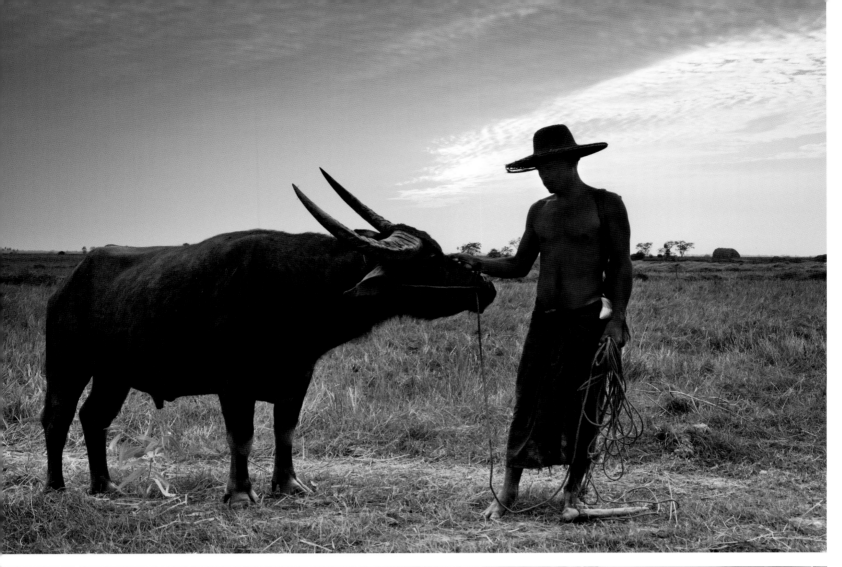

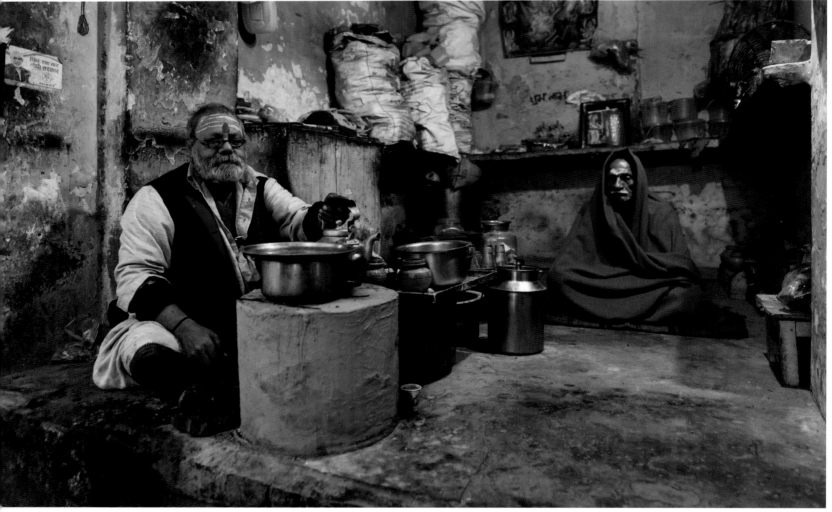

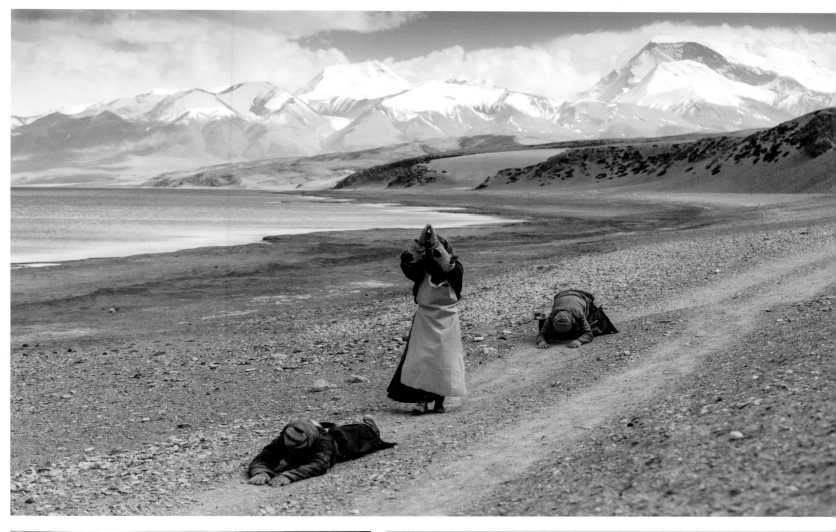

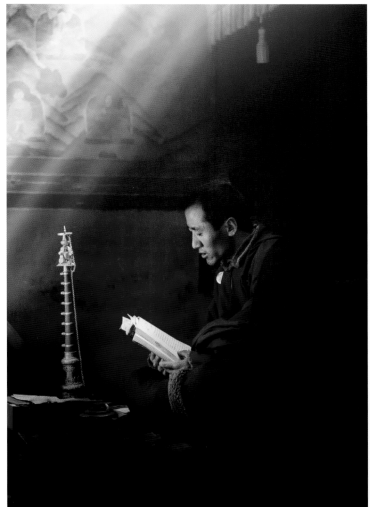

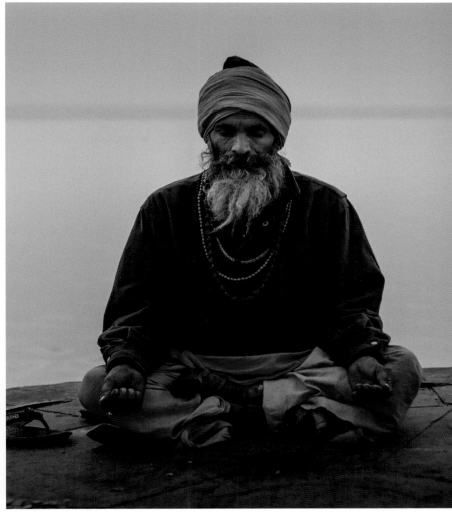

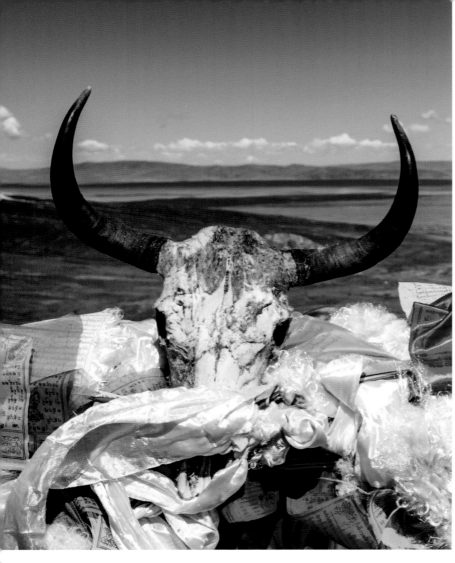

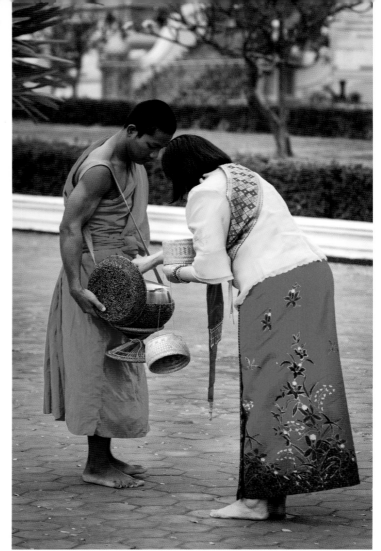

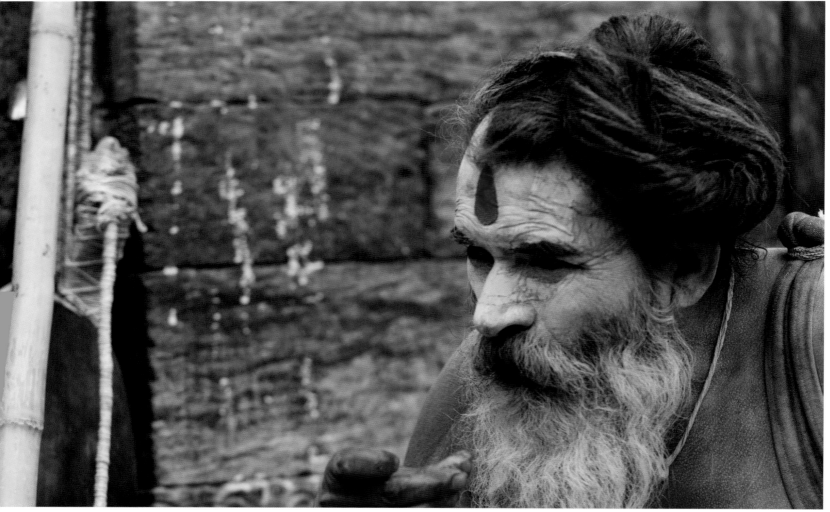

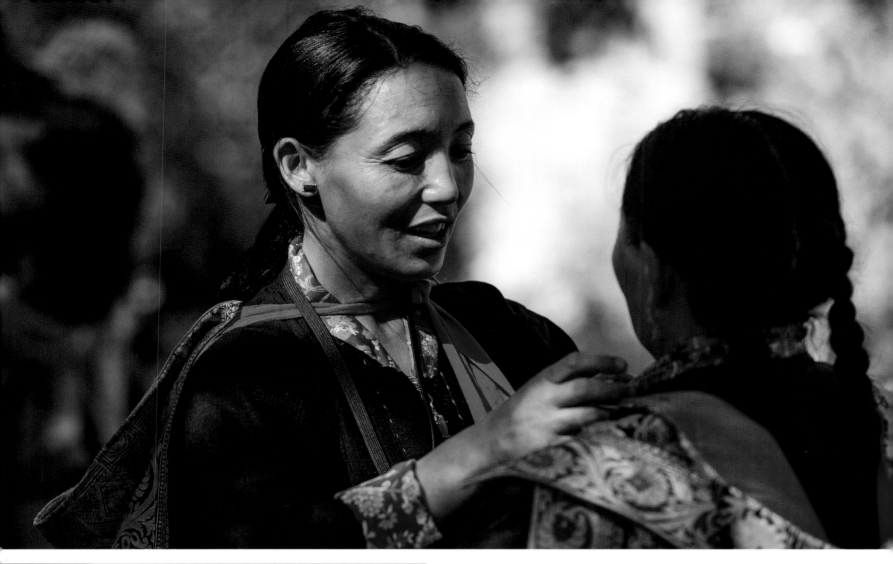

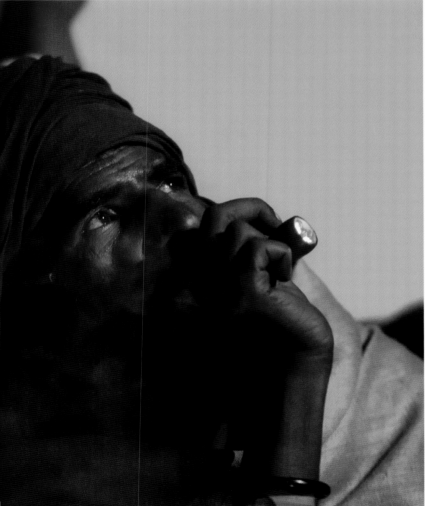

The five precepts, or *silas*, are the fundamental principles of behavior for all Buddhists for the development of virtue, which in turn forms the foundation of Buddhist practice as part of the Noble Eightfold Path.

Kill no living being.

Take nothing that is not freely given, and do not steal.

Control your sensual desires

Do not tell lies, do not hurt others with your words, and do not engage in meaningless conversations.

Abstain from intoxicants, such as alcohol and drugs, to ensure that your mind and spirit remain clear.

SACRED SITES
OF

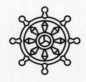

THERAVADA

Bangkok, Ayutthaya, Phitsanulok,
Sukhothai, Chiang Mai, Chiang Rai

Nuwara Eliya, Adam's Peak, Kandy,
Anuradhapura, Ritigala, Kataragama,
Colombo, Kelaniya

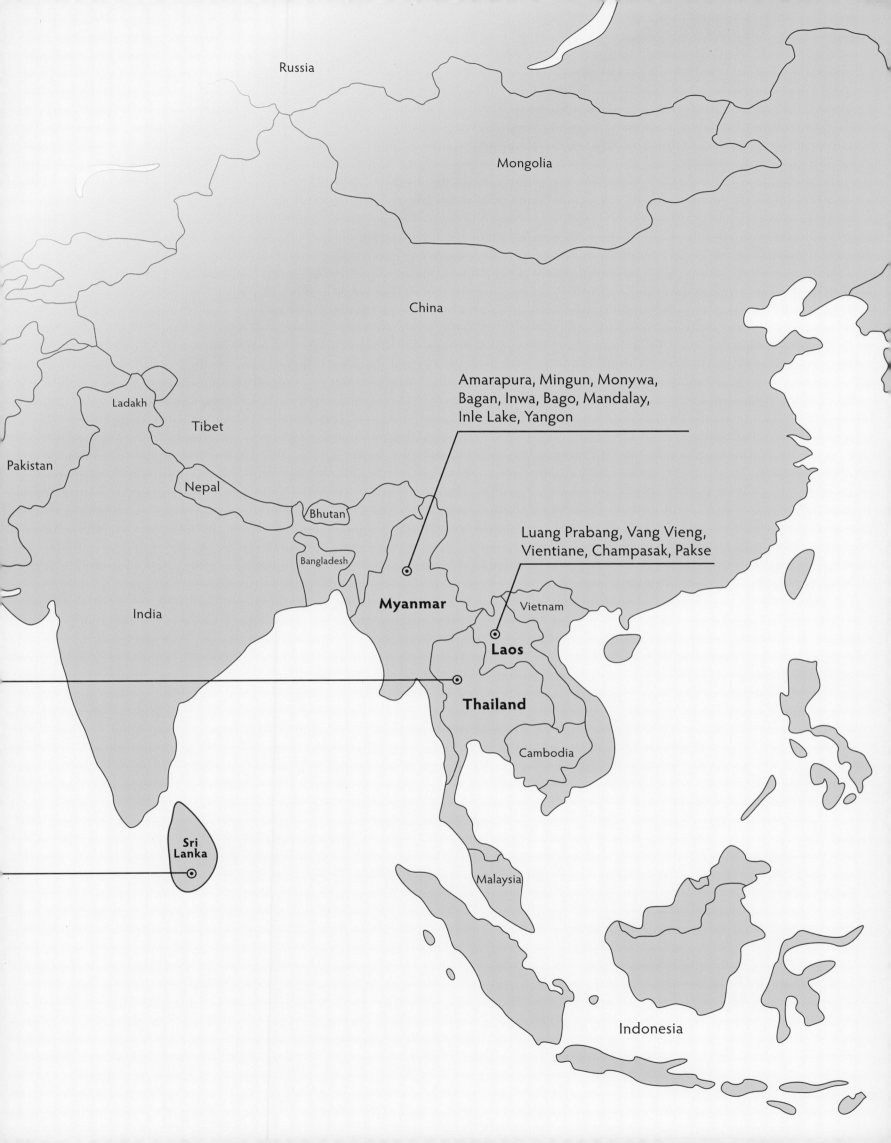

Russia

Mongolia

China

Ladakh

Tibet

Pakistan

Nepal

Bhutan

Bangladesh

India

Amarapura, Mingun, Monywa,
Bagan, Inwa, Bago, Mandalay,
Inle Lake, Yangon

Luang Prabang, Vang Vieng,
Vientiane, Champasak, Pakse

Myanmar

Vietnam

Laos

Thailand

Cambodia

**Sri
Lanka**

Malaysia

Indonesia

Sacred sites of
THERAVADA

At some point, I stopped counting. After the many hours of climbing, my legs are as heavy as lead. In the endless, constant stream of pilgrims, I climb step by step—around 5,200 of them—up to the summit of Adam's Peak, measuring 7,359 feet (2,243 meters) in height. They say that you are gifted a year of life for every ascent, so that gives me some motivation—even though I'm cursing the stairs at the moment. Locals call the mountain *Sri Pada*, or "holy footprint," because on the peak there is a footprint that measures about 5.9 feet (1.8 meters) in length. It is thanks to this footprint that followers of all the world's major religions find themselves peacefully and laboriously making their way up the mountain: Hindus believe the footprint to be that of Shiva, Muslims think it is from the Prophet Adam, and Christians believe it was left behind by the Apostle Thomas. Buddhists, who make up the largest group of pilgrims, are convinced that this is the footprint of Buddha.

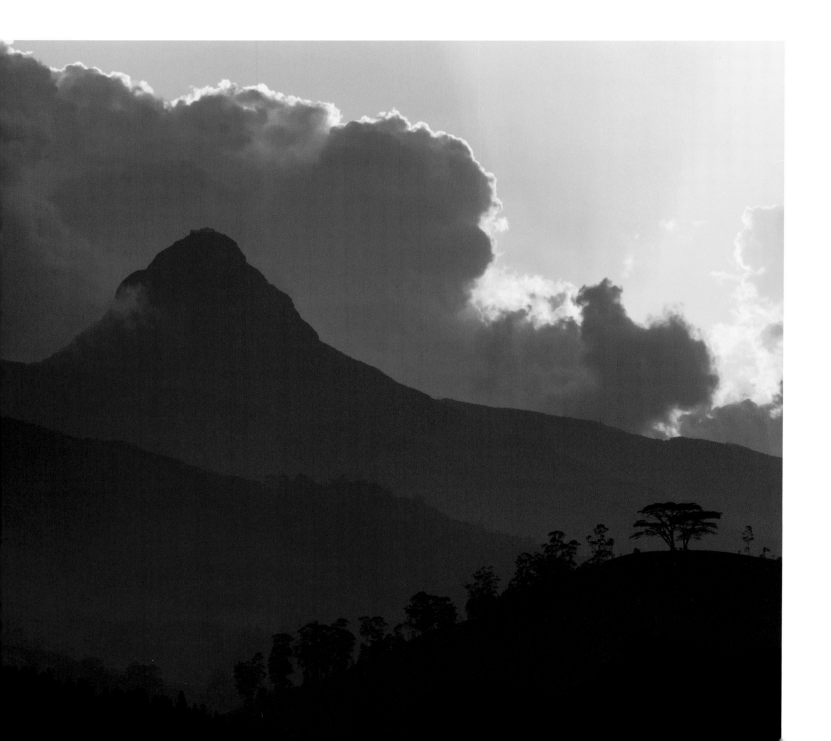

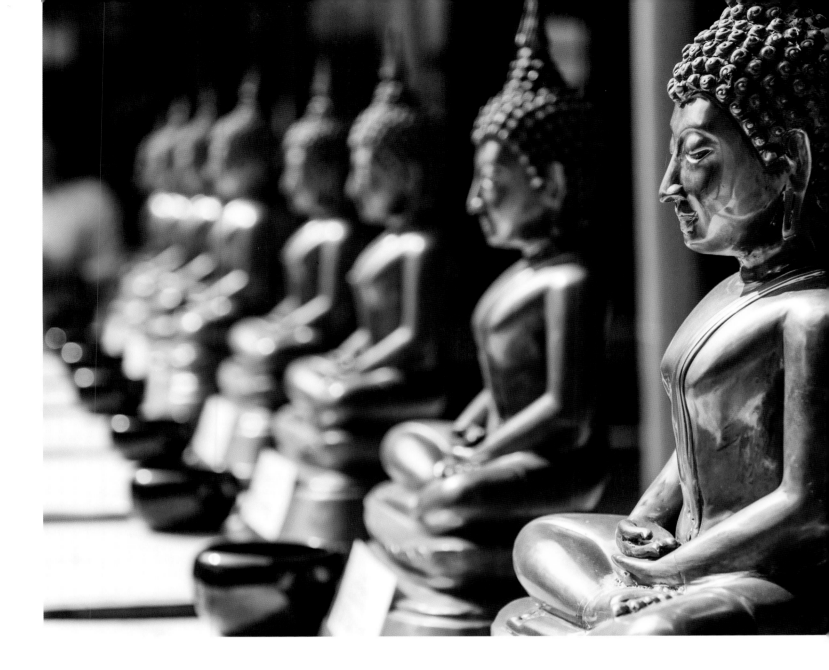

While I continue my climb, I start thinking about the history of Buddhist missionary work. Buddhism was able to spread in northern India early on, but its great moment came in 258 B.C.E. under Ashoka Mauriya, the ruler of India at that time. He had realized the suffering caused by his wars of conquest and converted to Buddhism. Afterwards, he had the doctrine spread throughout his empire and finally convened the Third

Buddhism was able to spread in northern India early on

Buddhist council. Ashoka regarded the council as a way to settle the existing clashes in policy between the more than a dozen existing Buddhist schools with regard to the monastic rules (*vinaya*) and the interpretation of the teachings of Buddha (*dharma*). The division in the community, which had already begun during the second council in Vaishali, nevertheless deepened in the centuries that followed and finally culminated in the emergence of the two major schools of Buddhism: Theravada and Mahayana. For the one school, the

highest goal was to attain liberation from rebirth for oneself and become an *arhat* (saint), while the other focused on the bodhisattva as the ideal to be attained.

While all this is going through my head, I finally reach the top. The stream of pilgrims pulls me along to the temple with the footprint. The story goes that during his third visit to the island, Buddha placed his left foot on Adam's Peak, then stepped across the Bay of Bengal and placed his right foot in Thailand, and from there he intended to spread Buddhism throughout Southeast Asia. That's another way to approach missionary work. Ashoka had, in fact, sent monks out on mission to neighboring states. The one sent to Sri Lanka under Ashoka's son Mahinda was the most success-ful. Before long, the Sinhalese rulers made Bud-dhism the state religion. The island became Buddhist and has remained so to this day.

Although I like the idea of being able to walk across to Thailand, in reality those who brought Buddhism from Sri Lanka to Southeast Asia were probably the early monks—people with a celibate way of life, without property or home, who had no attachments anywhere, and who could therefore move on from village to village, from town to town, and from country to country—as well as travelers and traders. They only ever taught the doctrine where there was a corresponding interest or where instruction was specifically requested. The success of the Buddhist "mission" is not due to a fanatical proselytizing zeal. It is based on the propagated insight and peacefulness of the doctrine and on the avoidance of any intrusiveness or even coer-cion. It took until the 12th century for Theravada Buddhism to become the main religion in the territories of what is today Myanmar, Thailand, Laos, and Cambodia.

From that point on, the focus shifted to the construction of ever more magnificent and larger Buddhist temple complexes, even entire temple cities. Today, those sites have become true visitor

40

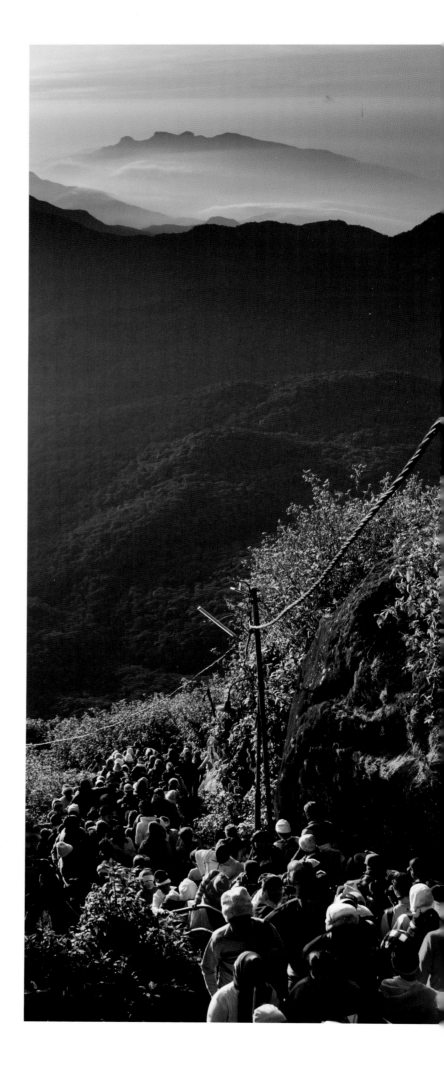

magnets as ruins or places of living faith. Many of them are high on the bucket list of modern travelers; unfortunately, rampant tourism has often robbed them of their charisma despite their splendor. Famous complexes are frequently reduced to objects to which you just devote the brief moment of a selfie. The list is long, from Wat Phra Kaew in Bangkok or the ancient royal city of Ayutthaya, to Angkor Wat in Cambodia or Luang Prabang in Laos. There is no disputing the fact that the famous complexes often have impressive architectural features. Yet it tends to be the smaller temples where you will feel the spirituality of these places—areas where Buddhism is lived in everyday life, where monks collect morning alms, and locations that feature special landscapes, such as Adam's Peak.

There are exceptions, however. I experienced one when I visited the Shwedagon Pagoda in Myanmar, a place of convergence, of spirituality—and a tourist attraction. Even the legend of its creation is fascinating. Two brothers met the newly enlightened Siddhartha Gautama and received from him eight strands of the Buddha's hair. Afterwards they moved to Myanmar, where, with the help of King Okkalapa, they built a pagoda on Singuttara Hill, in which the eight hairs are enshrined in a golden casket. The actual date of origin has been lost in the depths of history. Starting in the 15ᵗʰ century, it became customary to gild the Shwedagon Pagoda.

The Shwedagon Pagoda in Myanmar, a place of convergence, of spirituality—and a tourist attraction.

Apart from its brilliance, the complex has one other very special aspect. It represents the effect of space and time in interaction with the time of birth on the fate of individuals. It is, so to speak, astrology turned to stone. The circle around the pagoda is divided into sections, which are assigned to the individual days of the week. Thus, those born on a Monday not only bear the name of this day, but they also pray and offer flowers and water at the specific place designated for that day. This is not a prayer to a god, but rather an awareness of hidden connections that are considered to have a significant influence on the life destiny of the person concerned. By means of the rituals, people place themselves in harmony with the special forces that arise from their birth situation. These kinds of "effective powers" are present in various ways throughout Asia in how Buddhism is practiced, and the belief in them is exceedingly strong.

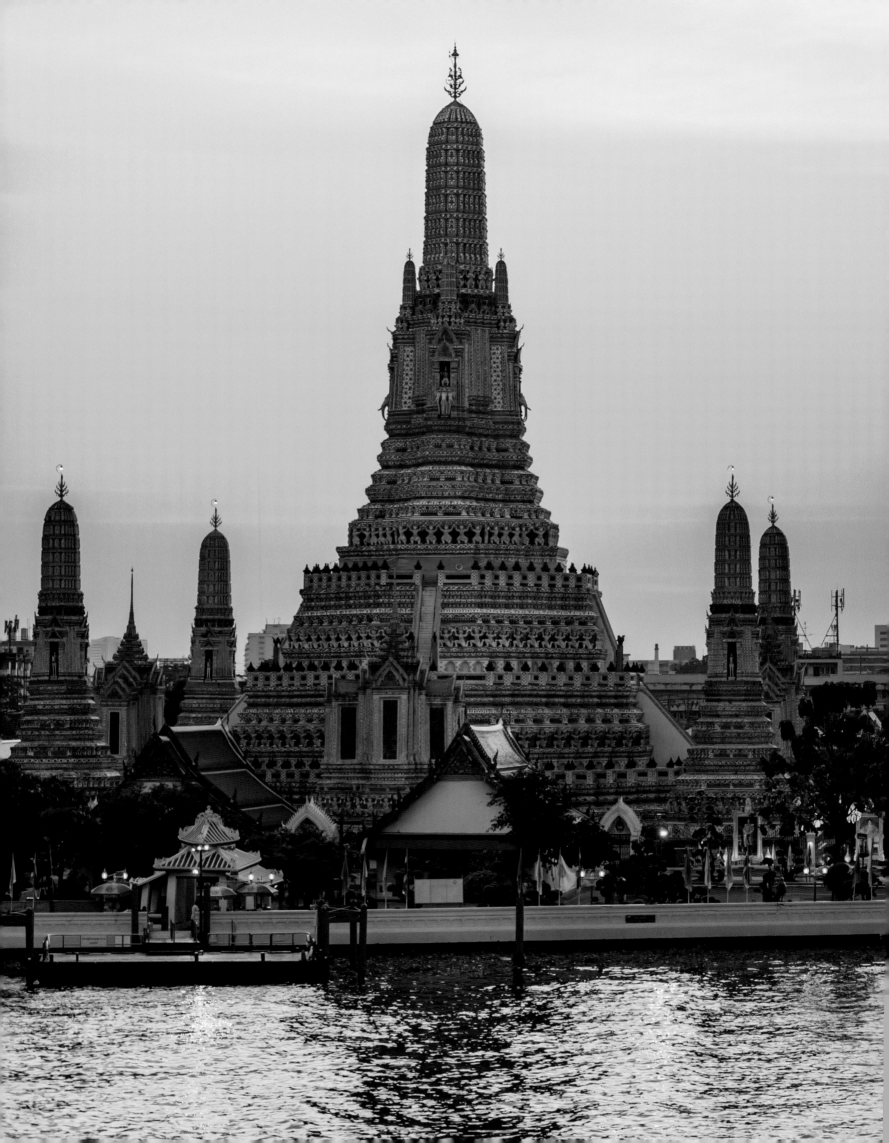

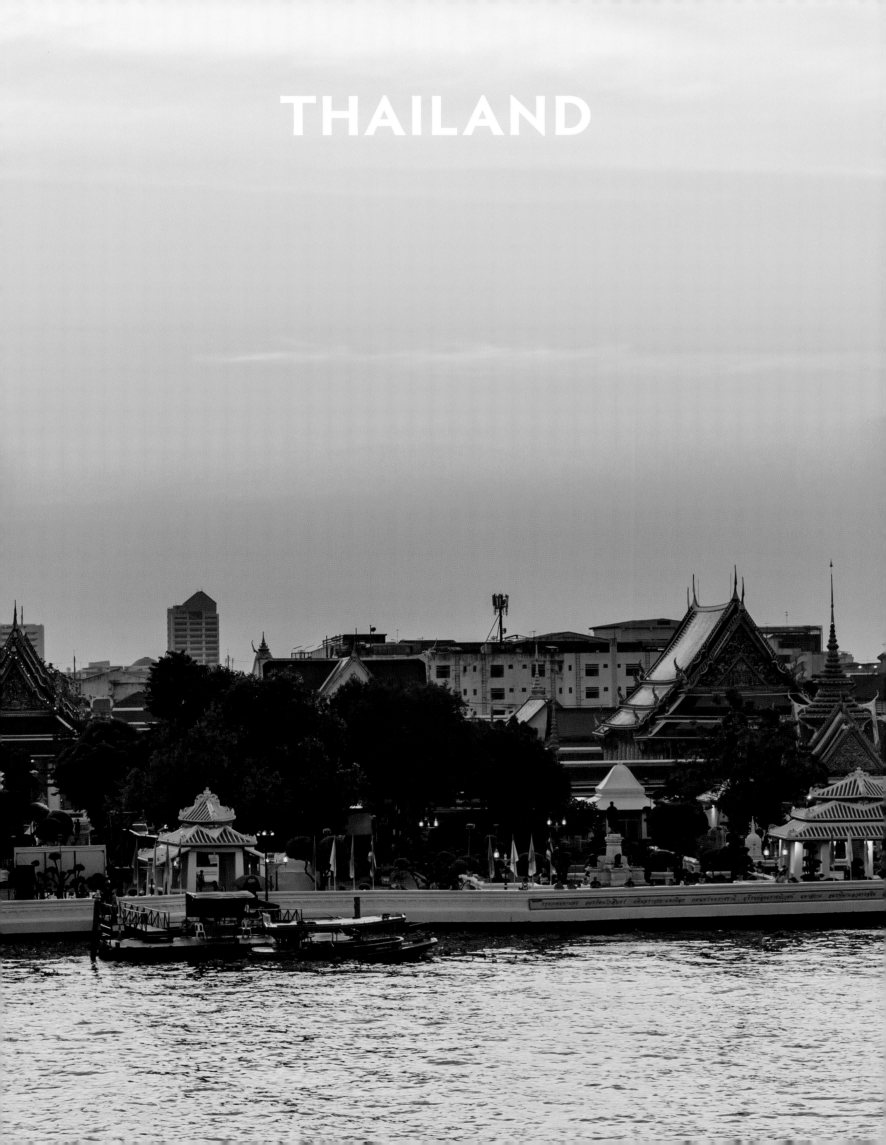

THAILAND

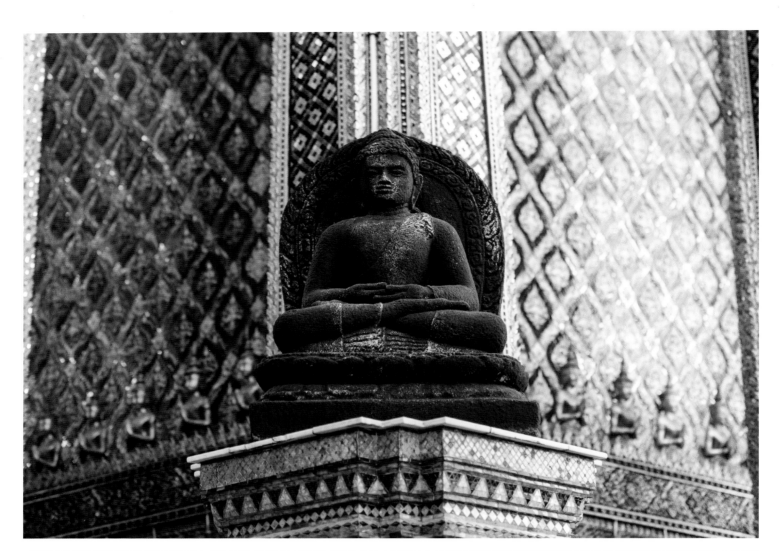

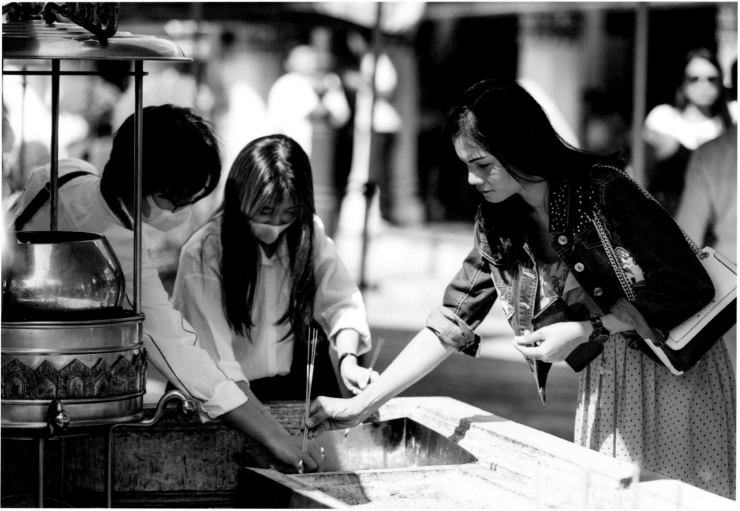

Sacred sites of Theravada Thailand Bangkok Wat Phra Kaew & Wat Pho

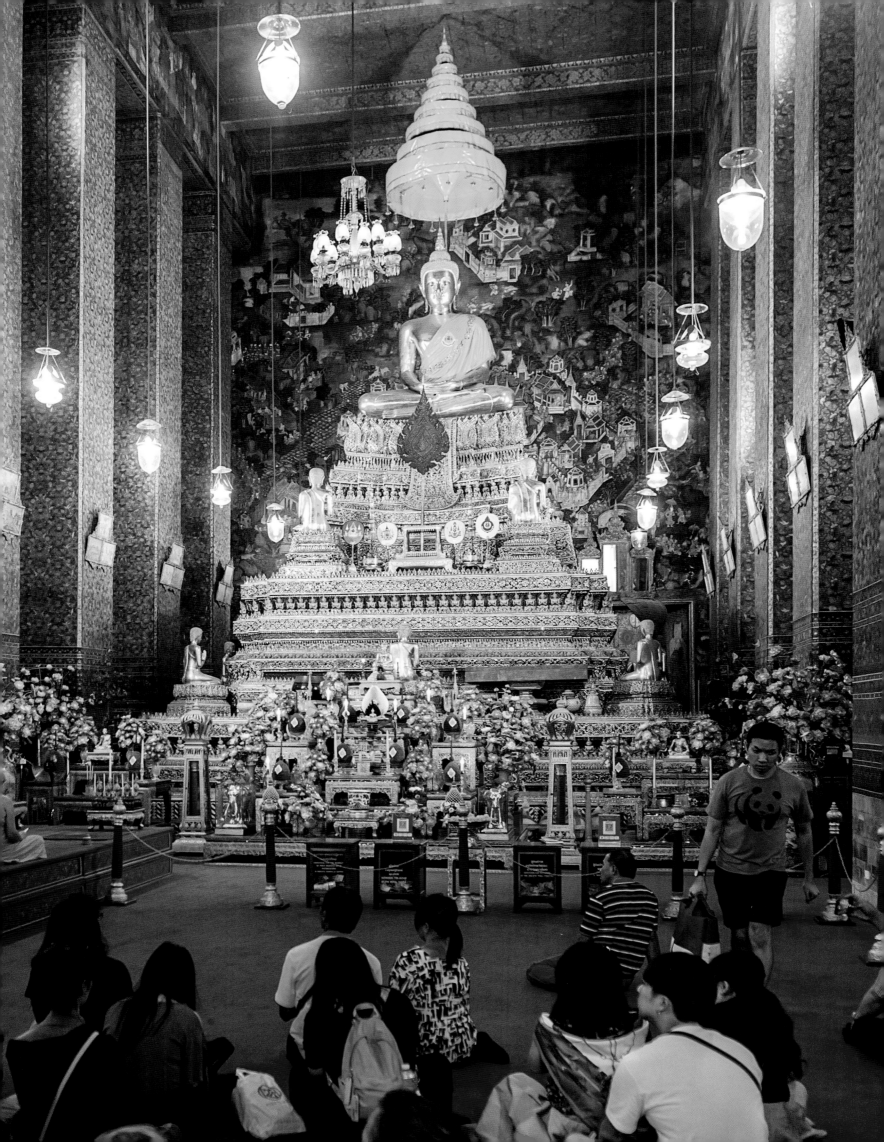

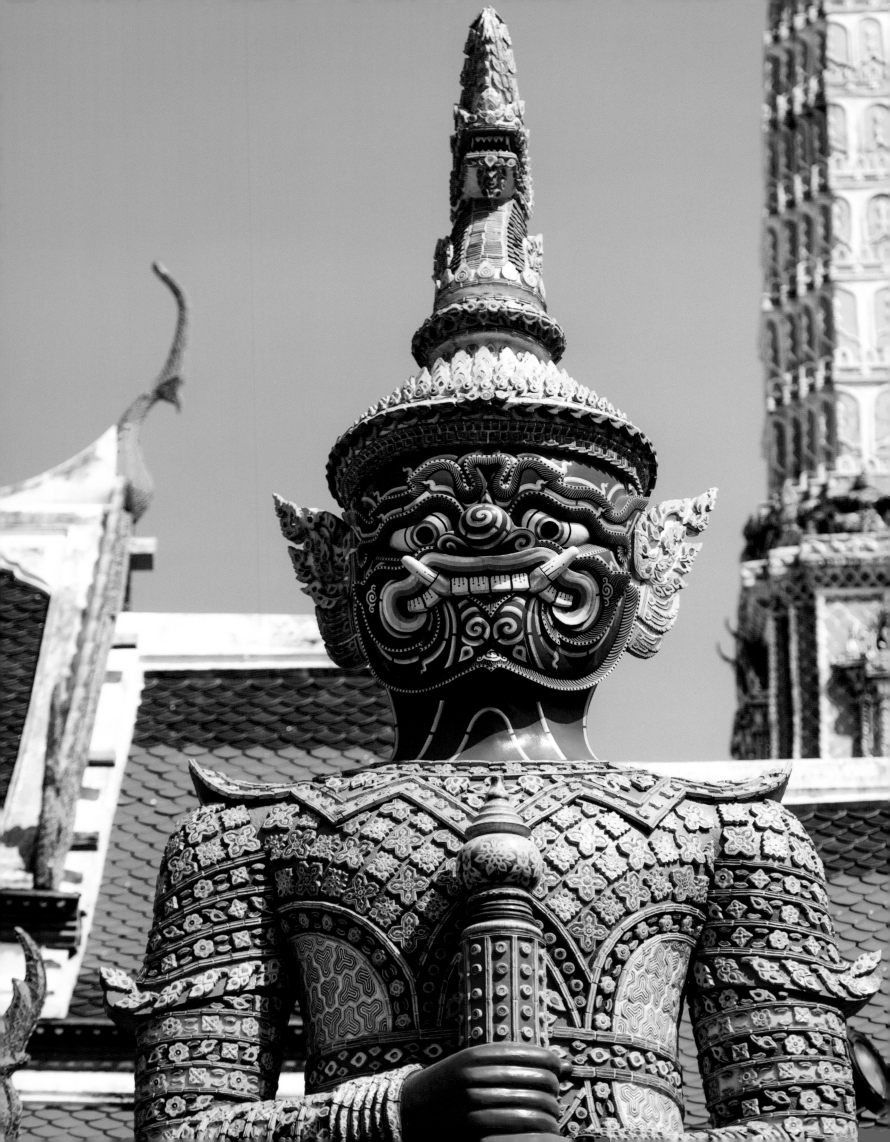

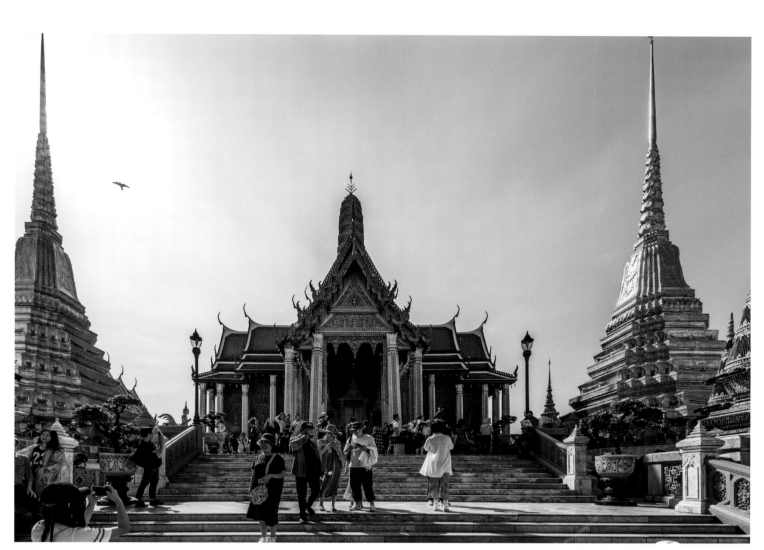

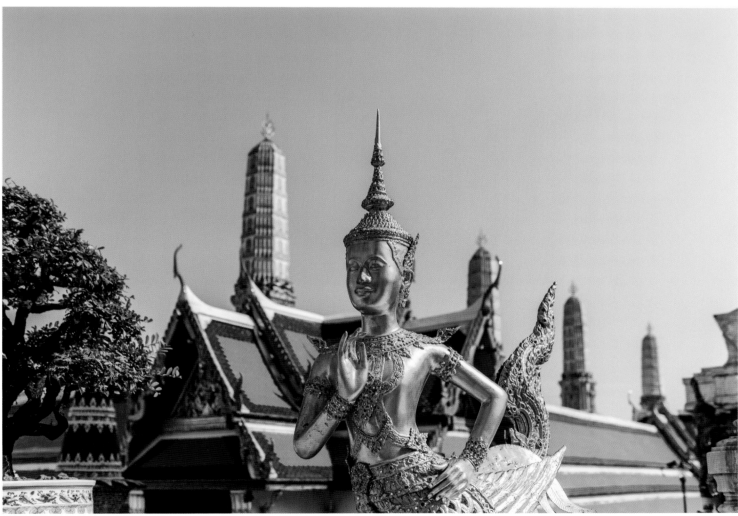

Wat Phra Kaew Bangkok Thailand Sacred sites of Theravada

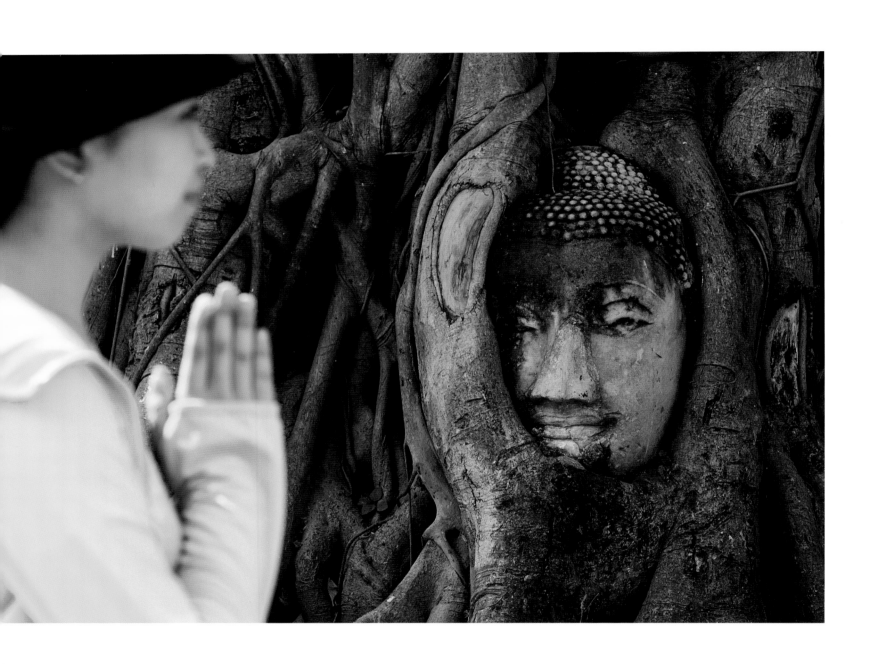

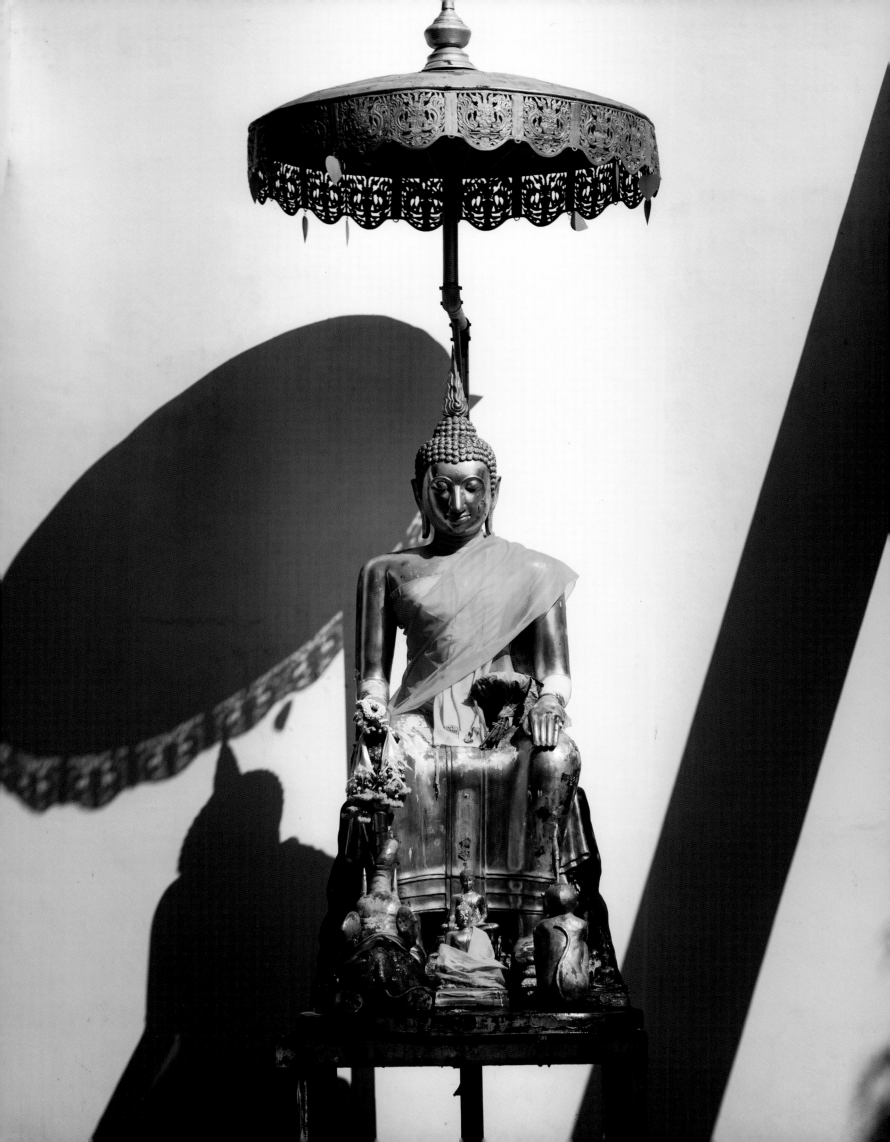

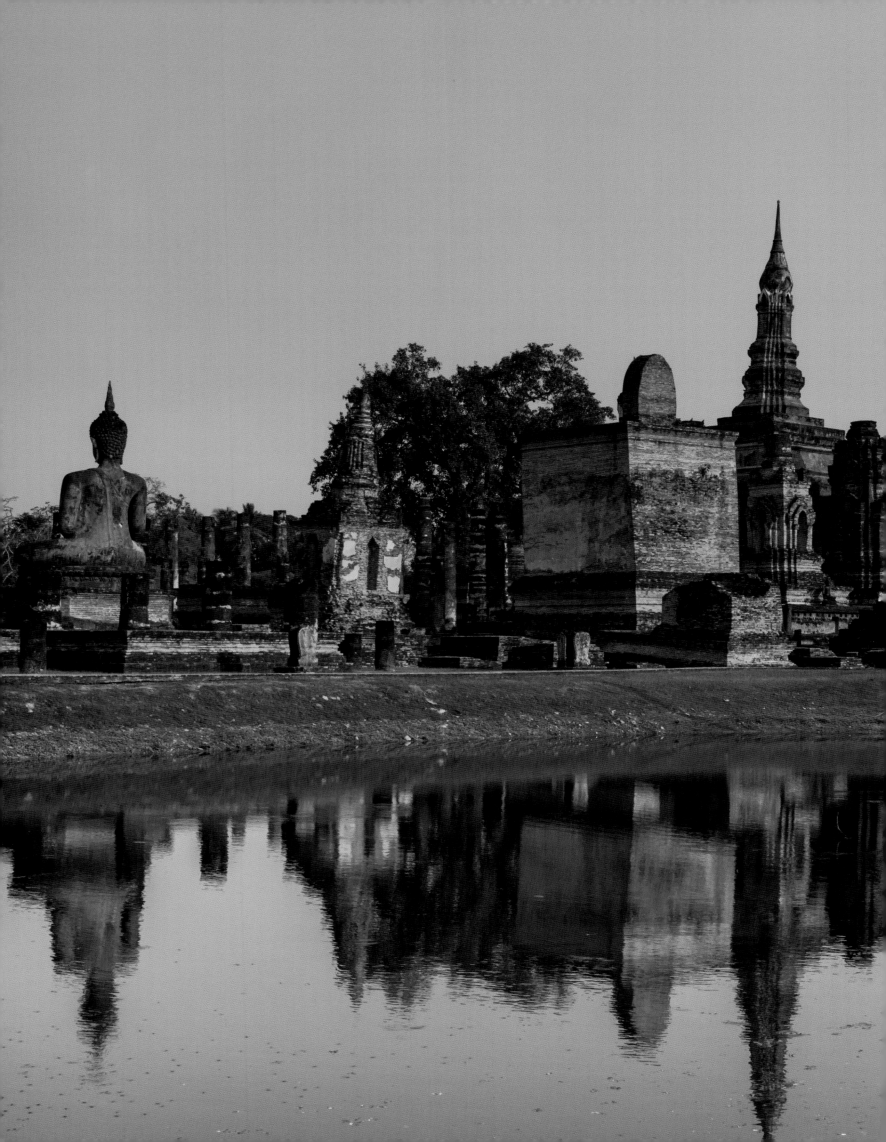

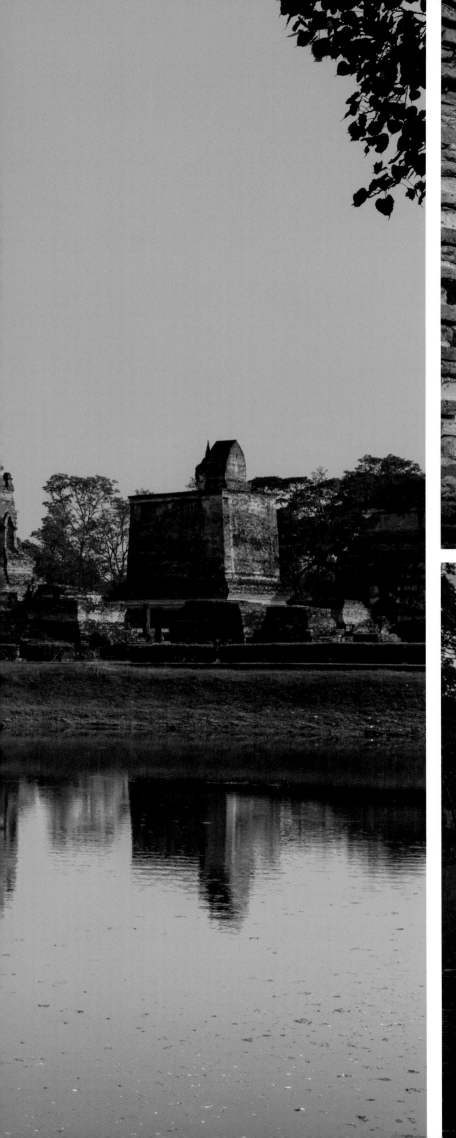
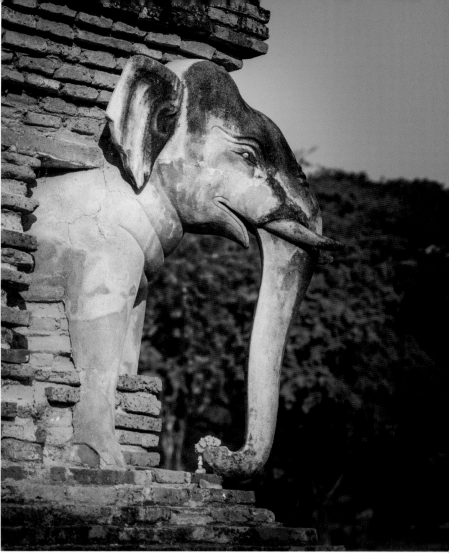
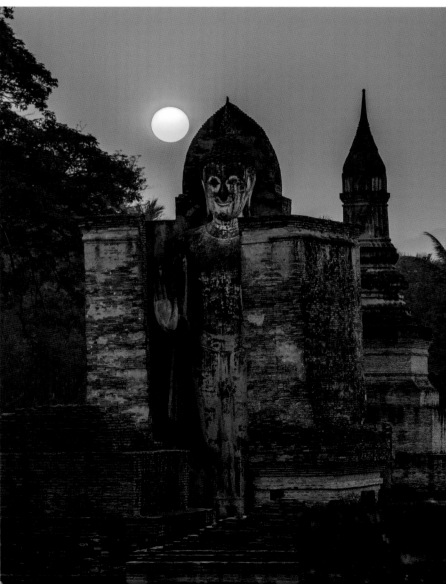

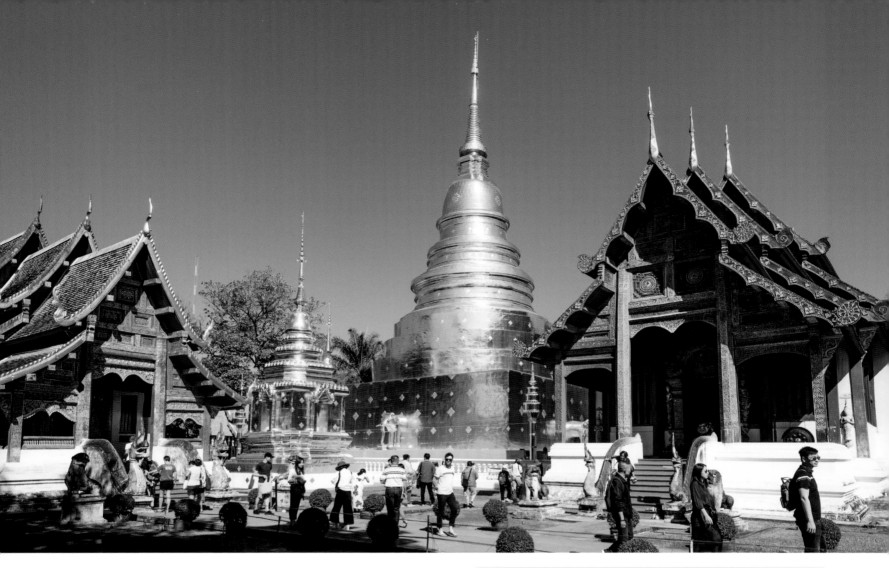

Wat Phra Singh and Wat Phra That Doi Suthep, two royal temples in Chiang Mai, are known for their precious Buddha sculptures. The Buddha exudes calm serenity during his meditation, which lasts several weeks. During this entire time, the Naga king, or the snake king, spreads his seven heads over him like an umbrella to shield him from the rain and bad weather.

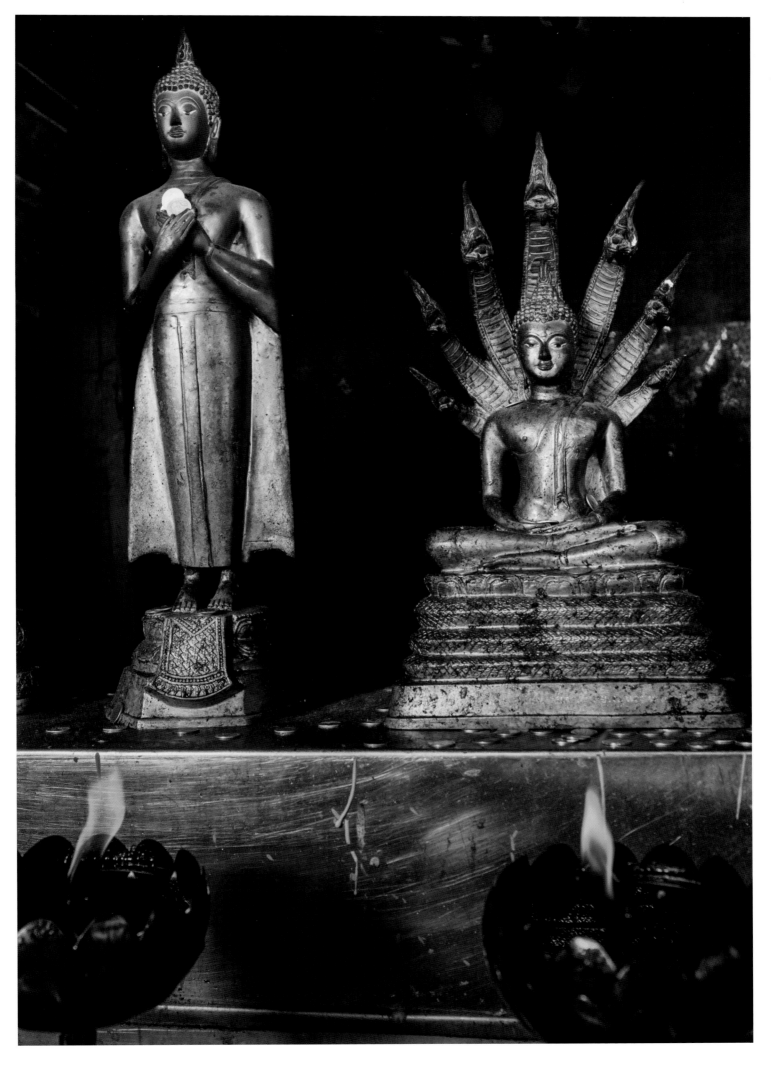

Wat Phra That Doi Suthep ✤ Chiang Mai ✤ Thailand ✤ Sacred sites of Theravada

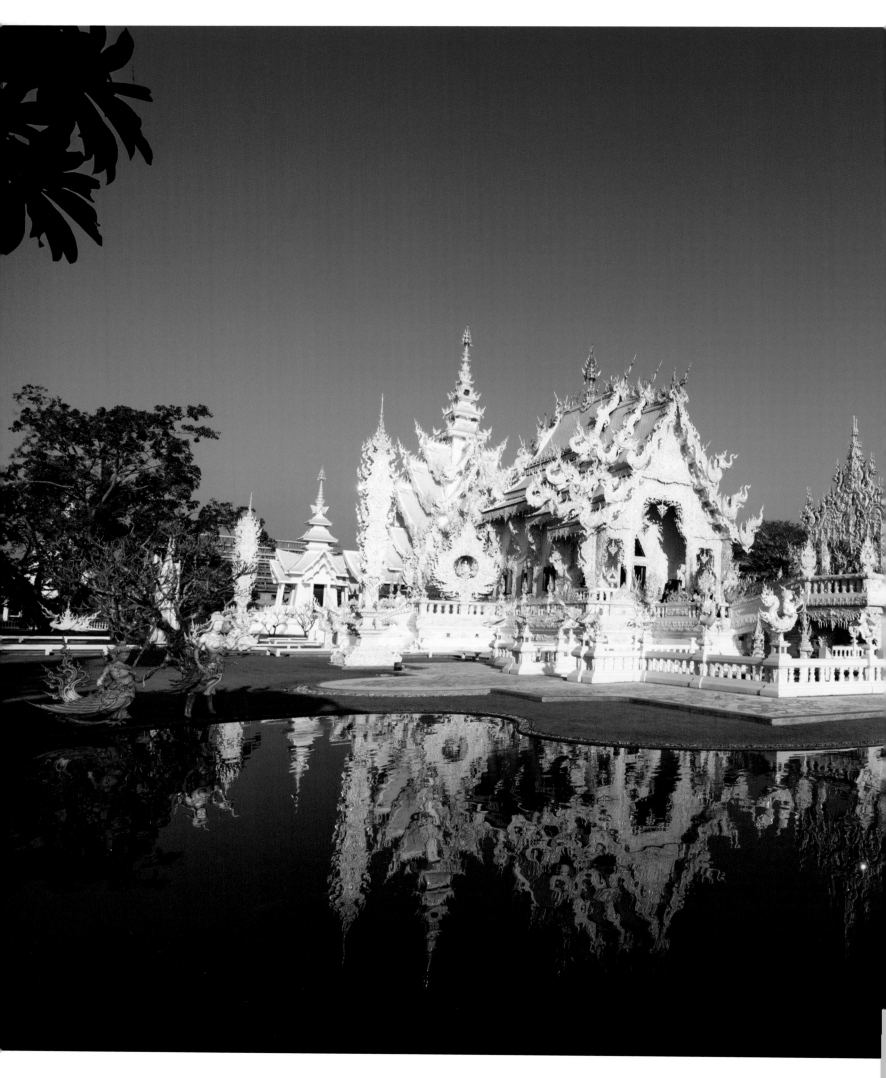

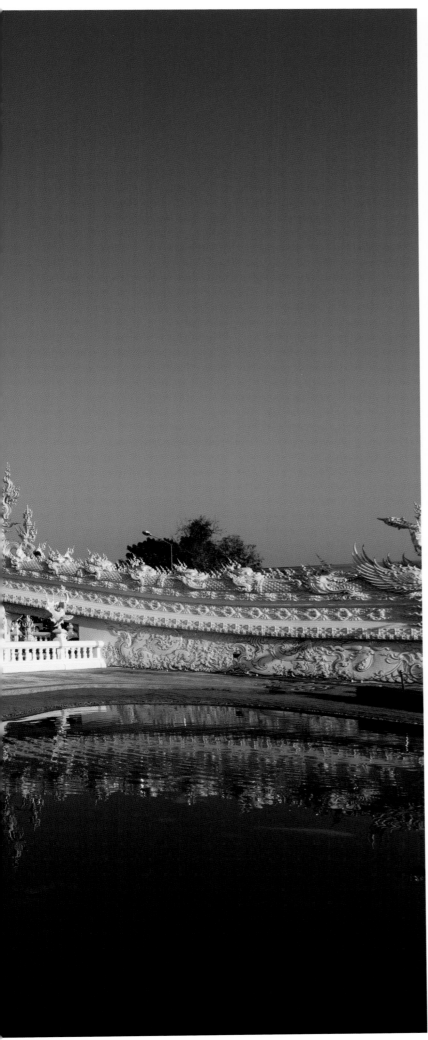

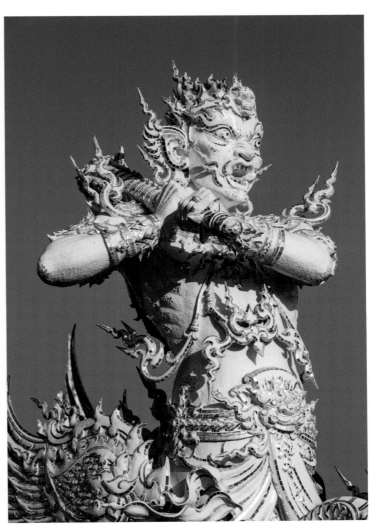

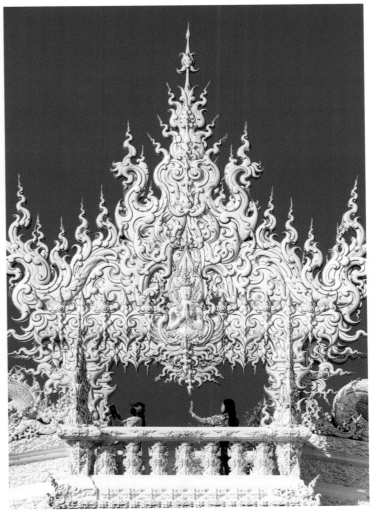

Wat Rong Khun ❖ Chiang Rai ❖ Thailand ❖ Sacred sites of Theravada

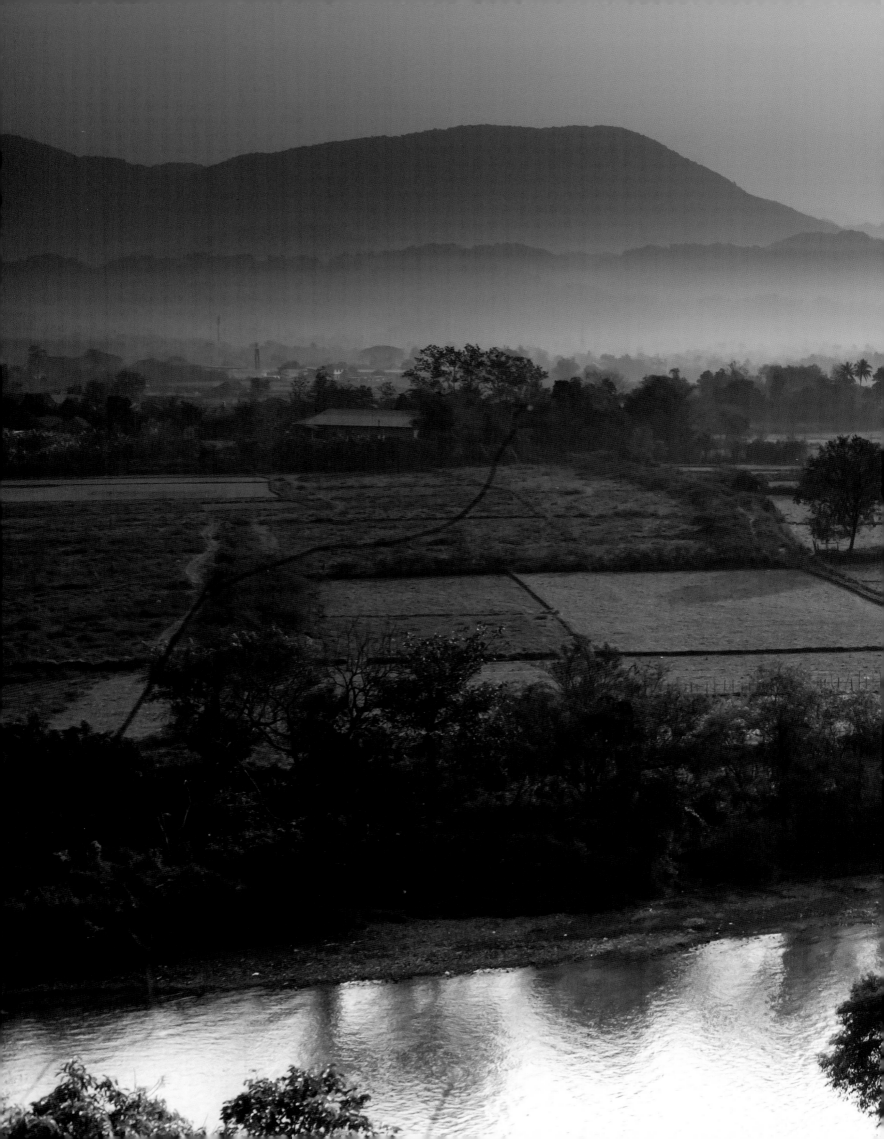

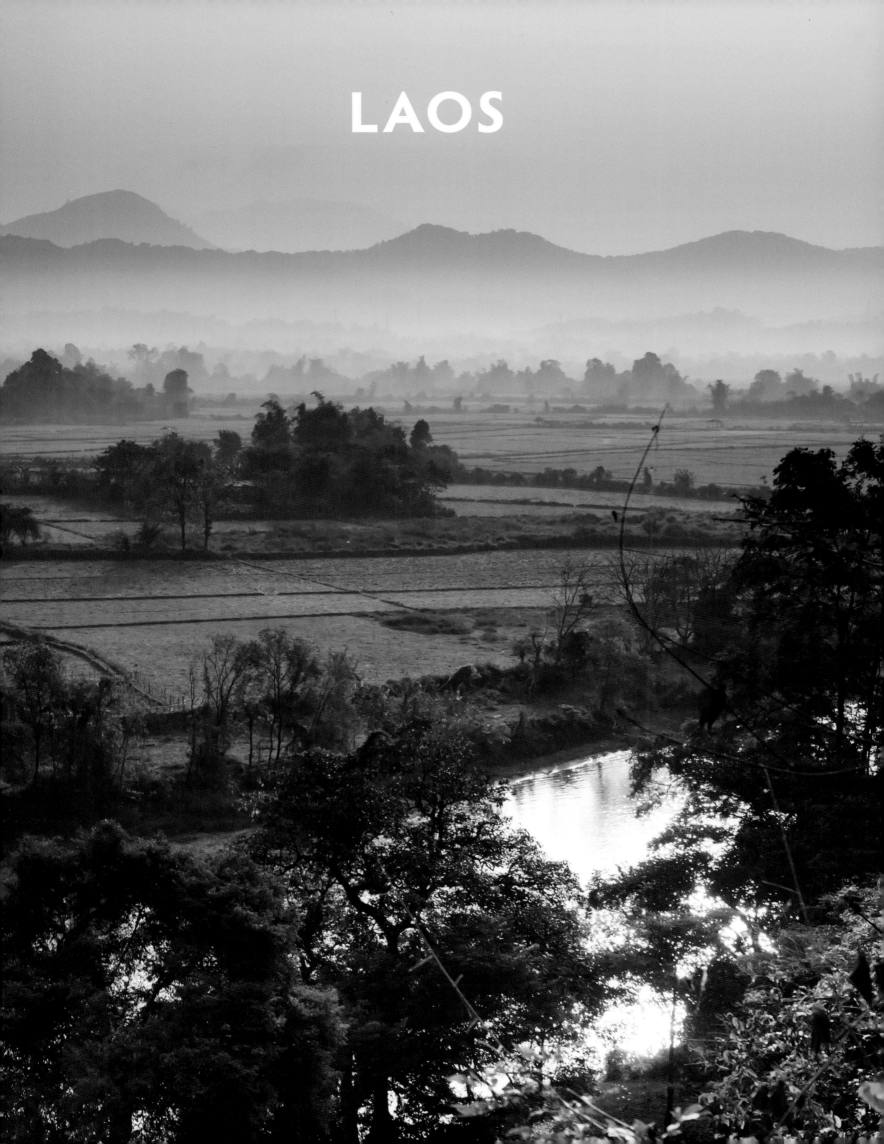

LAOS

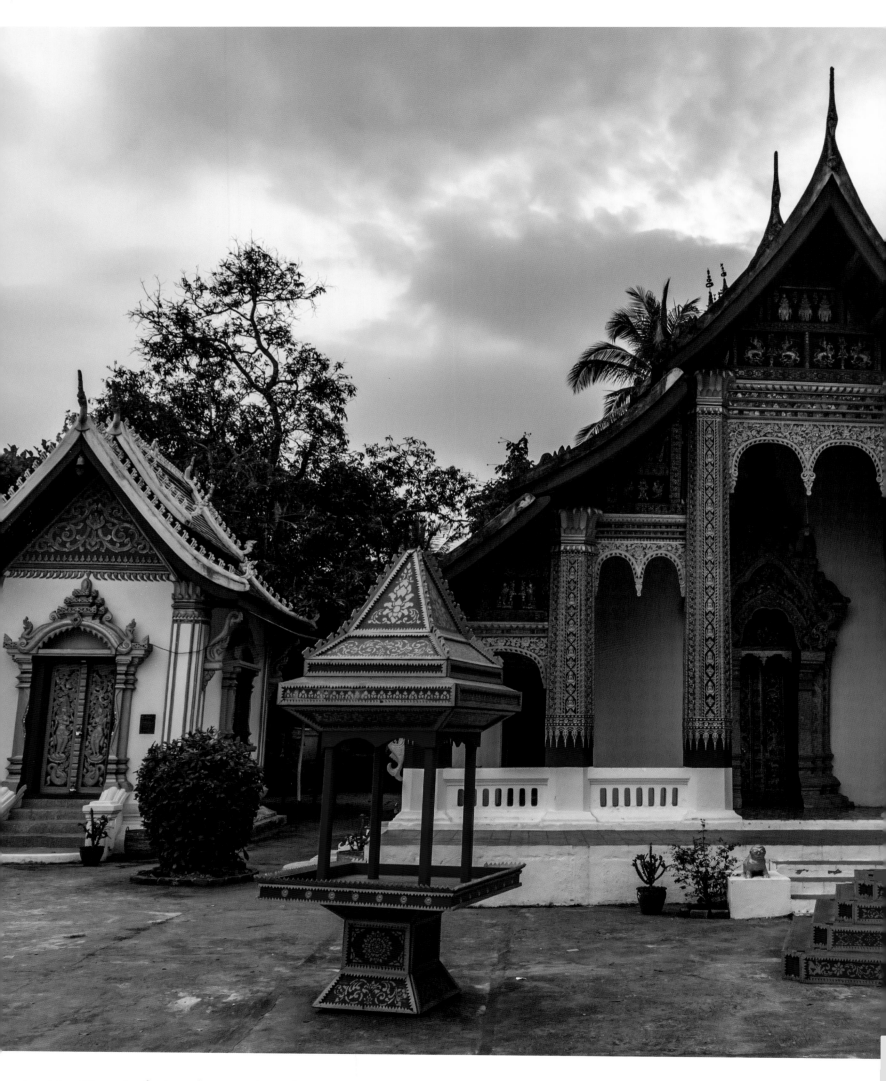

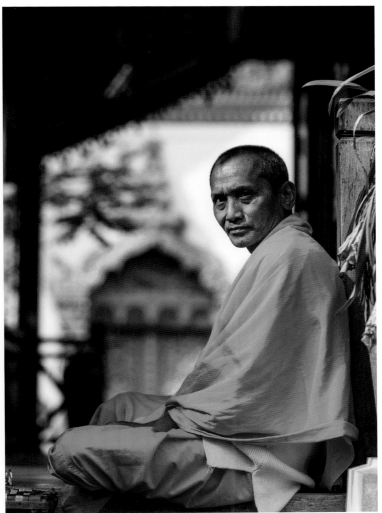

This double-page spread:
Situated in the sleepy village of Xieng Mene on the Mekong River, Vat Xieng Mene is a typical Laotian village temple. The cemetery located in the bamboo forest behind the temple, however, is something special. This is where members of the royal family from nearby Luang Prabang were buried who were not allowed to be cremated for religious reasons.

Next double-page spread:
The karst mountains of Vang Vieng are home to numerous caves, such as Tham Phu Kham, which is sacred to the Laotians. Caves are the entrance to the underworld, a transitional place where the light fades and eternal darkness begins. This is where the reclining Buddha, representing his passing into parinirvana, is worshiped. Caves are also places for visions and thus ideal locations for meditation.

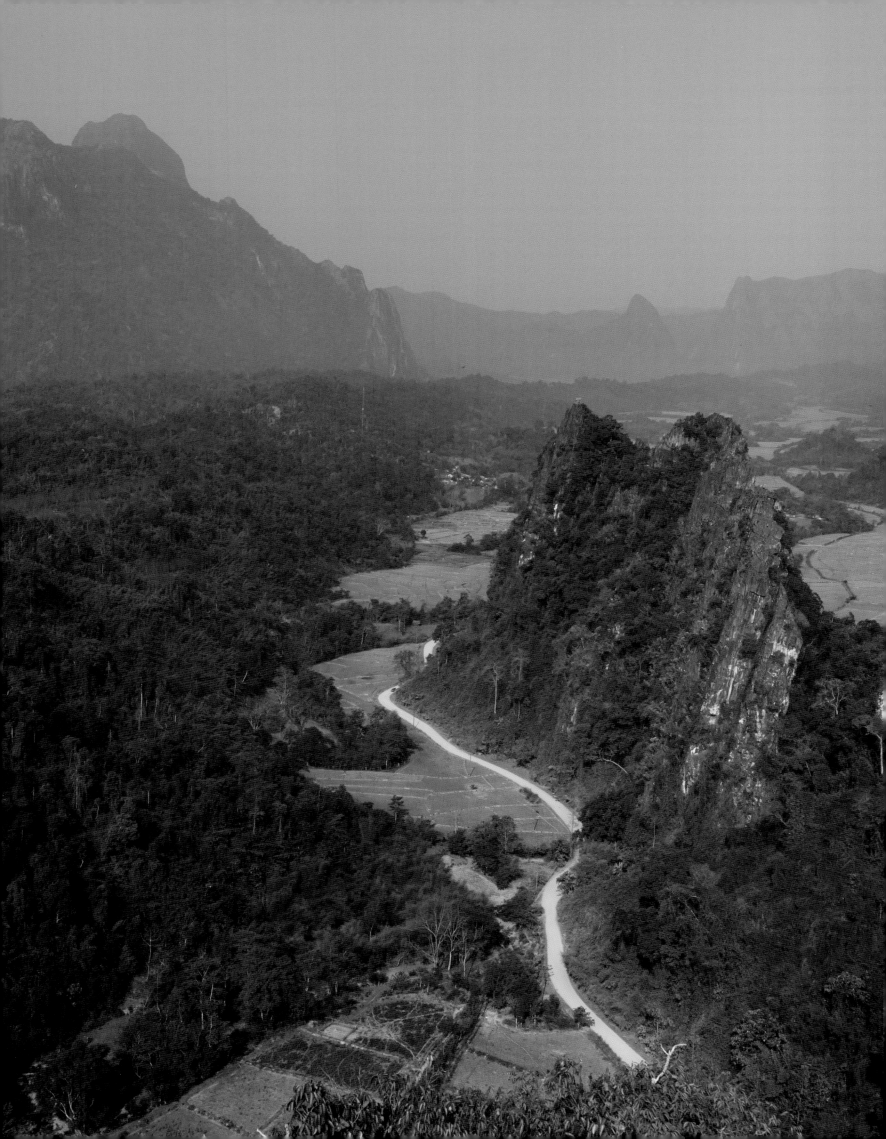

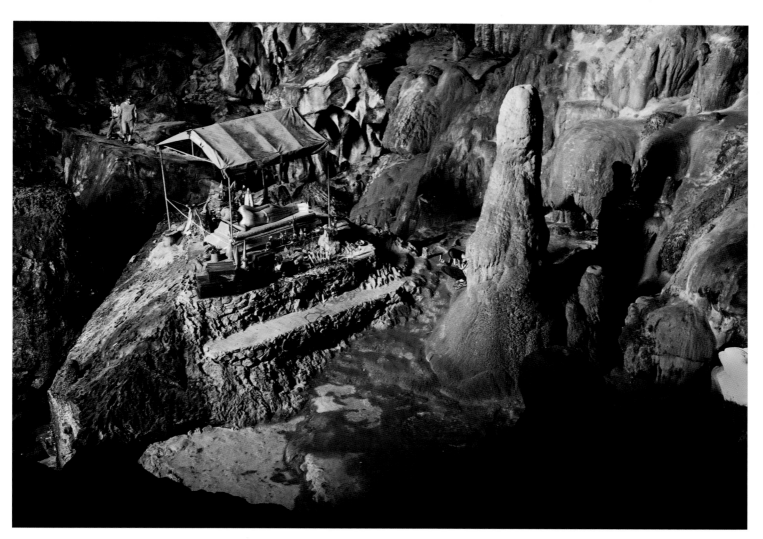

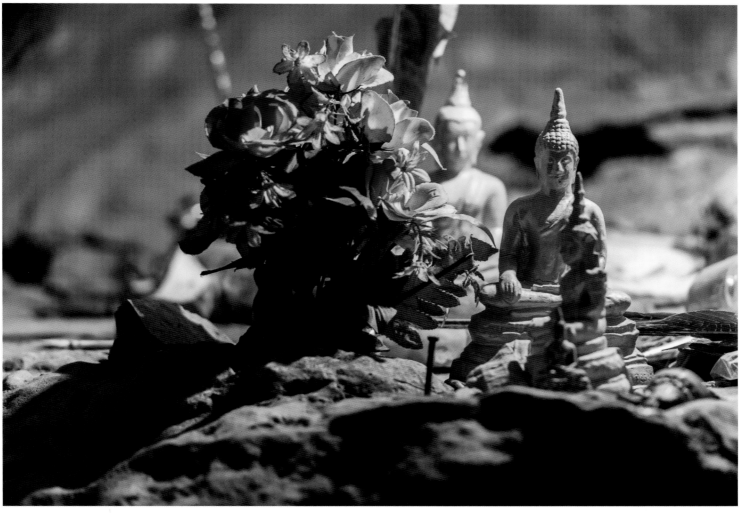

Tham Phu Kham & Tham Chang cave Vang Vieng Laos Sacred sites of Theravada

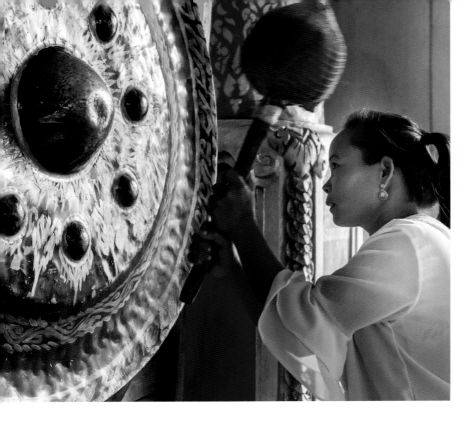

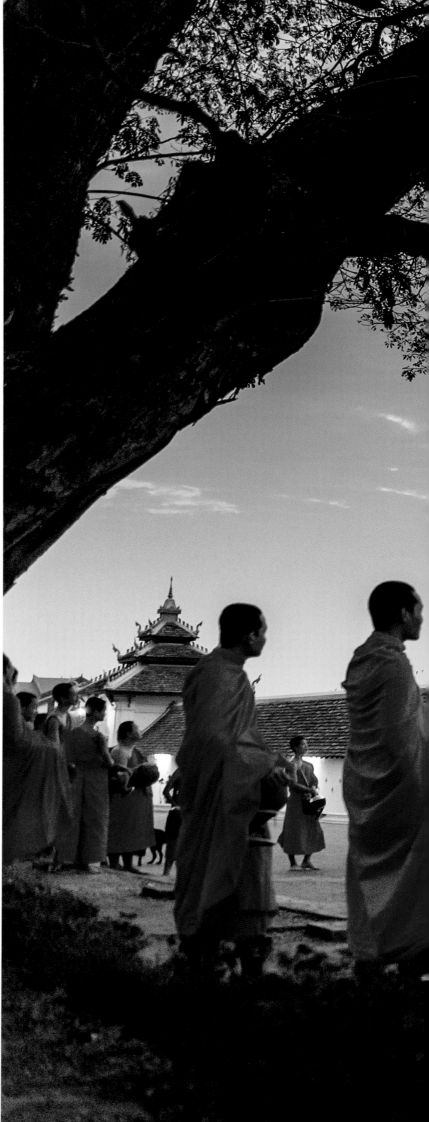

 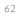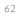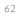

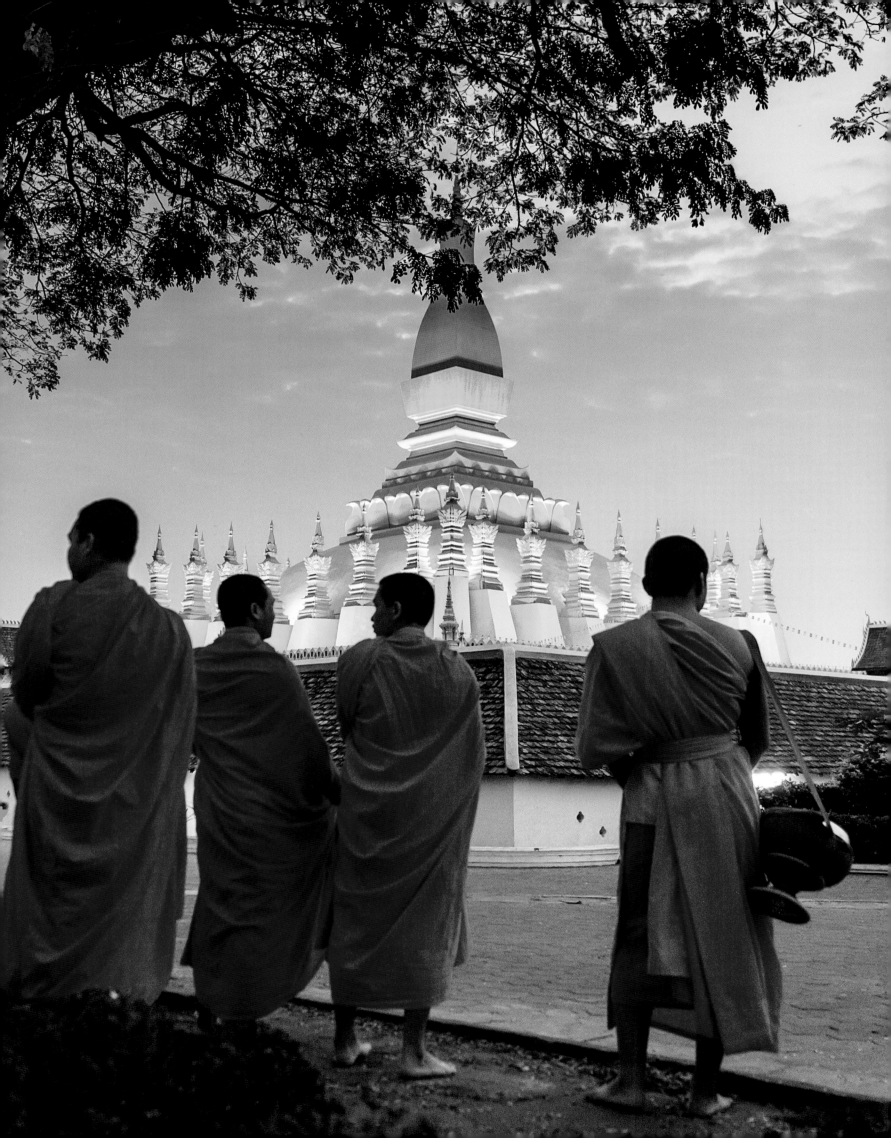

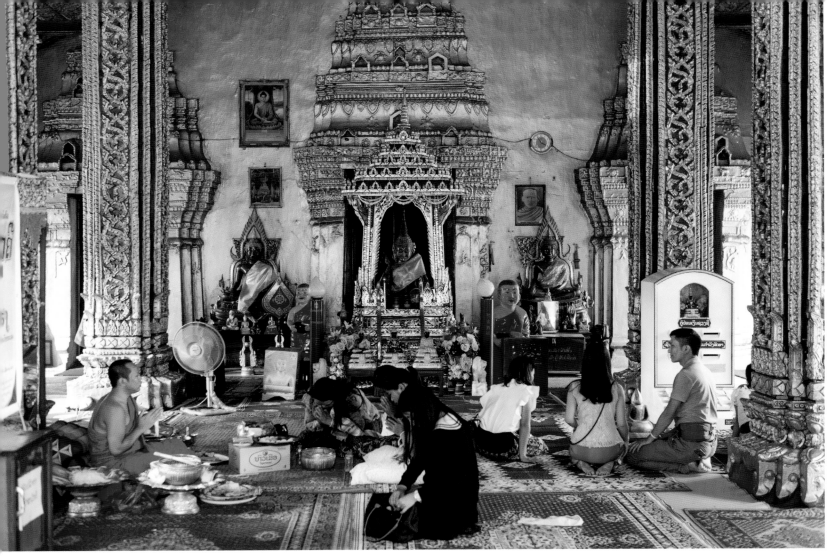

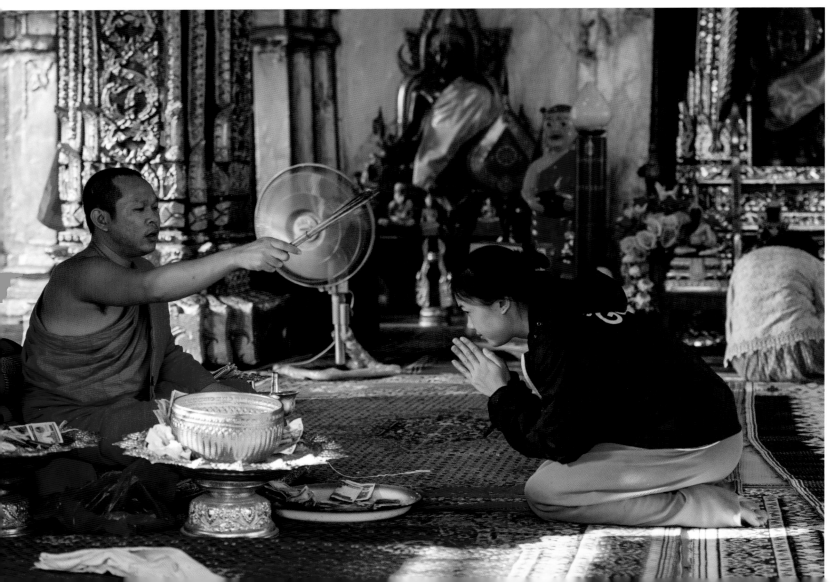

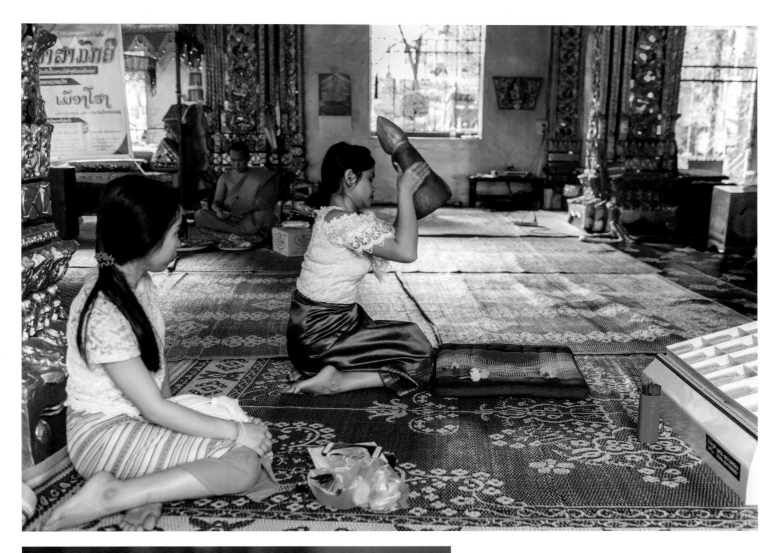

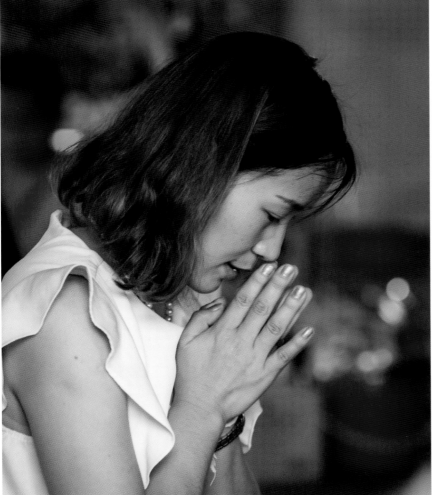

Vat Si Muang (or mother temple) is the guardian temple of Vientiane. According to legend, a pregnant young woman named Si Muang voluntarily sacrificed herself at this place to appease angry spirits and to allow the temple to be constructed. The site is considered to be especially powerful, and many women come here to pray for a pregnancy free of complications.

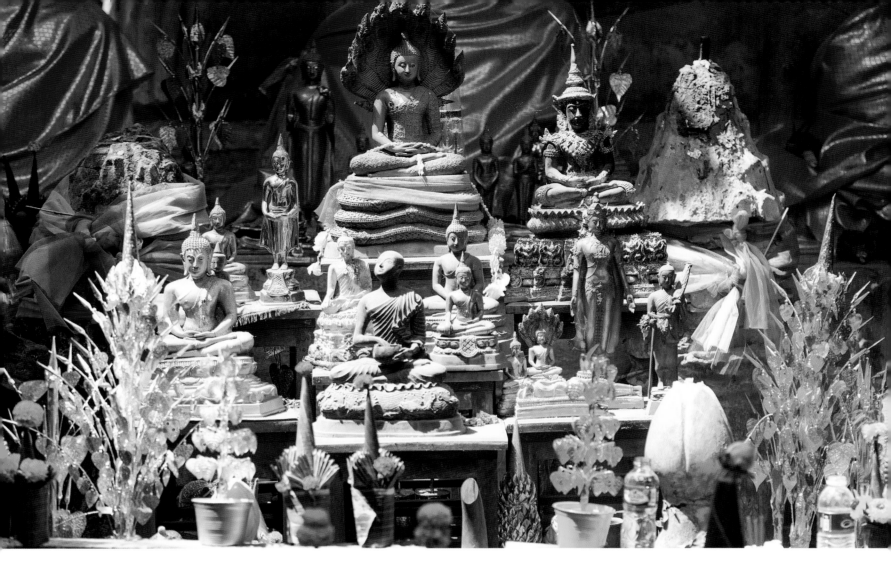

Originally dedicated to the Hindu god Shiva, Vat Phou near Champasak is considered to be the architectural model for Angkor Wat in Cambodia. Once a year on the 15th day of the third moon, thousands of pilgrims stream into the UNESCO World Heritage complex to celebrate the Buddhist festival of Boun Makha Busa. During the festival, people dance, pray, and leave numerous offerings.

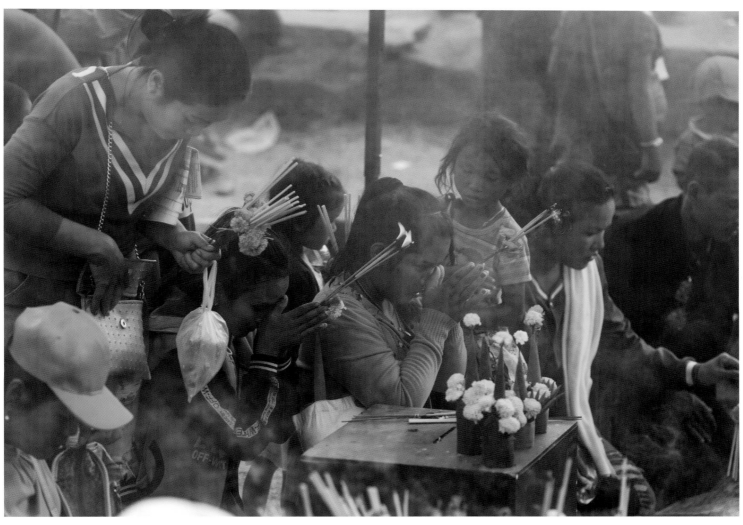

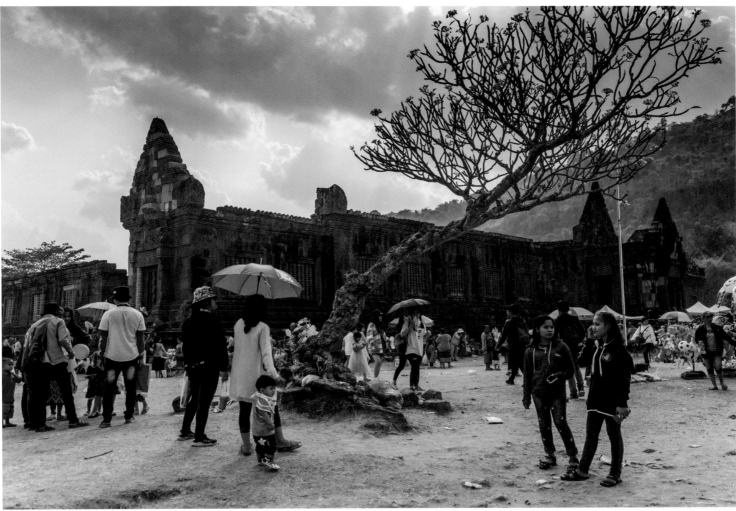

Vat Phou ✣ Champasak ✣ Laos ✣ Sacred sites of Theravada

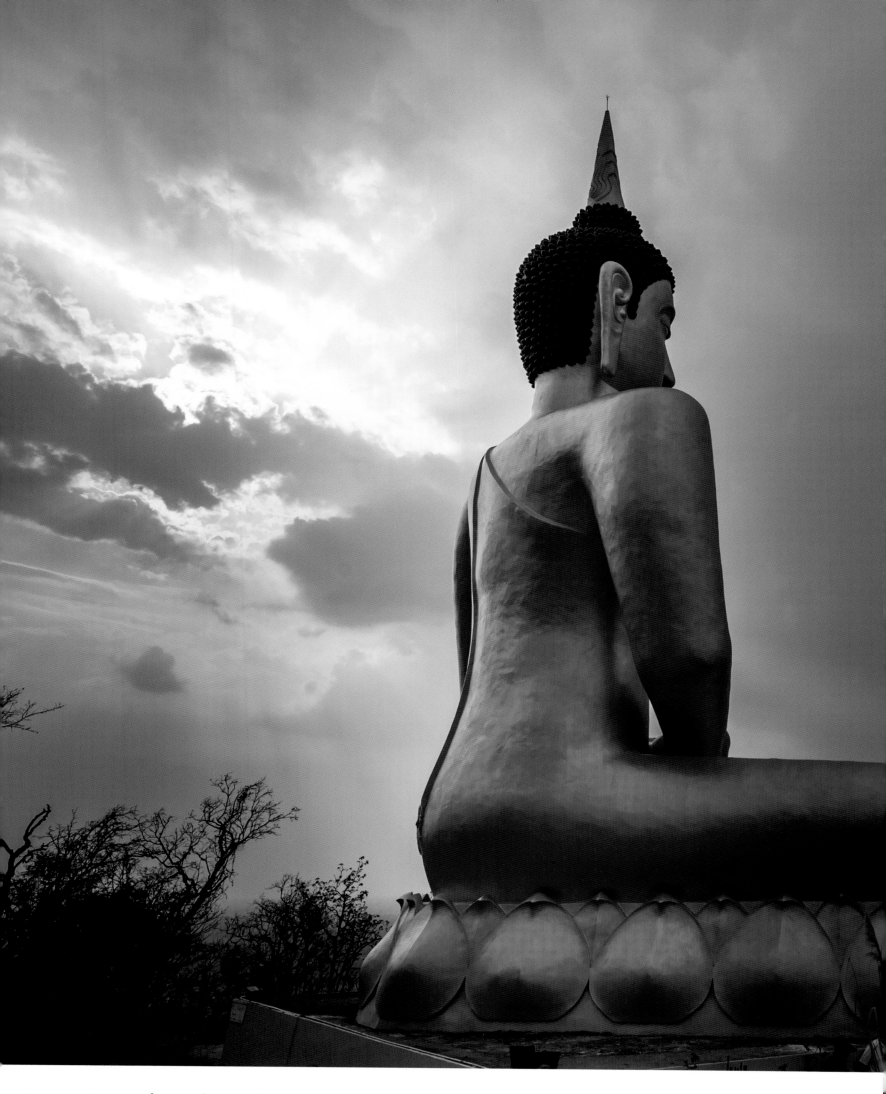

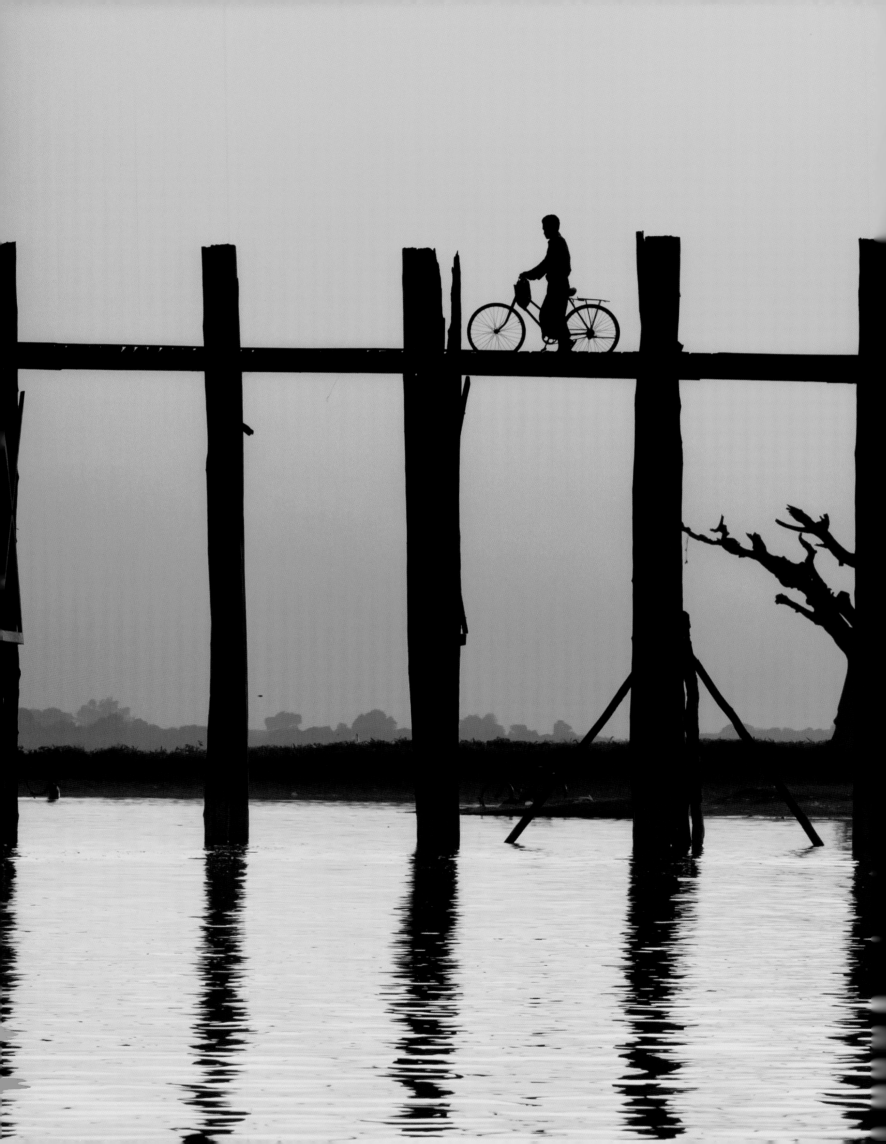

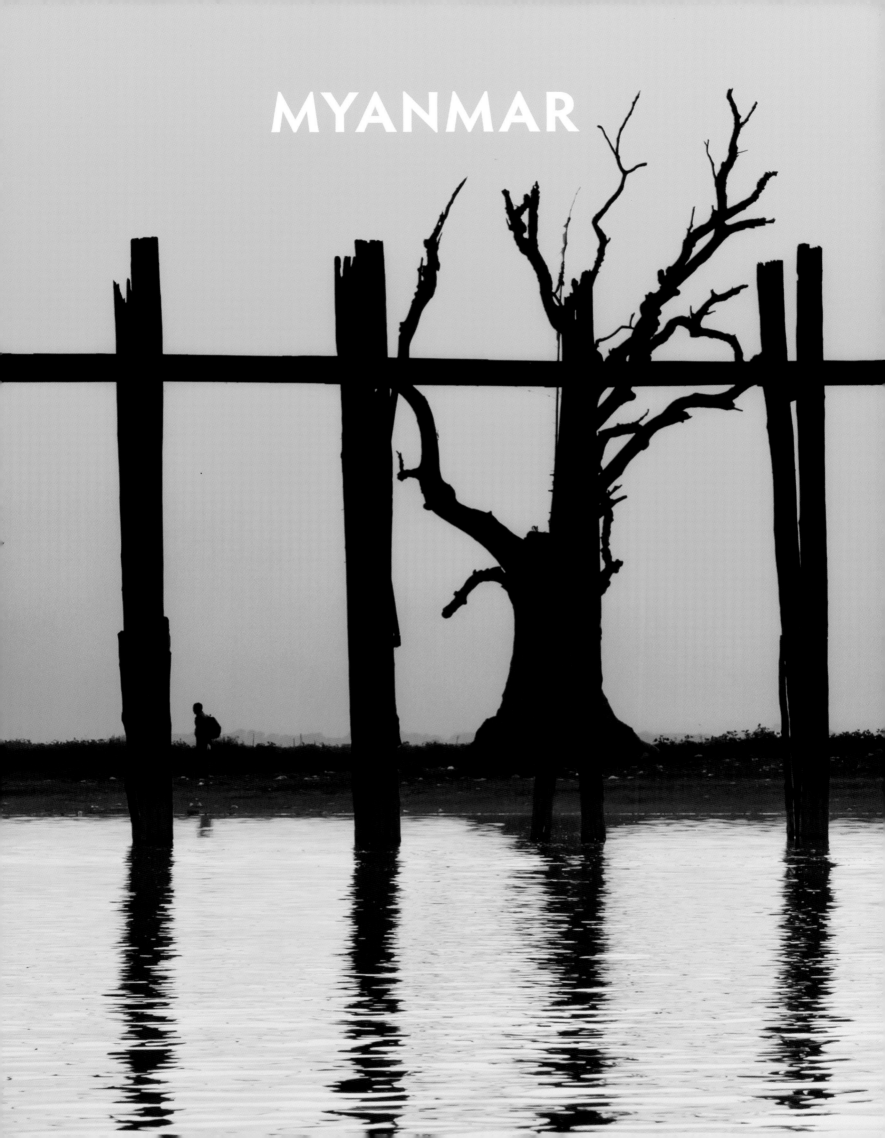

MYANMAR

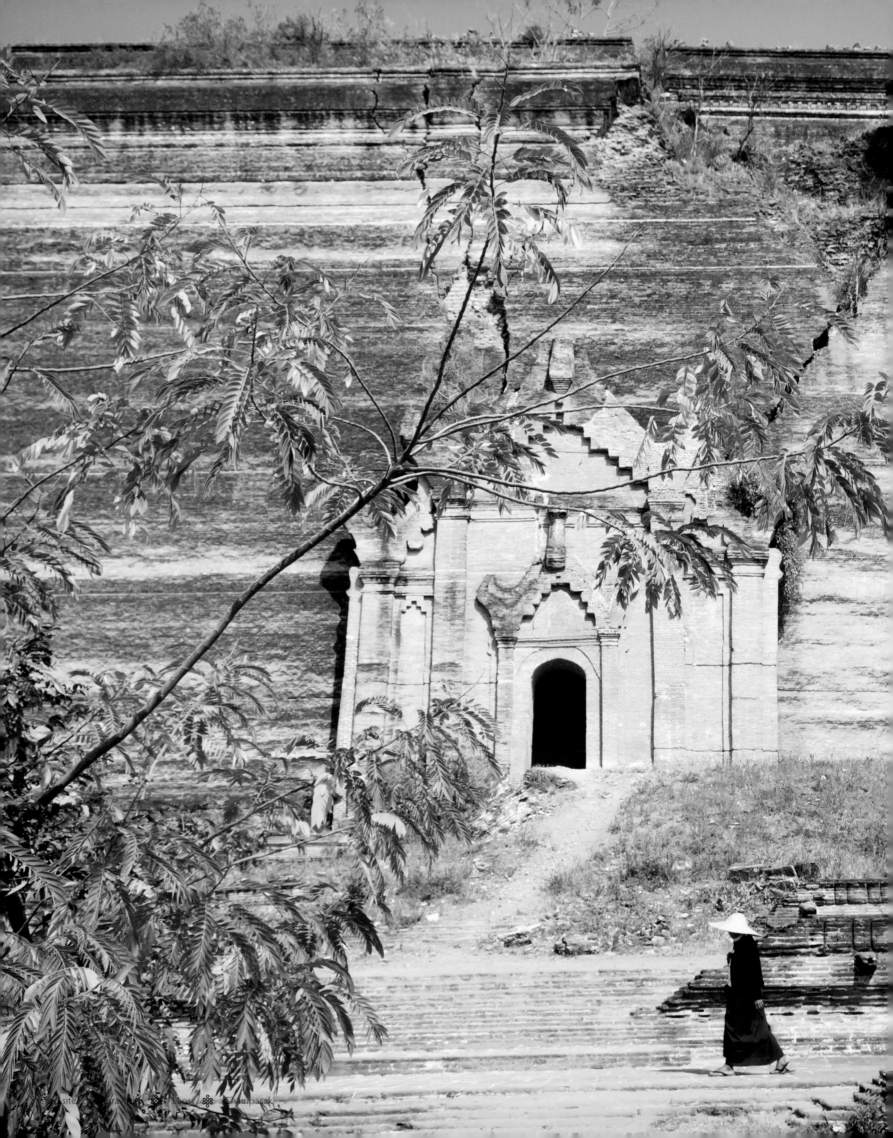

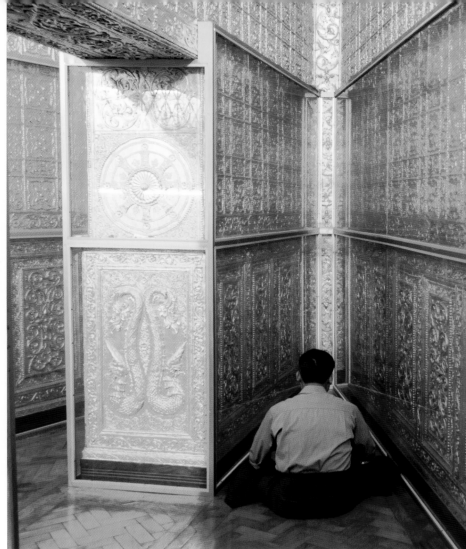

With a planned height of 499 feet (152 meters), the Mingun Pagoda near Mandalay was supposed to be the largest pagoda in the world. King Bodawpaya ordered its construction in 1790 for the purpose of storing a tooth of Buddha. The megalomania did not pay off, however. In 1838, an earthquake destroyed large parts of the structure. The magnificent Botataung Pagoda in Yangon was also built for a relic of Buddha.

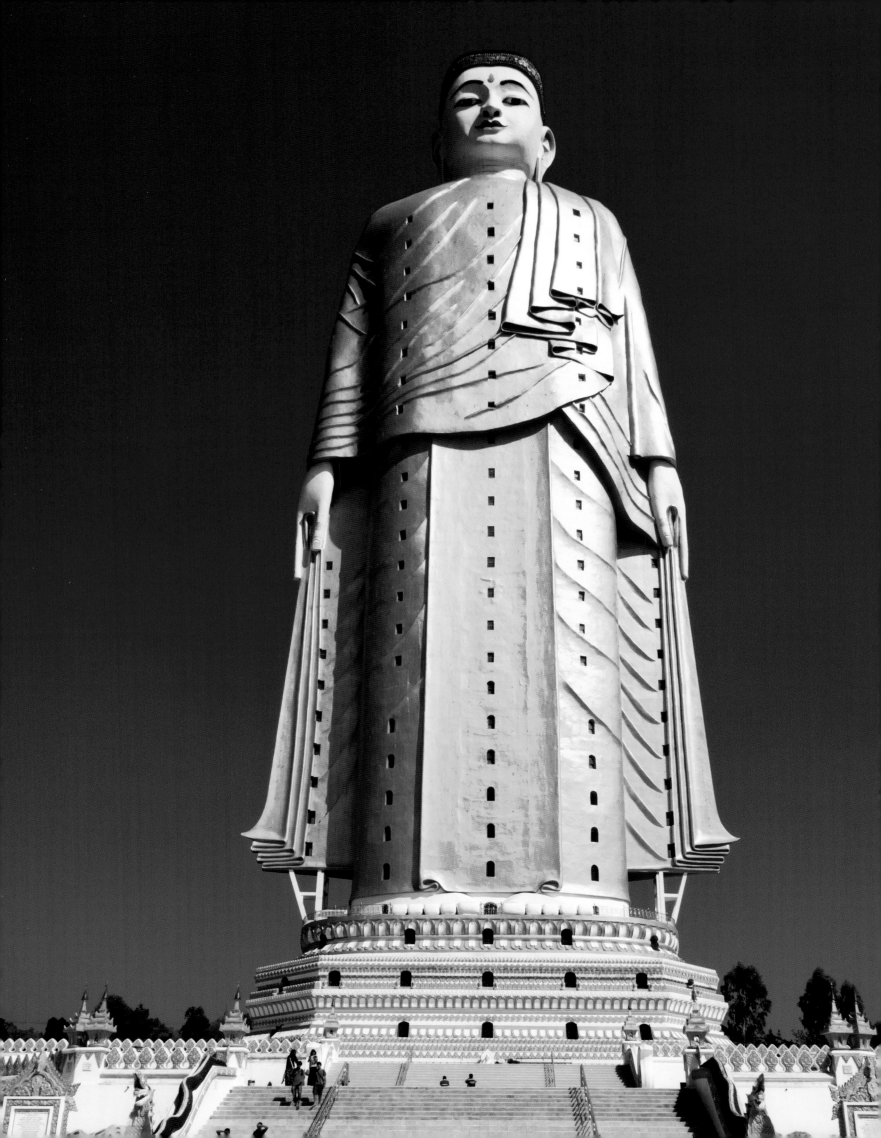

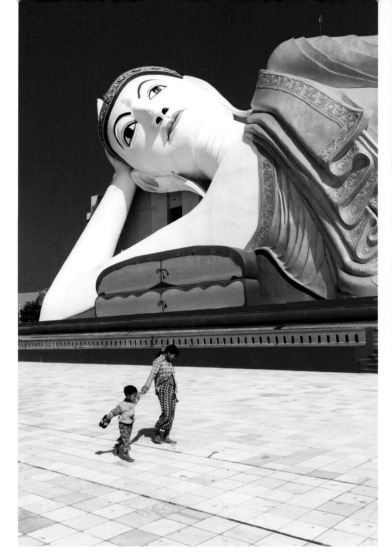

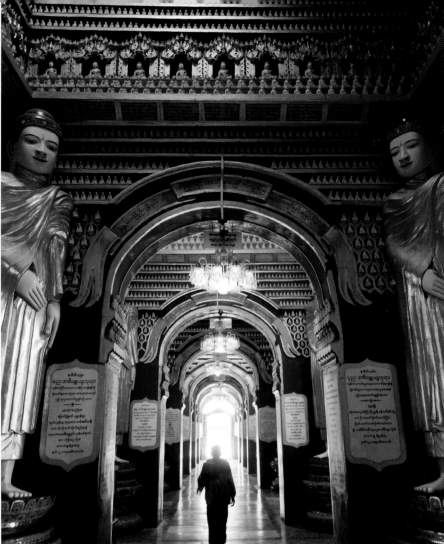

The 31 floors of the 380-feet-tall (116-meter-tall) Buddha statue in Monywa represent the 31 realms of existence from the Traibhūmikathā, a Thai literary work. The realms are split into the sensual world, the form world, and the formless world. At its feet is the reclining Bodhi Tataung statue, which symbolizes the Buddha's passing into parinirvana. Nearby, 580,000 Buddha figures adorn the impressive temple complex of the Thanboddhay Pagoda.

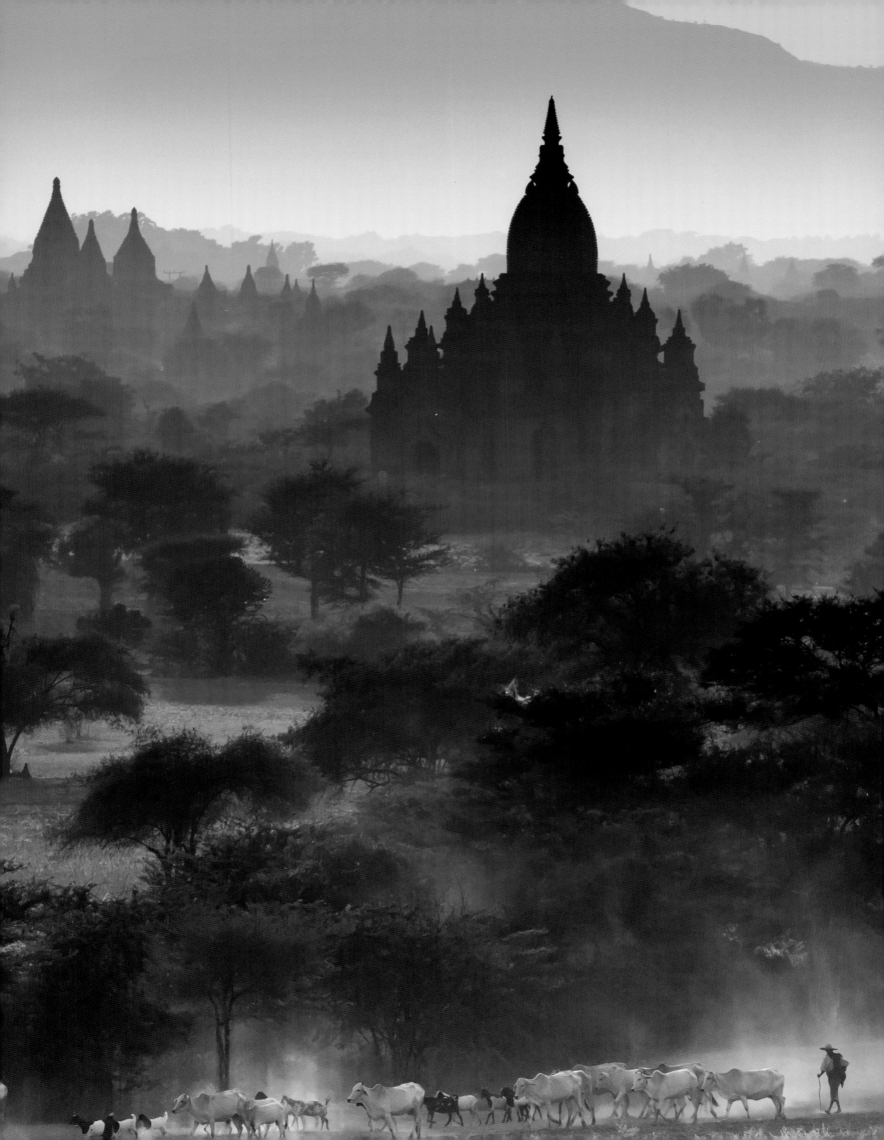

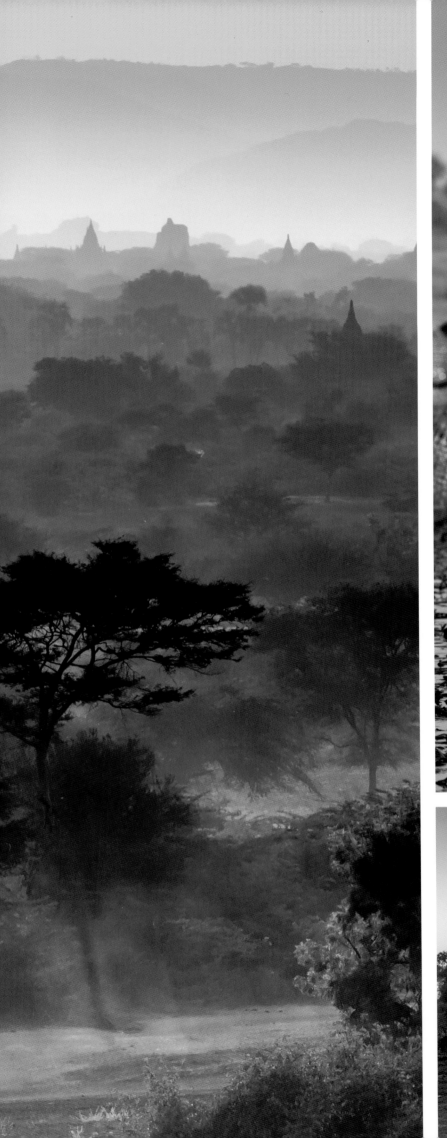
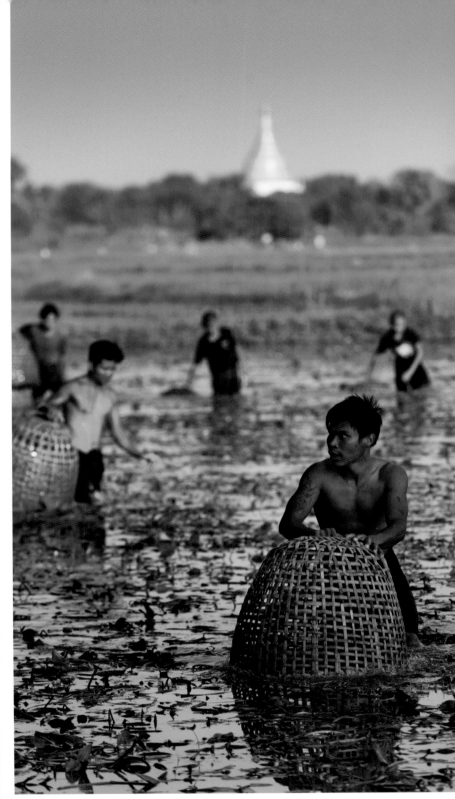
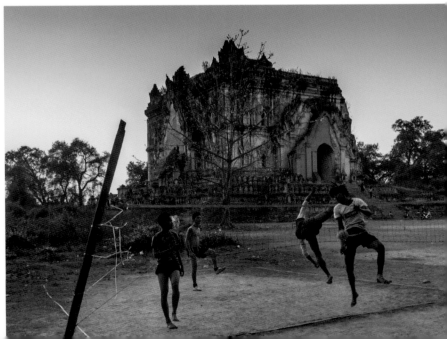

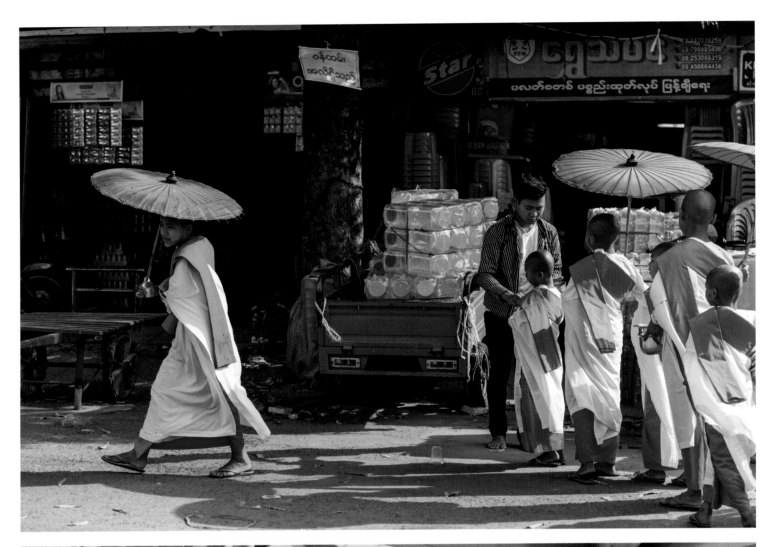

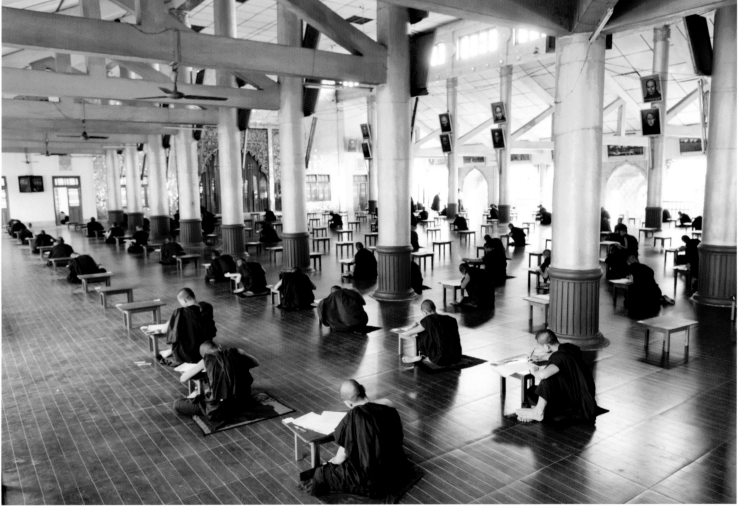

Sacred sites of Theravada & Myanmar & Mandalay & Bago & Kha Khat Waing Kyaung Monastery & Kyaiktiyo Pagoda

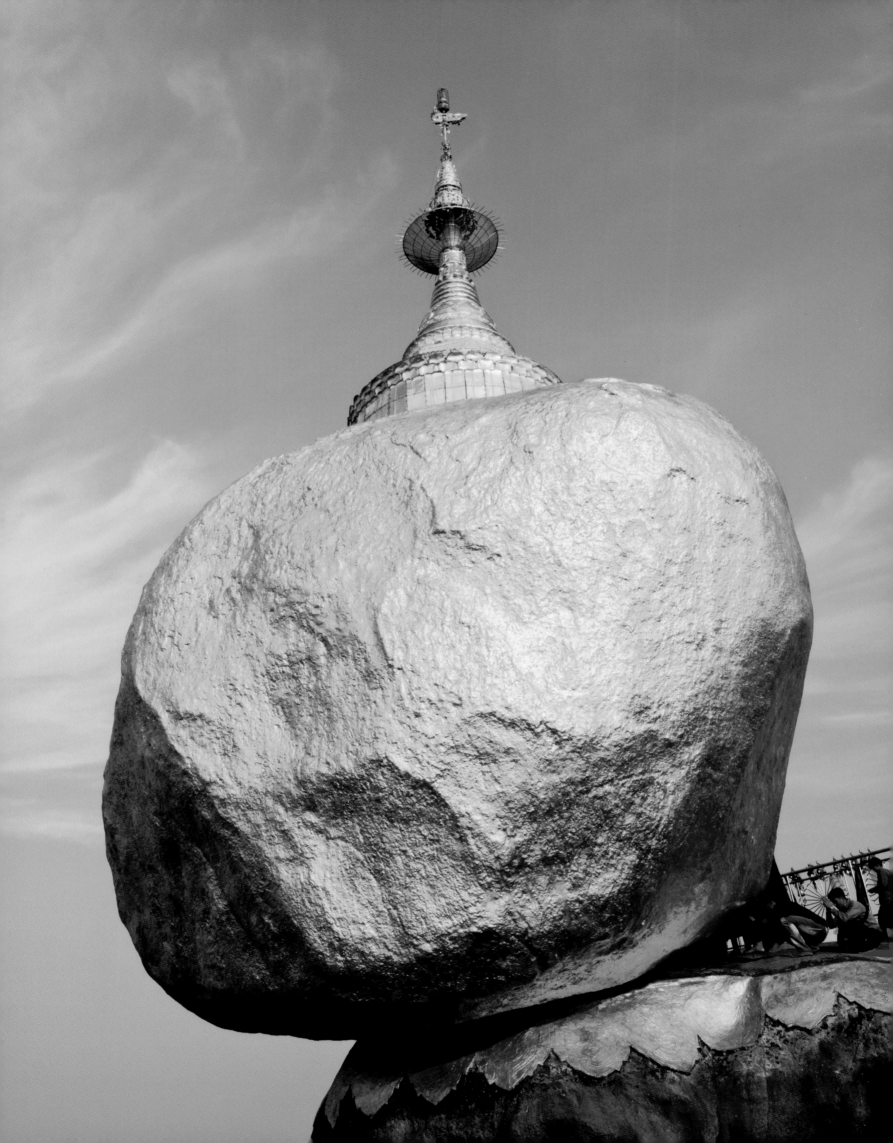

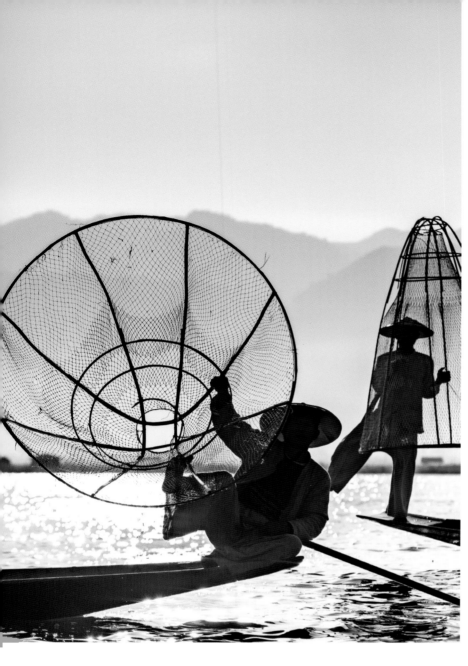

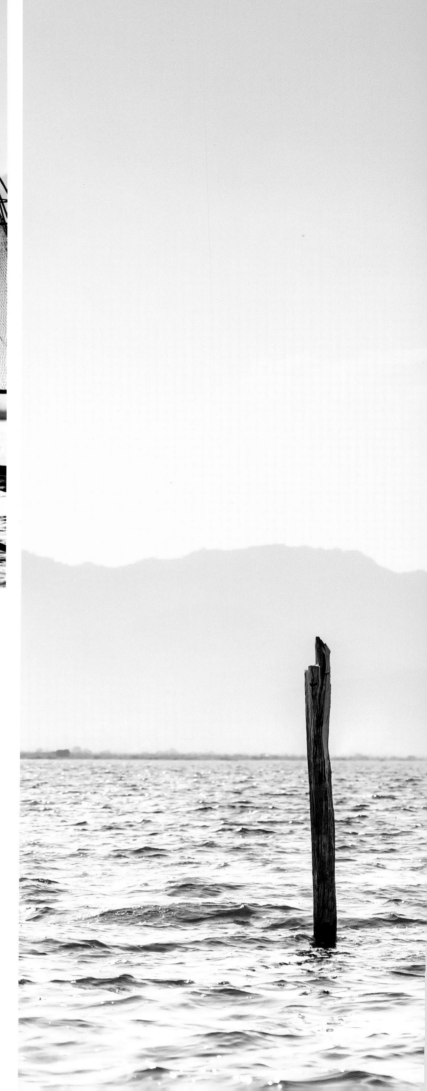

Previous double-page spread:
Even as *sammaneri* (or novices), the girls have to collect
alms every day and then study, like the novices at the
Kha Khat Waing Kyaung Monastery in Bago.
According to legend, the Kyaiktiyo Pagoda, also known
as the Golden Rock, is held in place by only a single
strand of the Buddha's hair. The entire formation is
one of the holiest Buddhist sites and one of the most
influential places of power in Myanmar.

This double-page spread:
The *Intha*, or people who live on Inle Lake, are well
known for the distinctive one-legged rowing style they
use with their flat boats. They also use the level gauges
in the lake for their saints.

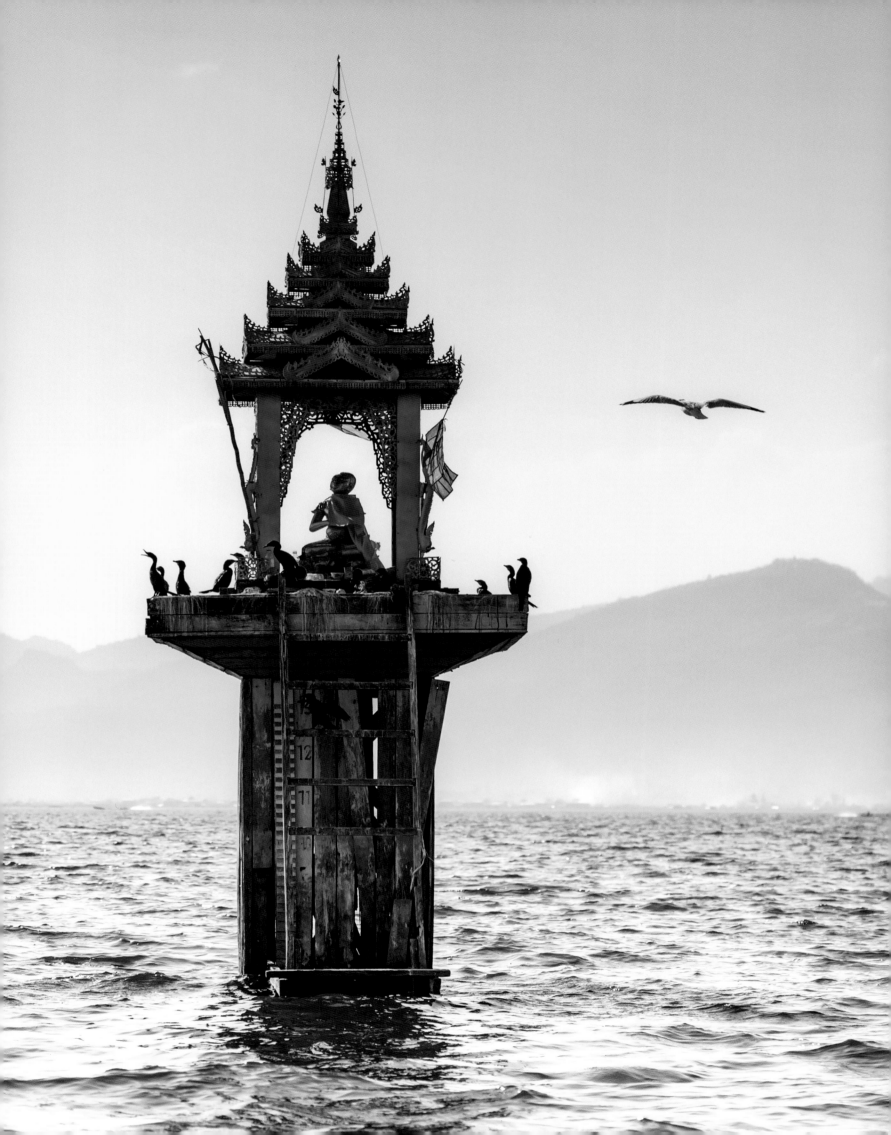

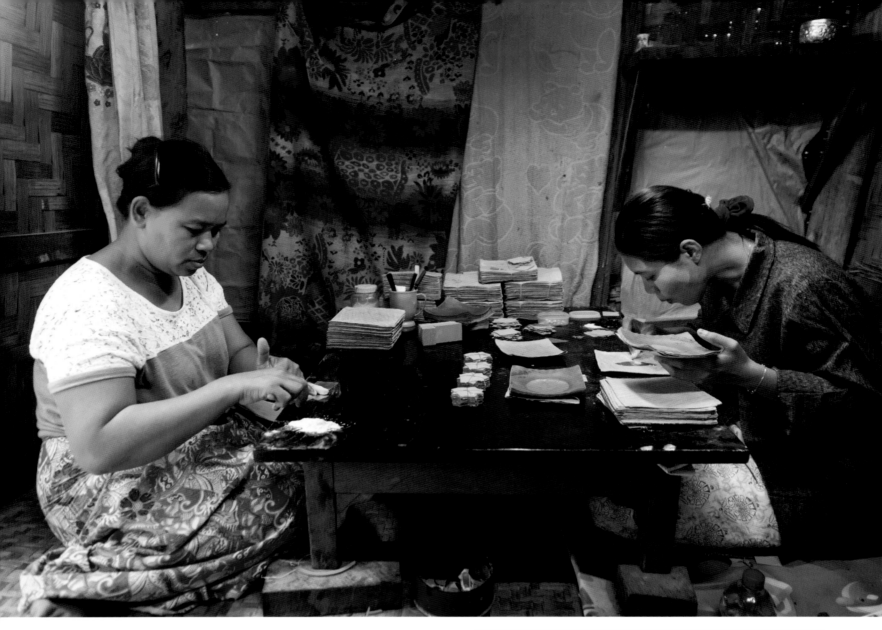

Mahamuni, which literally means The Great Sage, is covered all over with gold leaf. Mahamuni represents the life of the Buddha and his temple in Mandalay is one of the country's most important pilgrimage sites. The gold workshops in Mandalay are famous. After gold-beaters pound the gold ingots into wafer-thin gold leaf, women then cut the gold leaf into squares for sale.

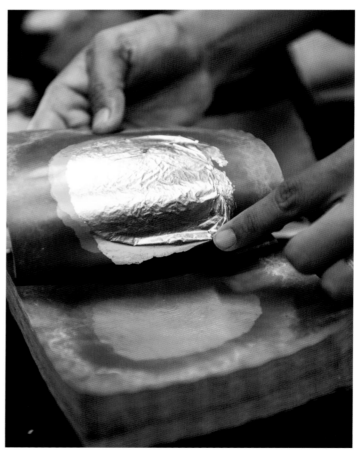

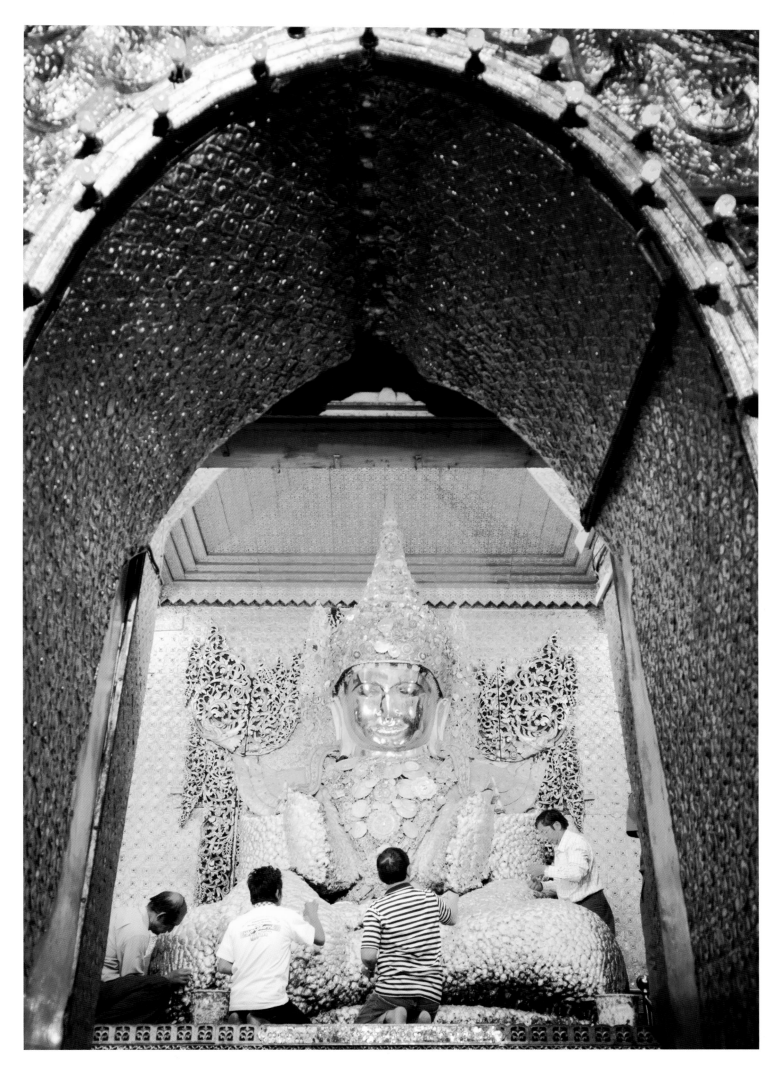

Mahamuni Pagoda ✾ Mandalay ✾ Myanmar ✾ Sacred sites of Theravada

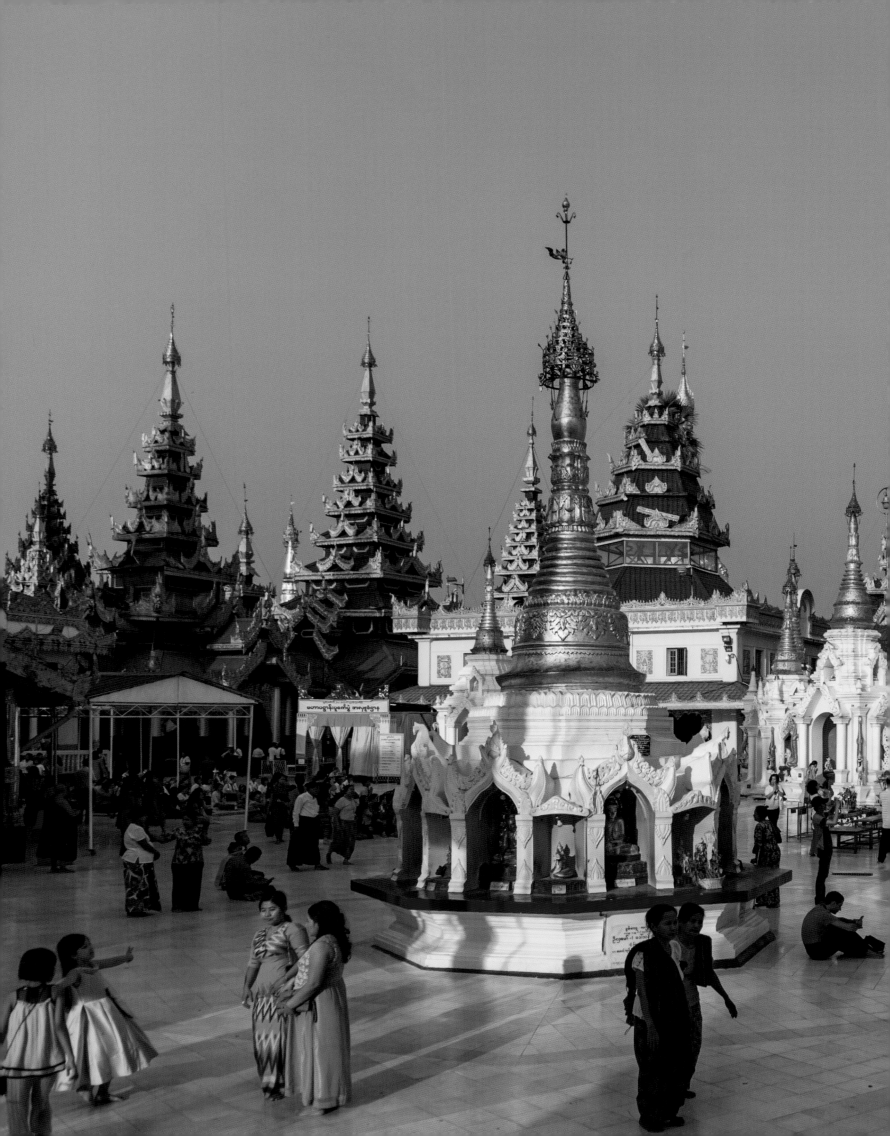

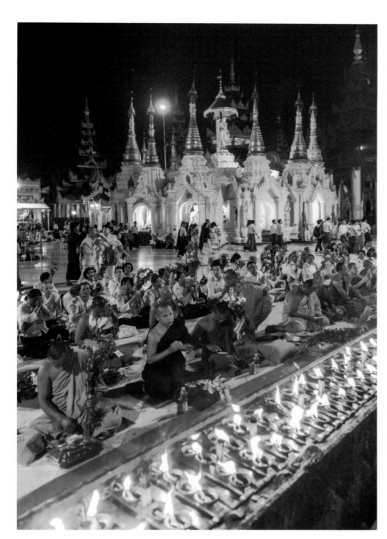

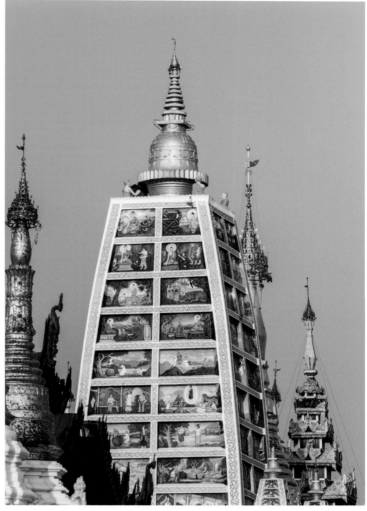

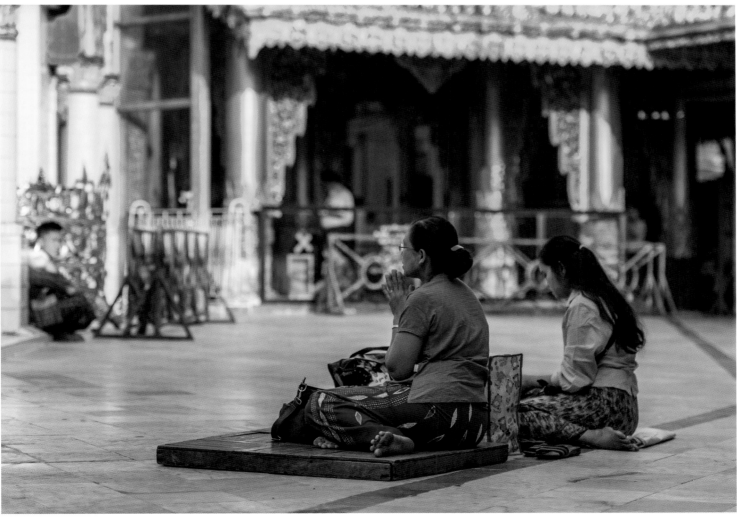

Shwedagon Pagoda　❋　Yangon　❋　Myanmar　❋　Sacred sites of Theravada

SRI LANKA

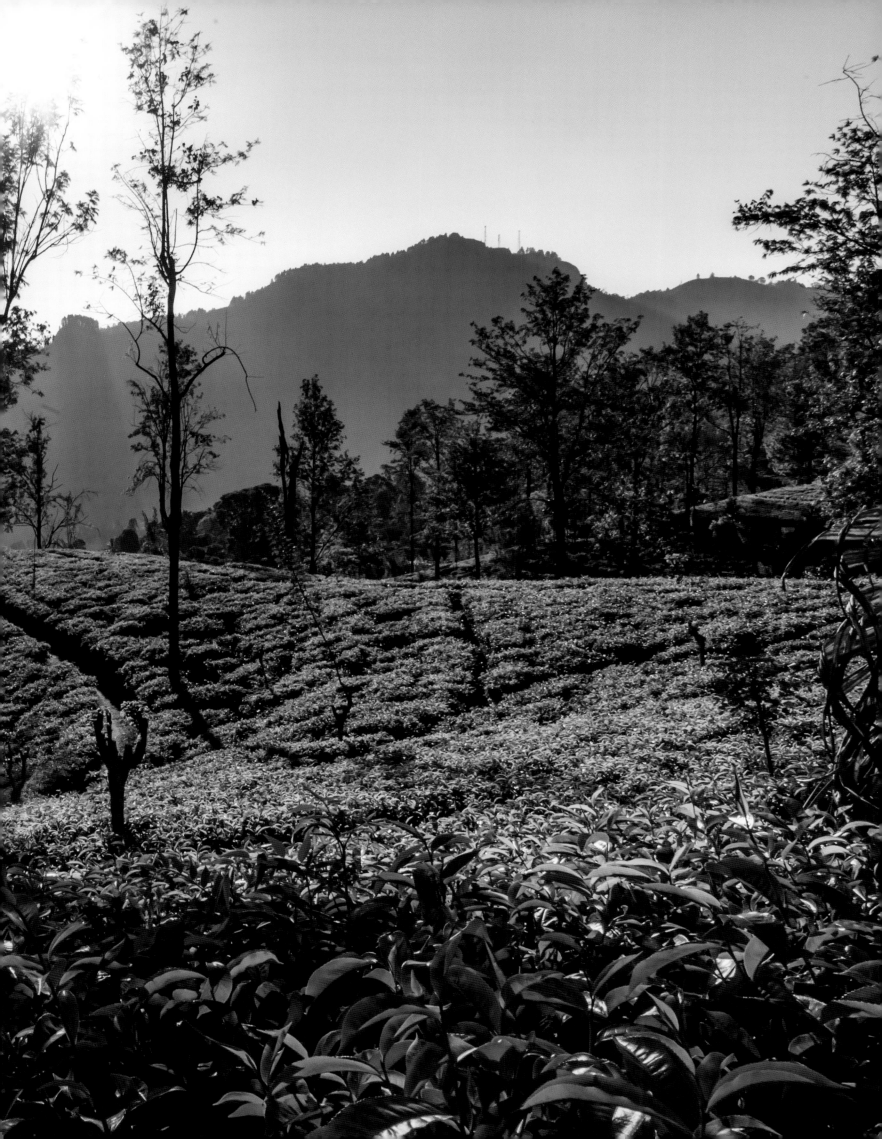

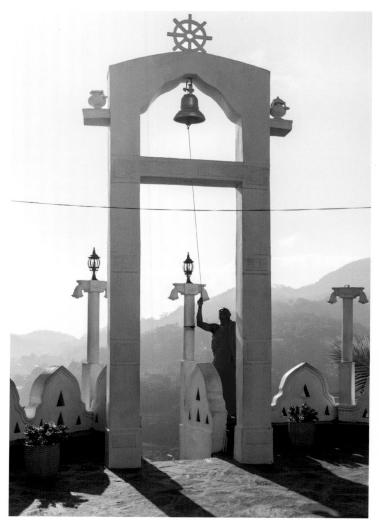

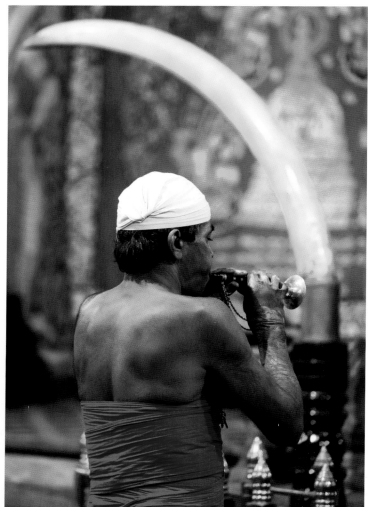

Sri Dalada Maligawa, the Temple of the Sacred Tooth in Kandy, houses a tooth of the Buddha as a holy relic. Worshippers believe that the tooth holds the spiritual power of the Buddha. Since it was also considered the palladium of the kings of Sri Lanka, the Portuguese and Dutch colonial rulers tried to destroy the shrine, which is now a UNESCO World Heritage Site.

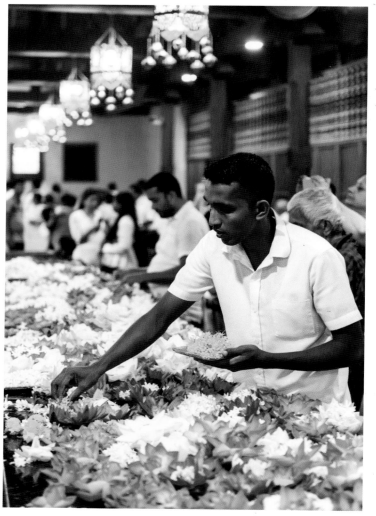

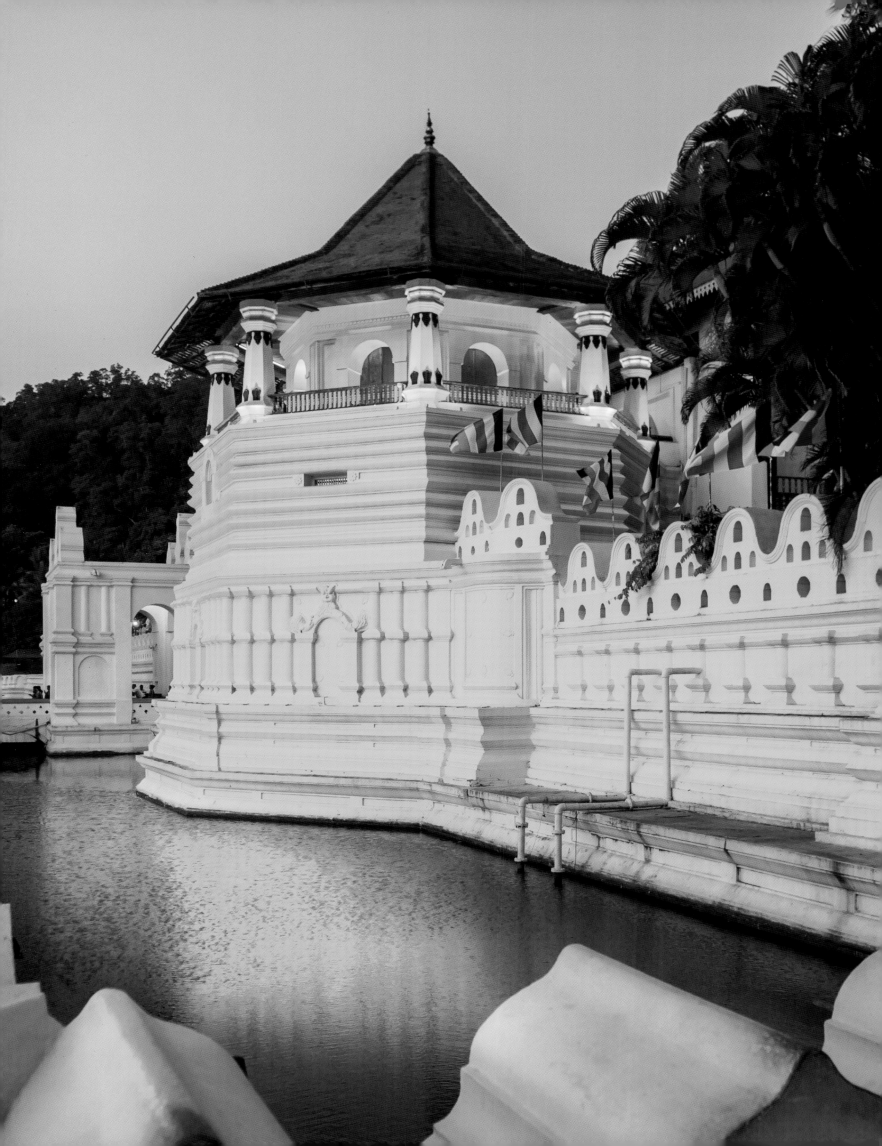

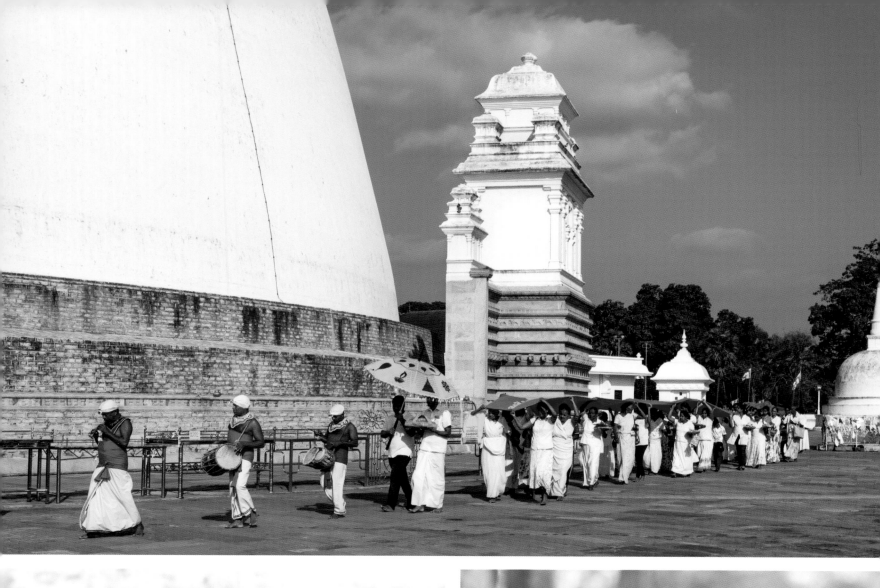

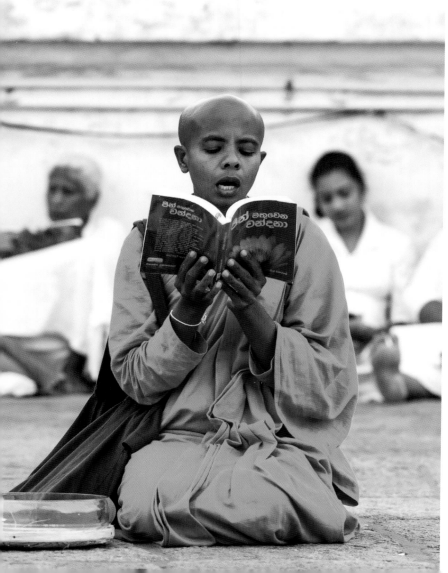

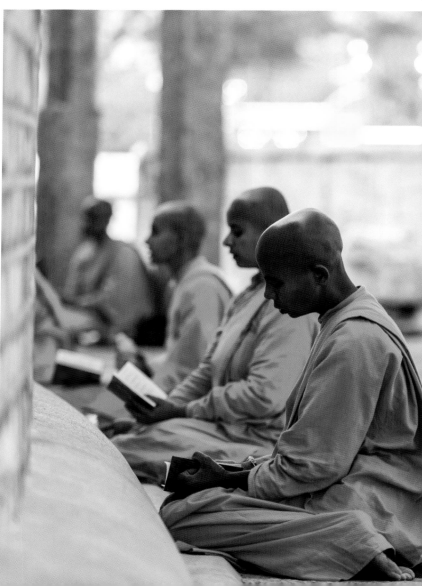

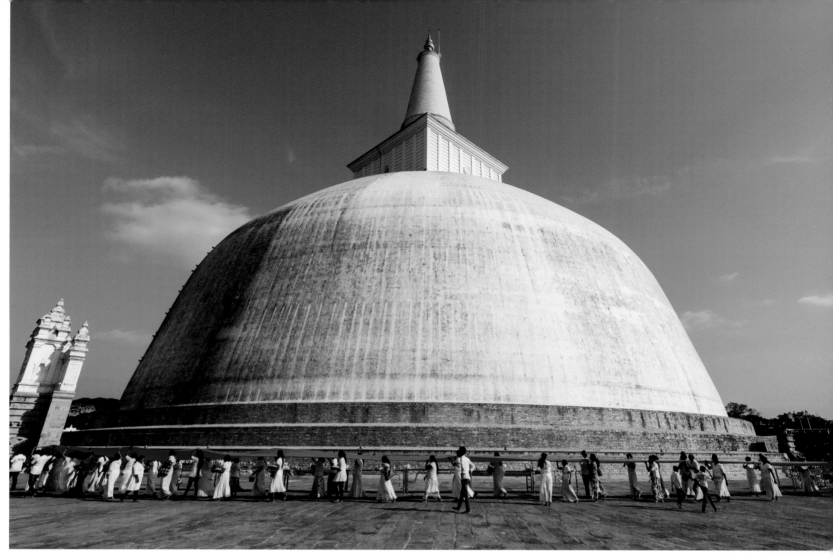

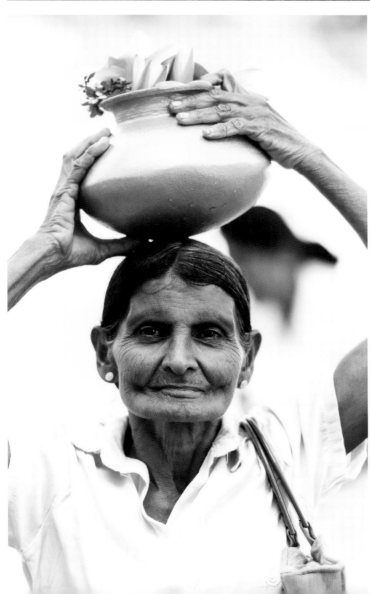

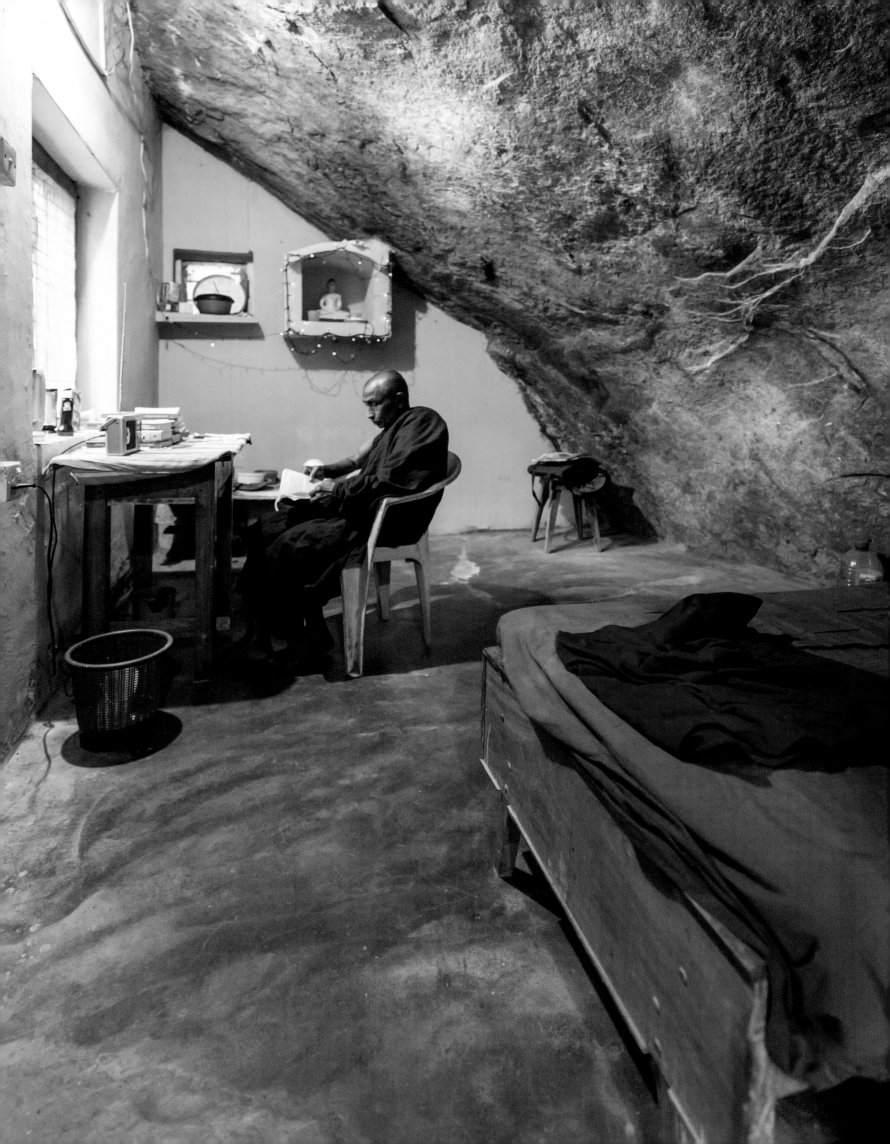

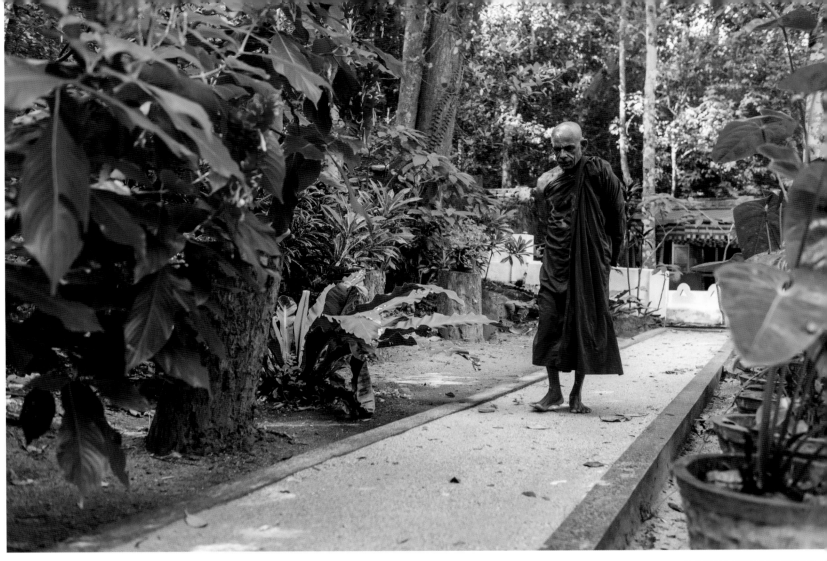

This double-page spread:
Humbulugala Aranya in the heart of Sri Lanka is home to
forest monks. They are role models for all the Buddhists
in the country and focus only on the mind. To this end,
they lead a frugal life reduced entirely to the basics.
Forest monks live in caves or under overhanging rocks,
which they refer to as monasteries—even if their archi-
tect was nature itself.

Next double-page spread:
The Kataragama temple is the most important religious
pilgrimage site in Sri Lanka and is a sacred place for
Buddhists, Muslims, Hindus, and the indigenous Vedda
people alike. Kataragama Deviyo is one of four guardian
deities of the island, and every year in January the large
interdenominational Kataragama festival, or Ruhunu
Perahera, is held in his honor.

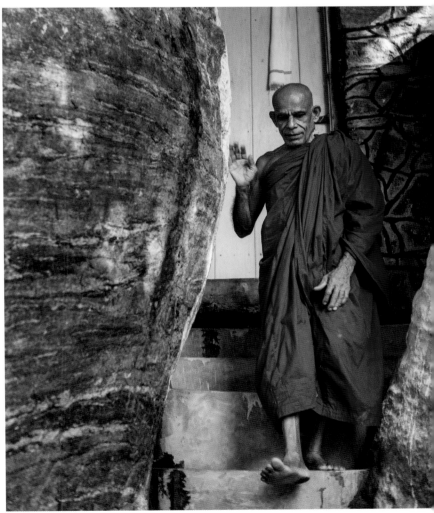

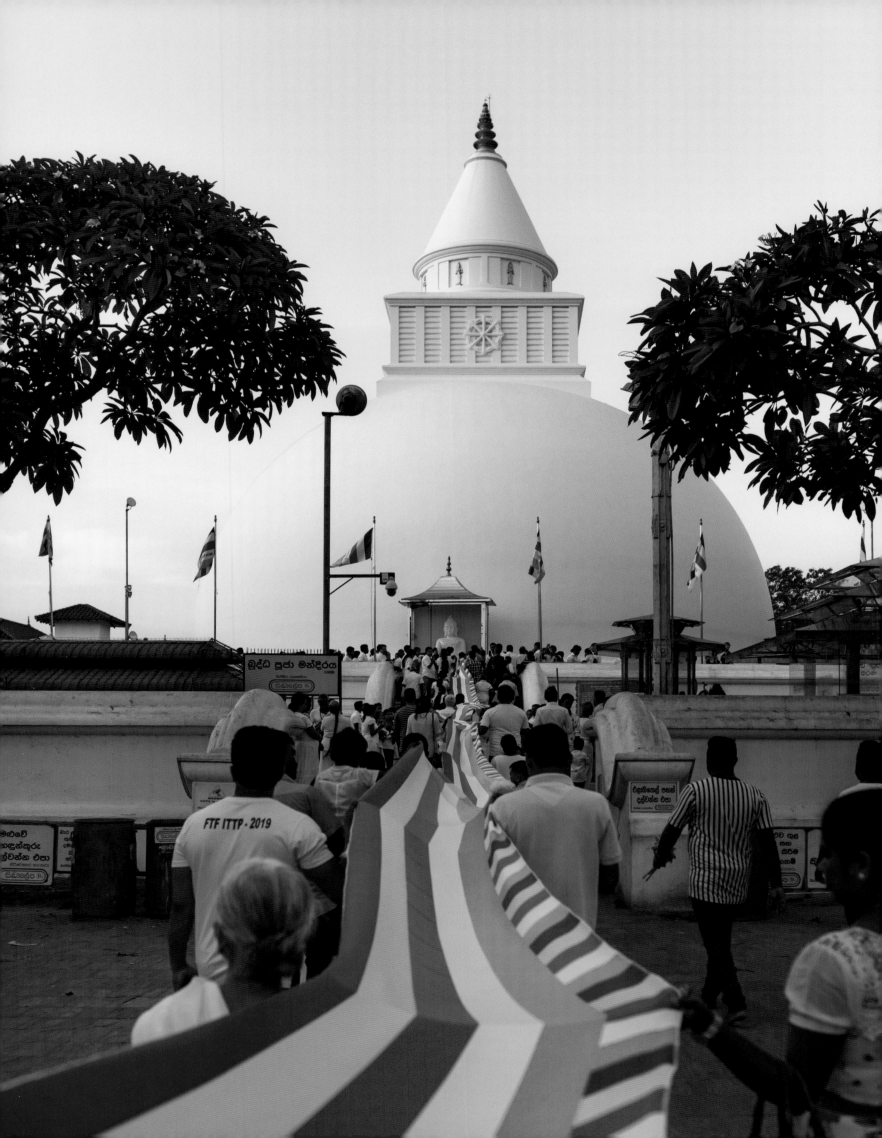

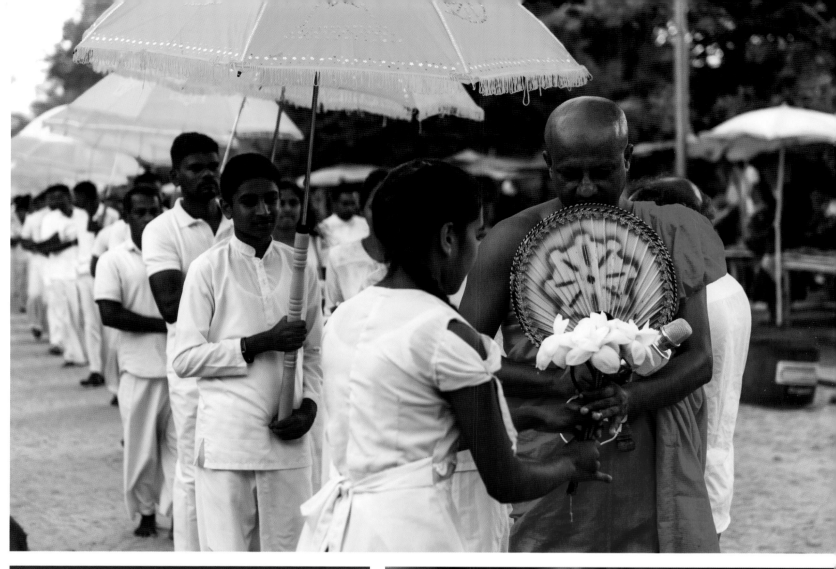

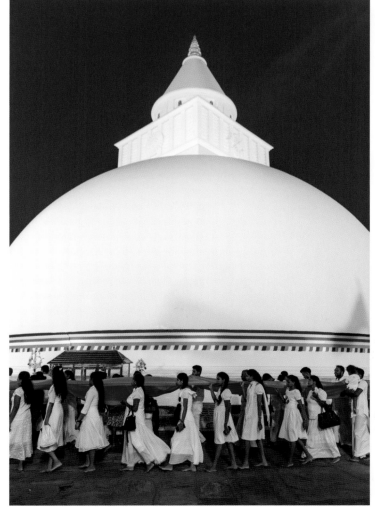

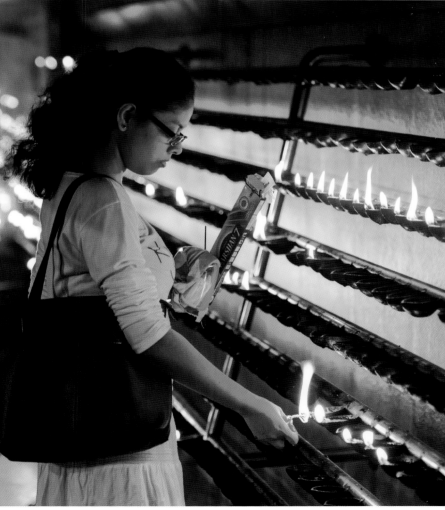

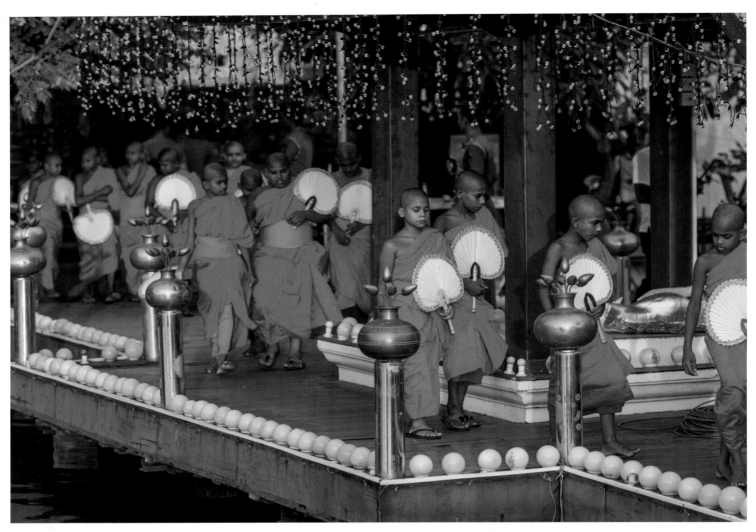

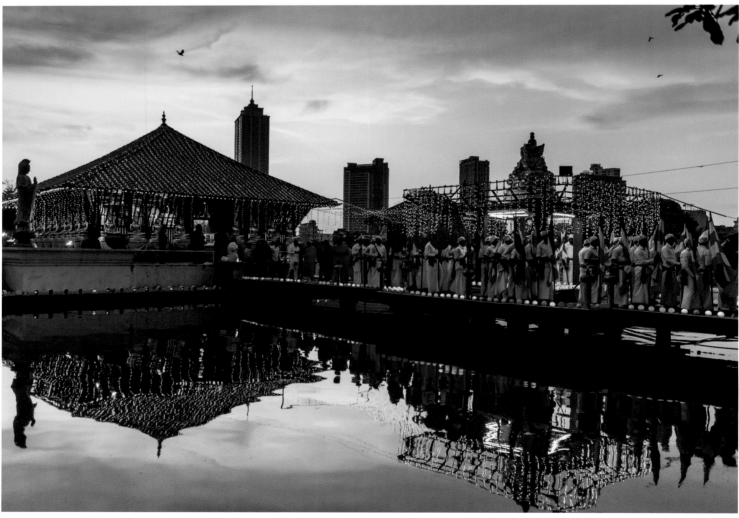

Sacred sites of Theravada ❦ Sri Lanka ❦ Colombo ❦ Seema Malaka Temple

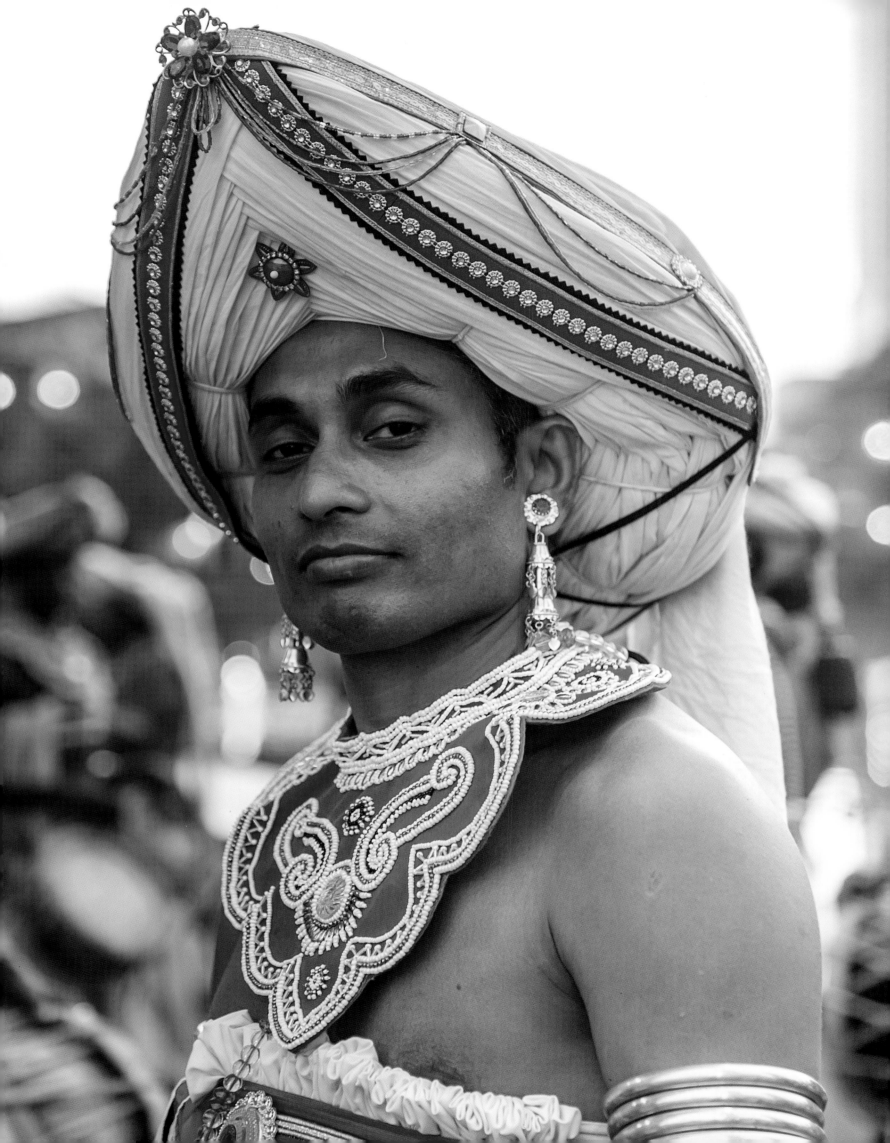

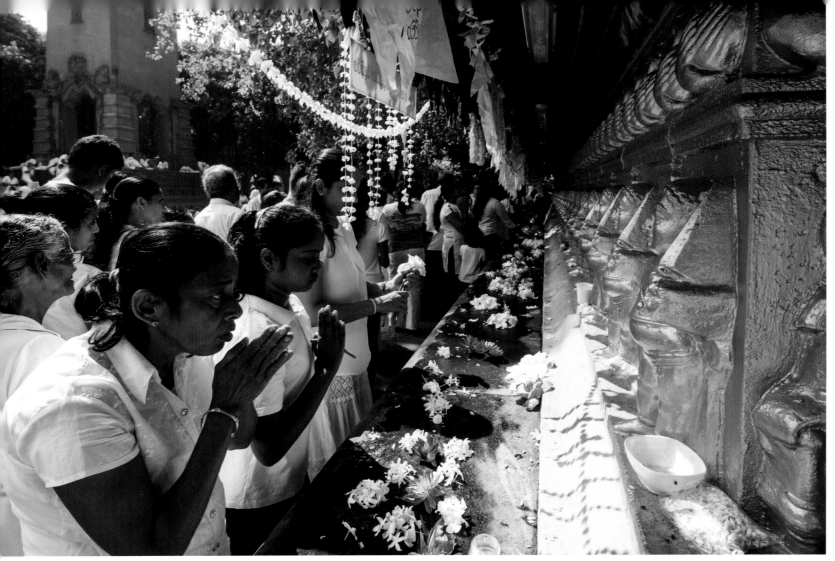

Previous double-page spread:

One of the most important festivals in Colombo is Nawam Maha Perahera. The spiritual background is to pay homage to the triple gem: Buddha, *Sangha* (community of monks), and *Dharma* (teachings).

One of the event's features is a procession from the Gangaramaya Temple to Seema Malaka, a Buddhist temple located in the middle of Beira Lake. Folk artists, such as the proud drummer, also have the opportunity to show off their talents.

This double-page spread:

Buddha himself is said to have explained his teachings in Kelaniya on his third visit to Sri Lanka. The Kelaniya Temple was built to mark this occasion, and it is said that as long as the temple prospers, so too will Sri Lanka. If it falls, however, the government will fail as well. As such, it is also a very political place.

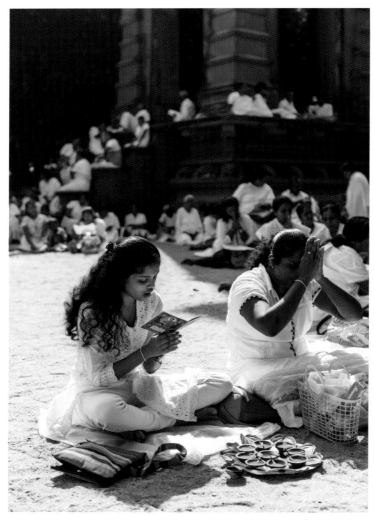

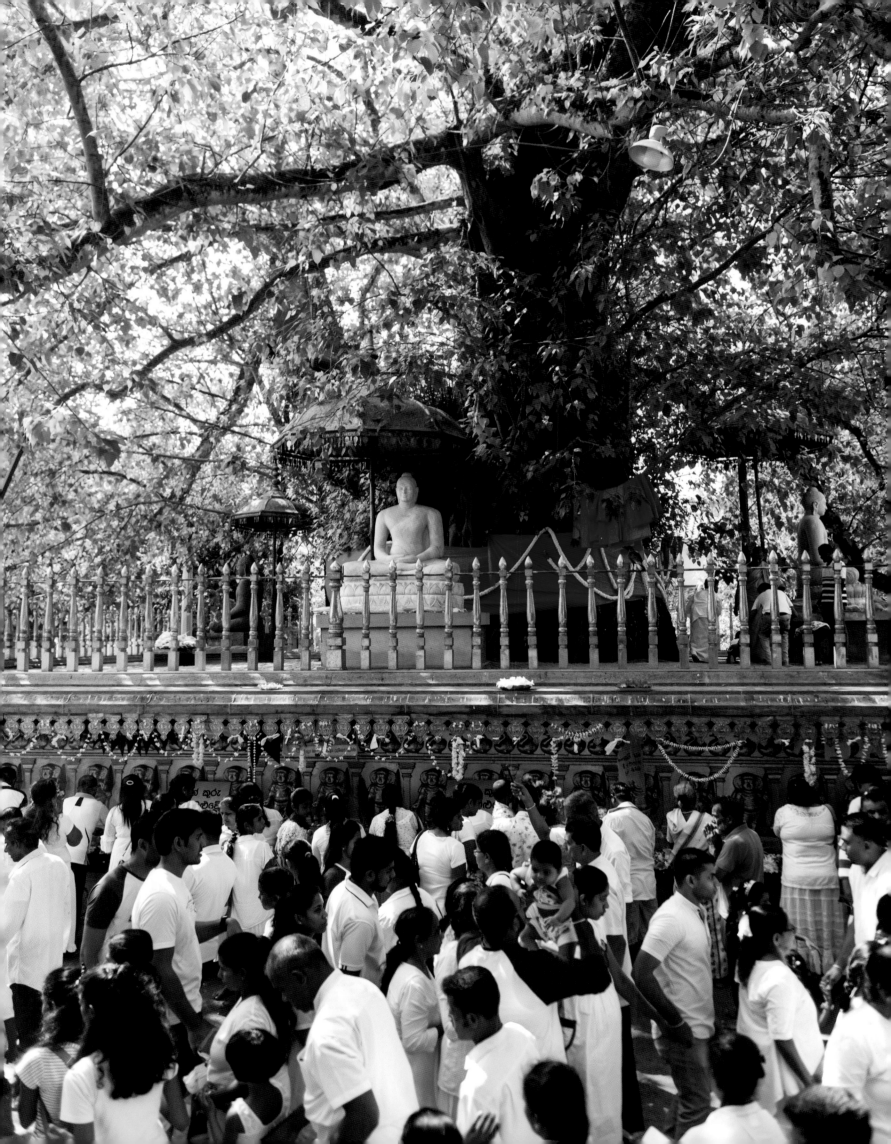

SACRED SITES
OF

MAHAYANA

Hongkong, Hangzhou,
Shanghai, Dunhuang, Beijing

Sapa, Ho Chi Minh City, Chau
Doc, Ninh Binh, Tay Ninh, Lao
Cai, Da Lat, Da Nang, Hanoi

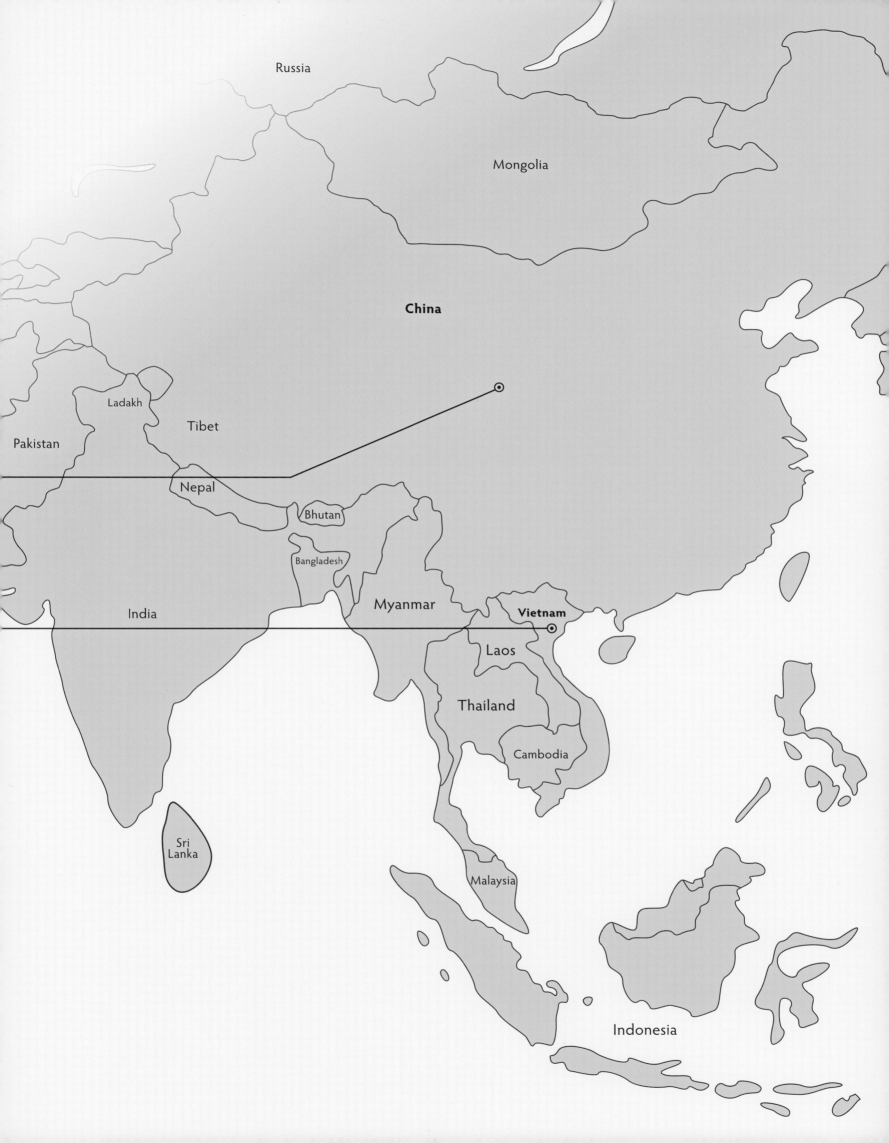

Russia

Mongolia

China

Pakistan

Ladakh

Tibet

Nepal

Bhutan

Bangladesh

India

Myanmar

Vietnam

Laos

Thailand

Cambodia

Sri
Lanka

Malaysia

Indonesia

Sacred sites of
MAHAYANA

"Only the bones of people and animals help to guide us on our journey," wrote the Chinese monk Faxian in *A Record of Buddhist Kingdoms*. In his travelogue, Faxian documented his travels between the years 399 and 414 through treacherous deserts and over impassable mountains to India. His goal was to familiarize himself with Buddhist teachings where they originated. Up to that point, such teachings had been brought to China exclusively by Central Asian translators and little was known about this new religion, which had been making its way to China along the Silk Road since the 2nd century B.C.E.

I have been on the trail of Buddhism in China for some time now. As I travel comfortably by train from Xi'an (formerly Chang'an), the capital of Shaanxi Province, to Hangzhou, I wonder how Buddhism, which postulates the non-existence of a soul, could spread in a country where ancestor worship plays such a central role and

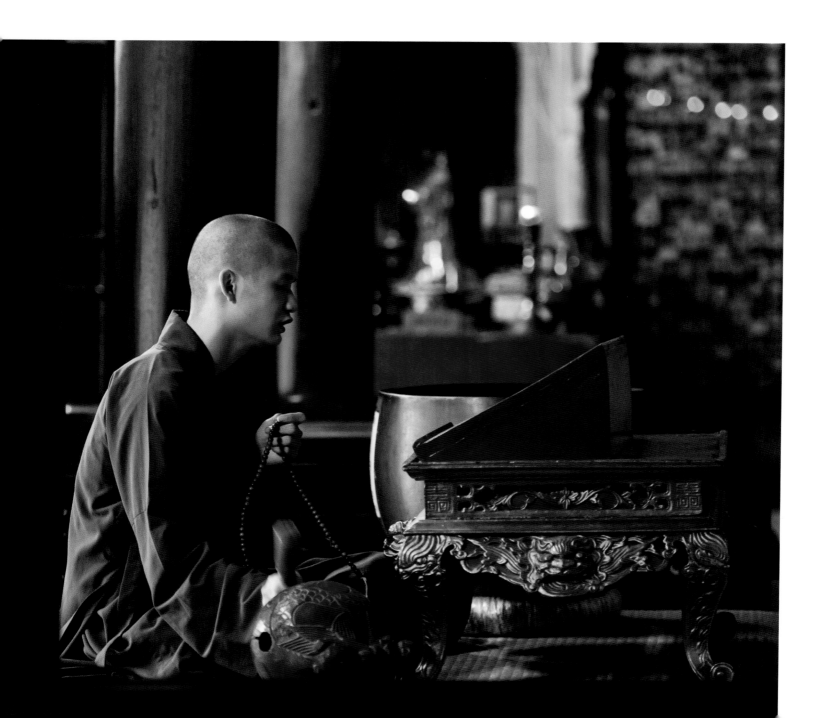

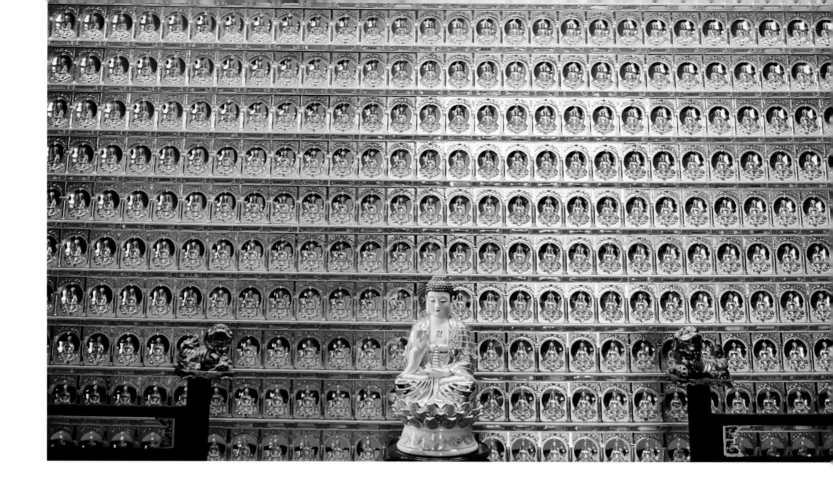

whose inhabitants also believe that they simultaneously possess two souls. It was in fact conquerors from Central Asia who paved the way for Buddhism to enter East Asia. The Turkish-Mongol tribal state of Toba ruled all of northern China starting in the 4th century. Under their rule, Buddhism developed into the state religion. One of their great achievements was the continued development of Buddhist grotto art, which can still be admired in numerous complexes to this day. Under the subsequent Tang Dynasty, which expanded its borders to the distant Aral Sea, China became cosmopolitan. A tremendous wave of Buddhist piety swept the country. Thousands of monasteries sprang up, and China's two ancient capitals of Chang'an and Luoyang emerged as the East Asian centers of Buddhism.

I wonder how Buddhism, which postulates the non-existence of a soul, could spread in a country whose inhabitants also believe that they simultaneously possess two souls.

Merchants, diplomats, artists, and students from Persia, Syria, India, and many other countries streamed into Chang'an, which grew into a multicultural cosmopolitan city of nearly two million people. Monks from throughout Central and East Asia came here to study Buddhism, while Chinese monks made pilgrimages to the sources of Buddhism in India. However, the schools of Mahayana, which were easier for the common people to integrate into everyday life through the worship of bodhisattvas, ultimately prevailed. From Chang'an, Japanese, Korean, and Vietnamese monks in turn spread Mahayana Buddhism throughout their countries.

Yet it was the success, the power, and the enormous wealth of the countless monasteries that eventually led to the great Buddhist persecutions between 842 and 845. They brought an end to the religious fervor of the 6th and 7th centuries, and Buddhism in China did not undergo any further significant development. Over the centuries, it merged with religious traditions, Taoism, and Confucianism. A similar development took place in Vietnam, where Taoism, Confucianism and a folk-religious strain of Buddhism, as well as the old Vietnamese Animism merged to form what is known as *Tam Giao* ("three teachings"). Although these adaptations allowed Buddhism to continue, it was now measured mainly by what personal benefits it brought to its followers while still in this world. Hence it is not the search for meaning that characterizes the relationship to religion, but the demand for concrete compensation for sacrifices made.

In the meantime, my travels have taken me to Vietnam. As I climb the 156 steps up Thuy Son, the largest of the Marble Mountains near Da Nang, I wonder how, with such a pragmatic attitude toward religion, there can be any sacred sites at all. But that's exactly what I'm here to find out. It's an exhausting climb in the muggy heat, though I only have myself to blame. After all, I could have taken the elevator to the top but chose not to because it doesn't really fit into the landscape.

As Buddhism made its way through China and on to Japan via Korea, then south to Vietnam, it not only changed its identity in a religious sense, but its architecture adapted to the Confucian state temples as well—which were themselves sacred places—and in its design to the requirements of the folk religion. Prior to the introduction of Buddhism, many of the sacred places were already considered to be holy sites that gave people access to the cosmic forces or even local spirits and gods.

Since ancient times, mountains in particular have served as pilgrimage centers and pillars to heaven.

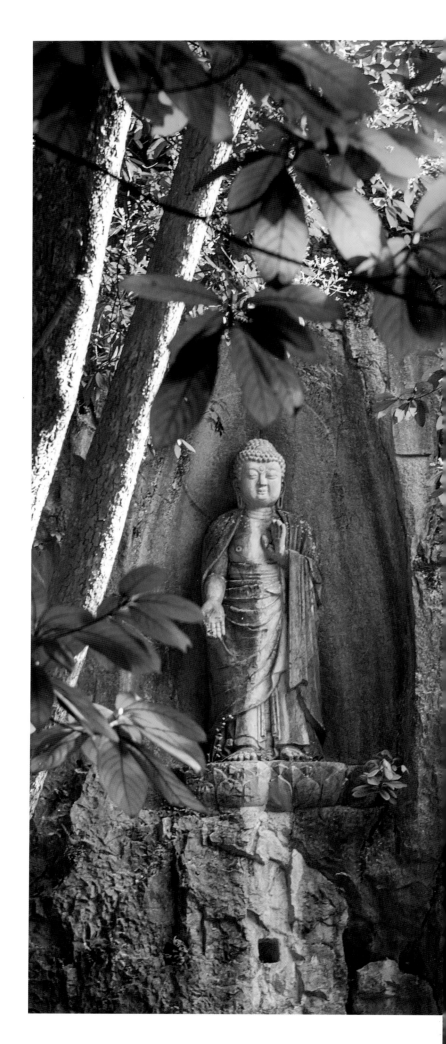

Over the course of time, they were often appropriated by the various religions. Mythical, sacred mountains became Taoist or Buddhist mountains and vice versa, while some also served as the centers of the most diverse directions. This, too, was the case with the Marble Mountains, which reflect the five transformational phases or elements under the rule of yin and yang. Thuy Son is named after the water element. The other four mountains are named Tho (earth), Kim (metal), Hoa (fire), and Moc (wood). The fire element represents the yang pole, while water is the epitome of the yin pole. The other elements—wood, metal, and earth—form the transitions between yin and yang. According to Chinese beliefs, this means that the five elements, like all appearances of our world, are subject to the law of transformation. According to legend, they are the hardened shells of a dragon's egg. In Vietnam, dragons were mythical creatures revered as a symbol of power and often adorned royal palaces.

The Marble Mountains reflect the five transformational phases or elements under the rule of yin and yang.

Usually large and often magnificent monasteries are found on the summits of the sacred Buddhist mountains of East Asia. The path upwards is simply the most convenient route to get from monastery A to monastery B. Steep, seemingly never-ending steps were built for this purpose—some of them constructed centuries ago. Buddhist mountains emphasize the view, the beauty of nature, and the spectacular vistas. Here hikers are observers who stand outside of nature and simply observe. The fact that the way up is very strenuous simply serves to remind pilgrims that the path of knowledge is difficult. Nowadays, however, funiculars, chair lifts, and even elevators take hikers up to the peaks.

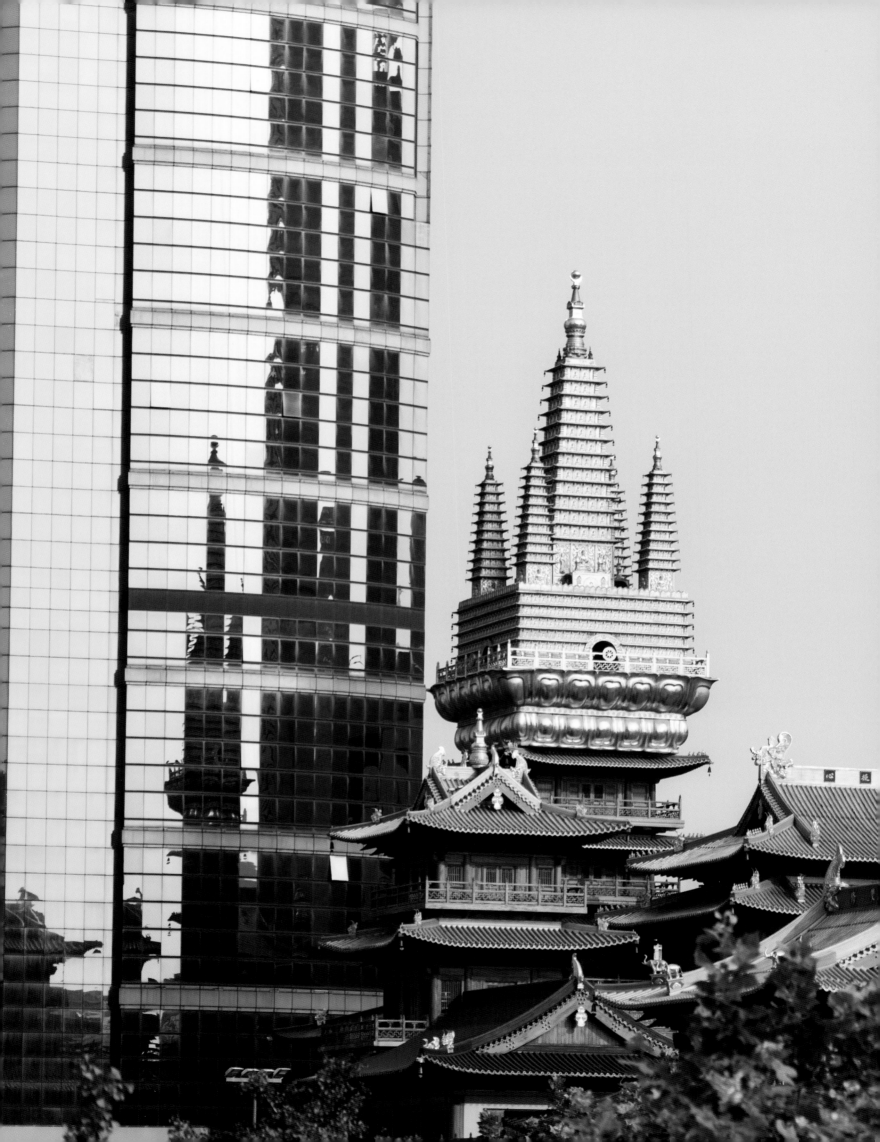

CHINA

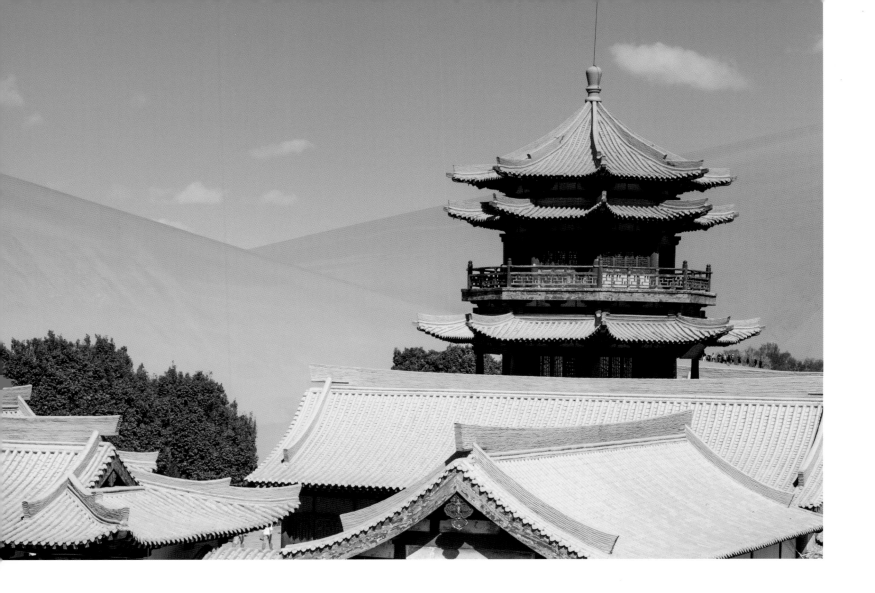

It is hard to believe that the desert town of Dunhuang
was once one of the richest cities in Asia and a major hub
of the Silk Road trade. From here caravans traveled west
through thousands of kilometers of sandy deserts.
Many merchants donated money to build temples and
Buddhist caves. In 1899, tens of thousands of Buddhist
documents from the 4th through 10th centuries were
discovered in the caves.

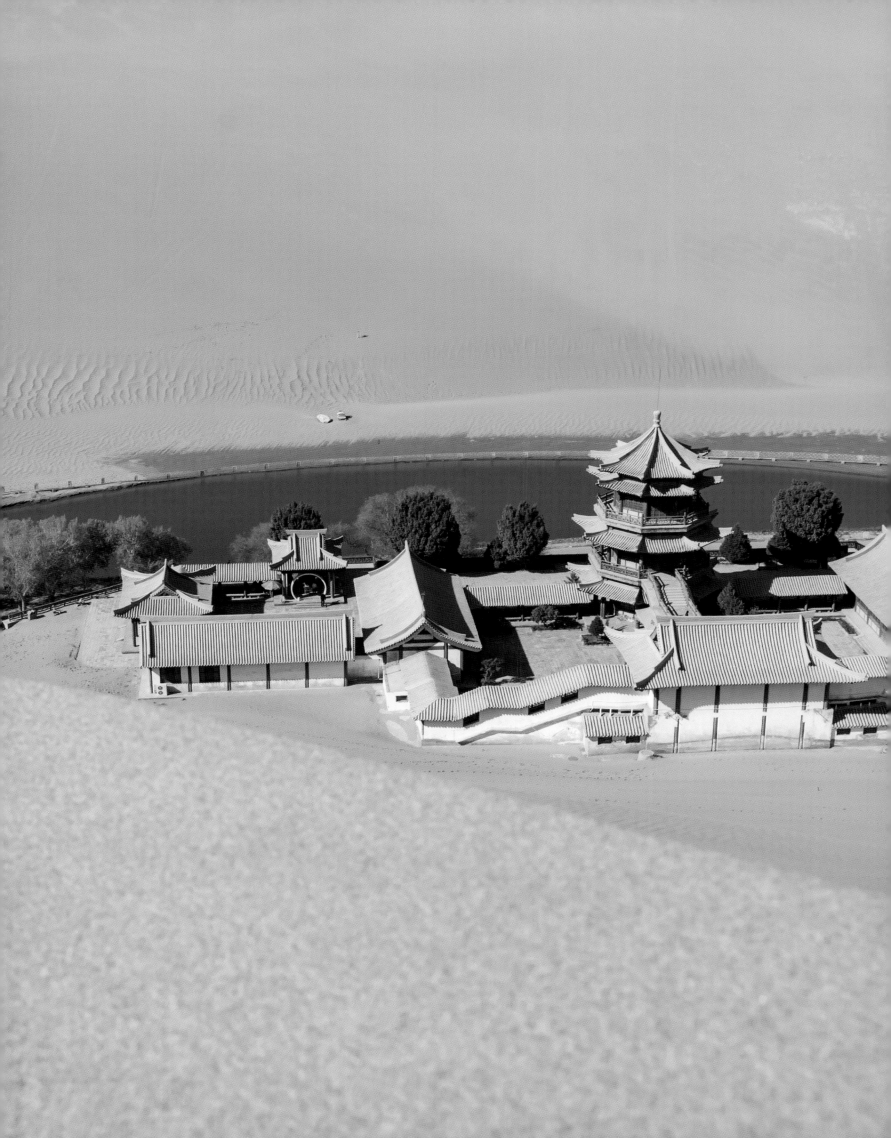

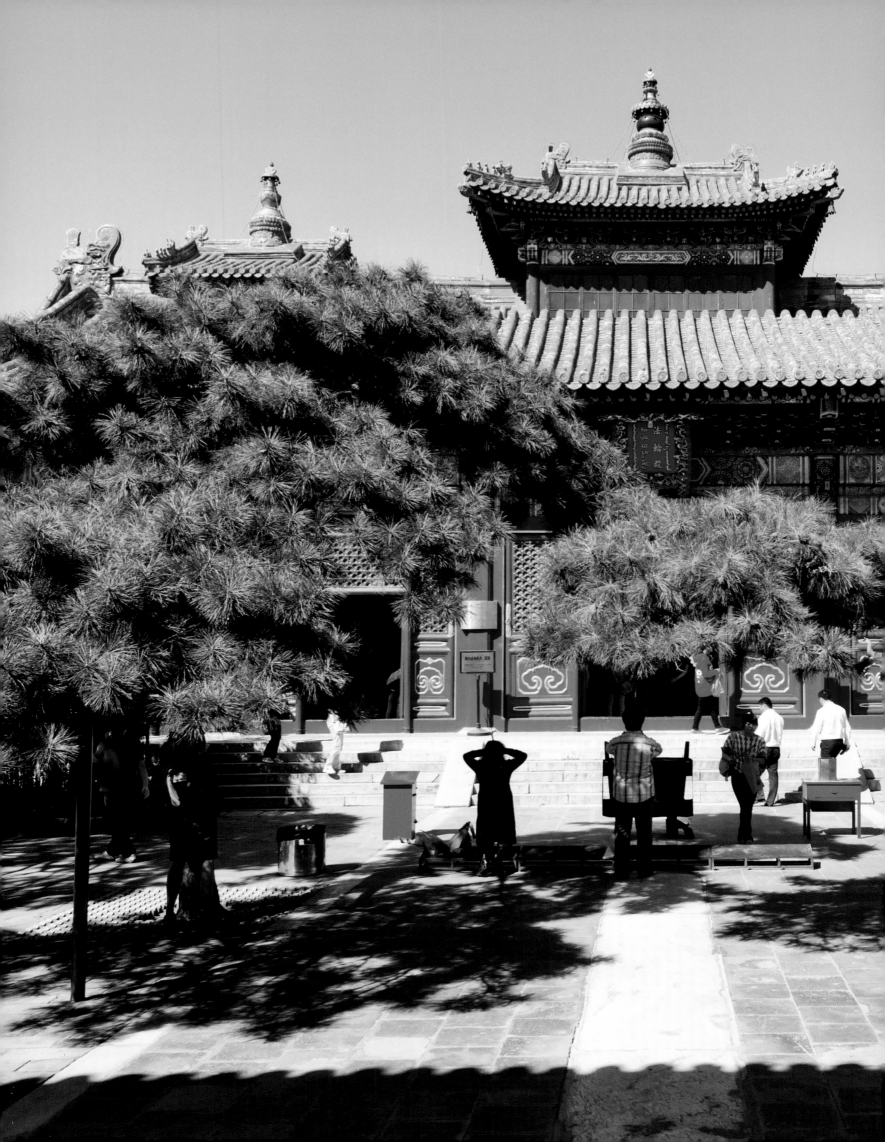

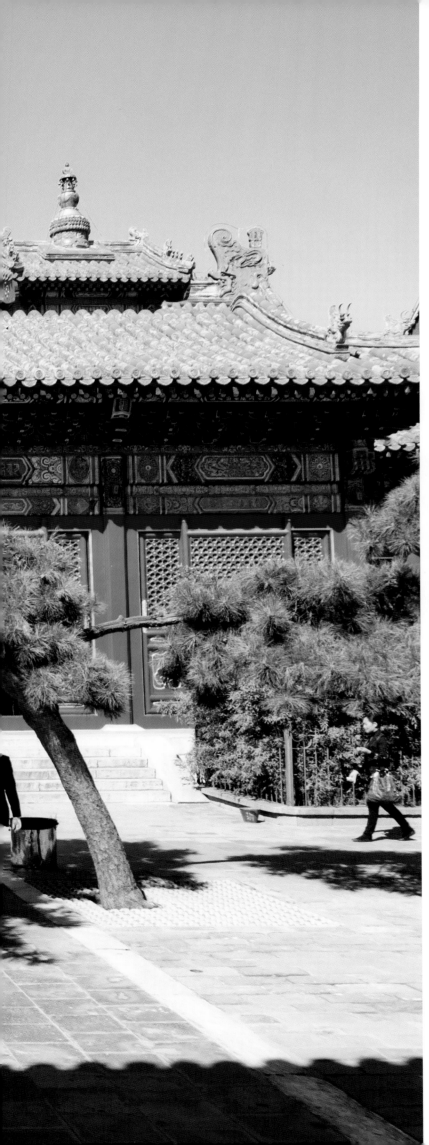
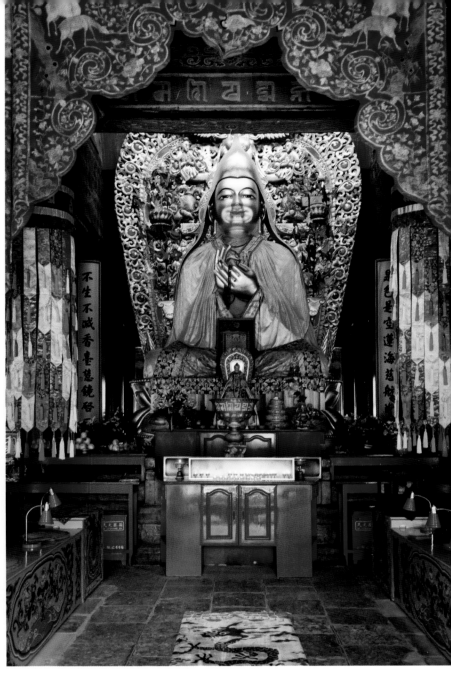

Lama Temple ❂ Beijing ❂ China ❂ Sacred sites of Mahayana

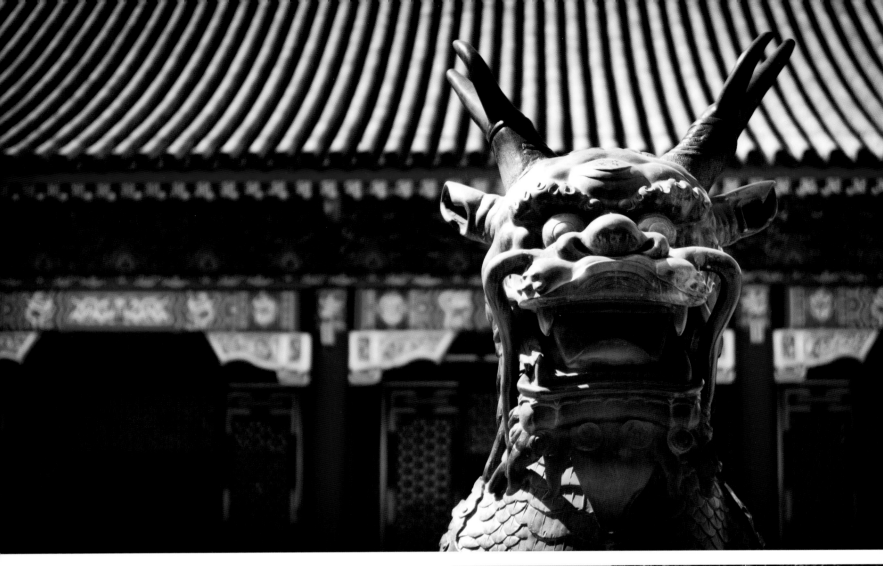

Many imperial gardens, such as the Summer Palace here or Beihai Park with its White Pagoda in Beijing, were home to Buddhist temples. Their spiritual radiance was intended to be reflected in the gardens and thus to invite the Buddha Amitābha to stay and be reborn in his paradise, the Pure Land, after his death.

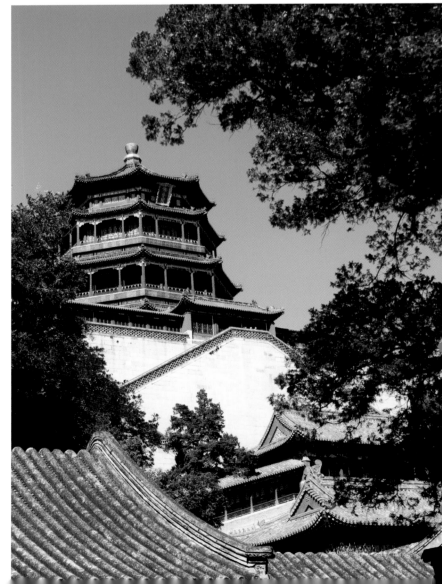

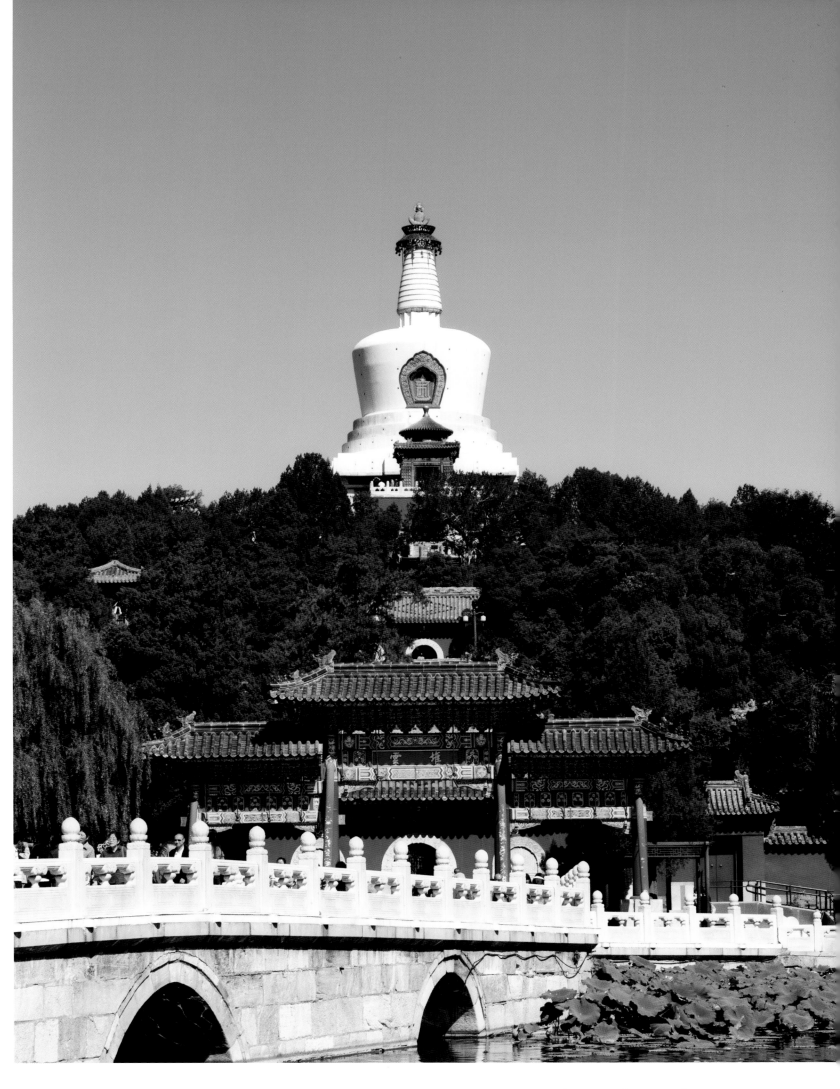

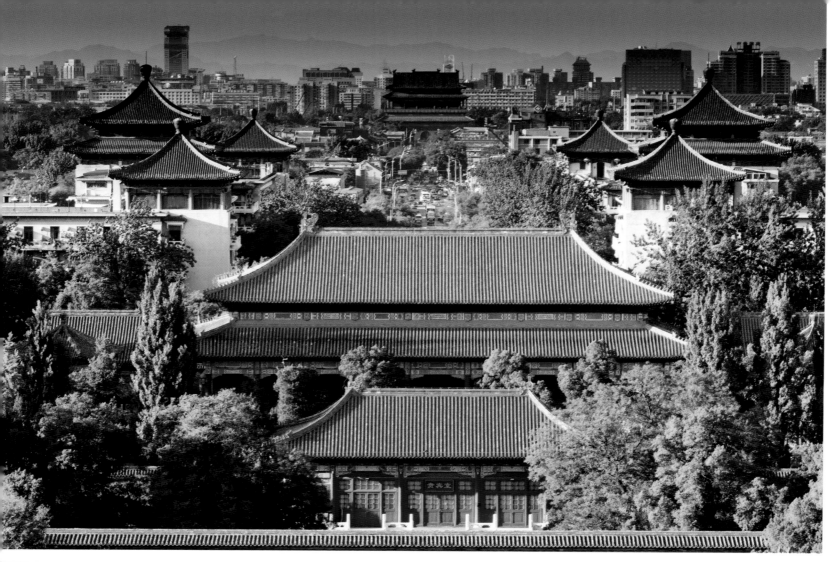

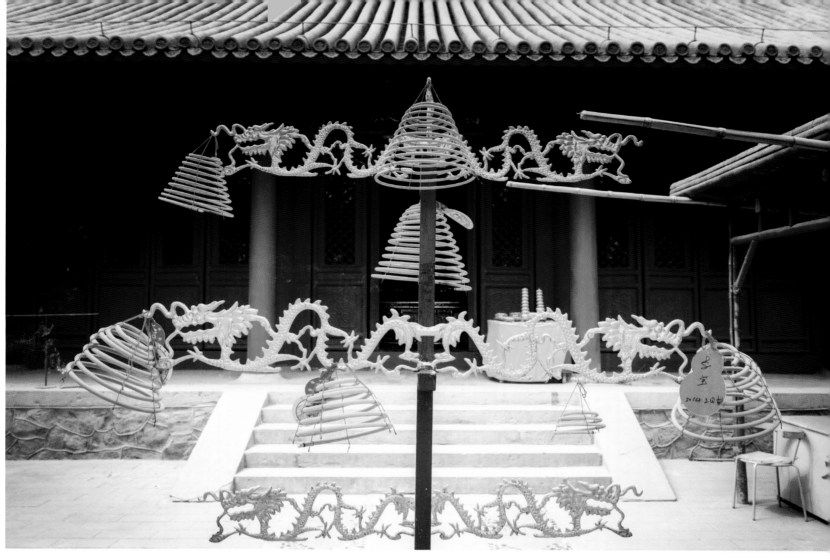

Only imperial temples, such as Shouhuang Hall (Hall of Imperial Longevity) in Jingshan Park in Beijing, were permitted to have yellow roofs and only members of the imperial family were allowed to enter them. In complete contrast are the city's countless Buddhist temples, which remain vibrant religious centers to this day. It is especially popular to hang red wooden prayer blocks and burn incense.

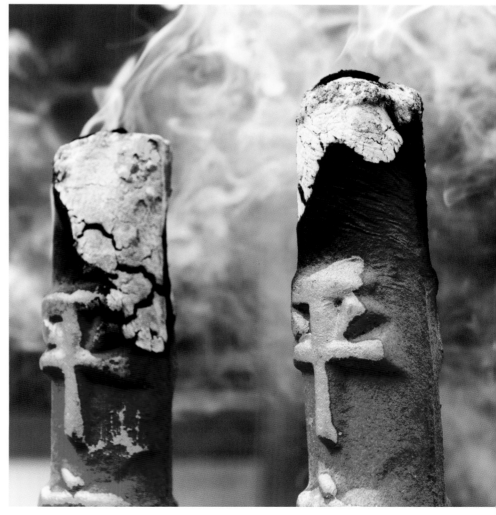

The Source of Law Temple above is one of the oldest temple complexes in the capital and is home to the Chinese Buddhist Institute. Although it primarily attracts devout Buddhists, other temples are often meeting places where people make offerings of incense sticks or spend their free time practicing water calligraphy, as seen here. The brush strokes are visible only fleetingly before they evaporate.

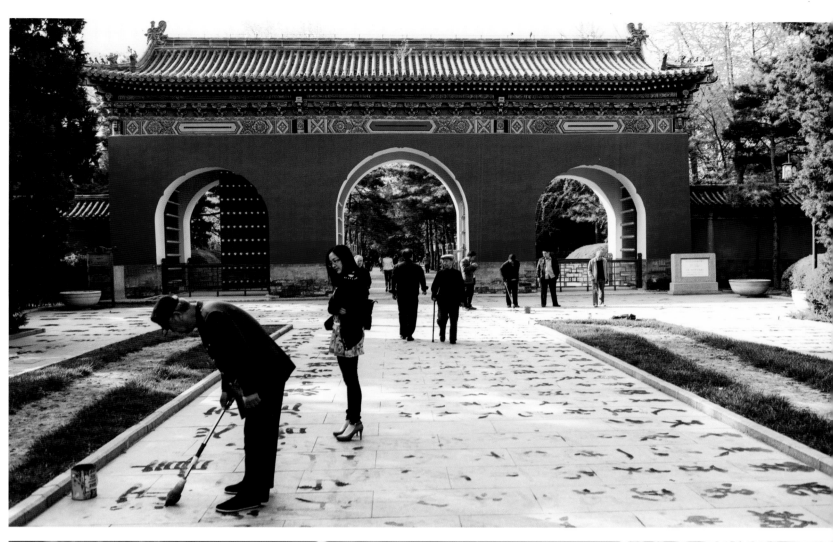

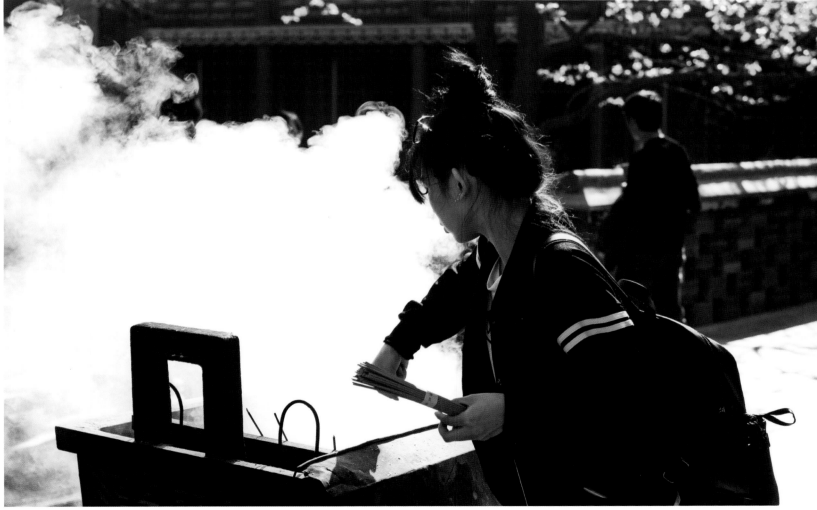

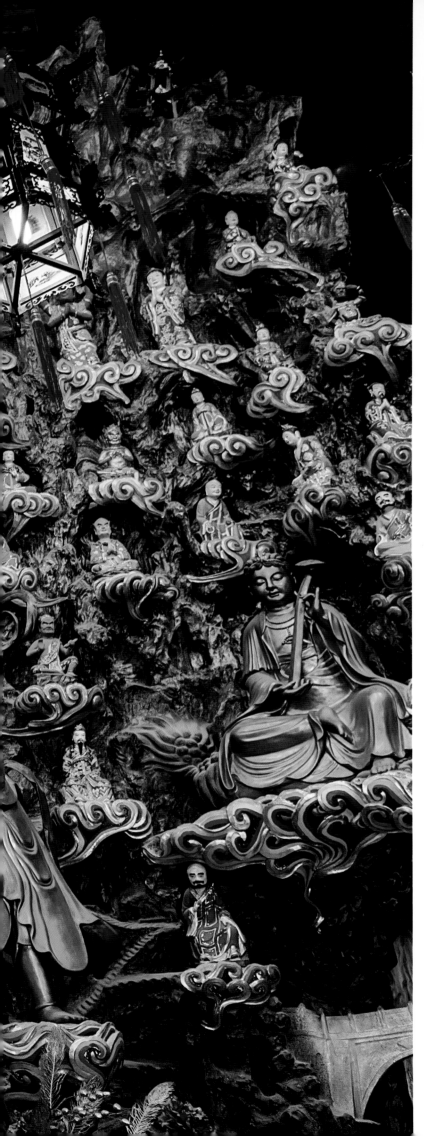

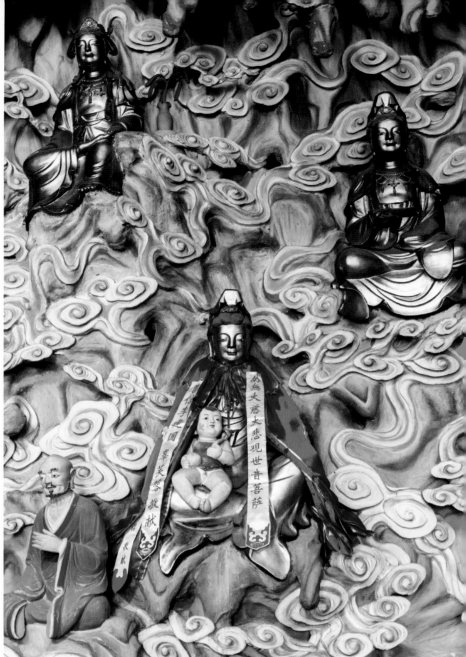

At the Longhua Temple in Shanghai, the huge altarpiece of Guan Yin, the Goddess of Compassion and the female manifestation of Bodhisattva Avalokiteshvara, is an allegory expressing the equality of the female versus the male path of salvation. The four stages of the Buddhist path of salvation are depicted: discipline, meditation, realization, and salvation in 12 steps.

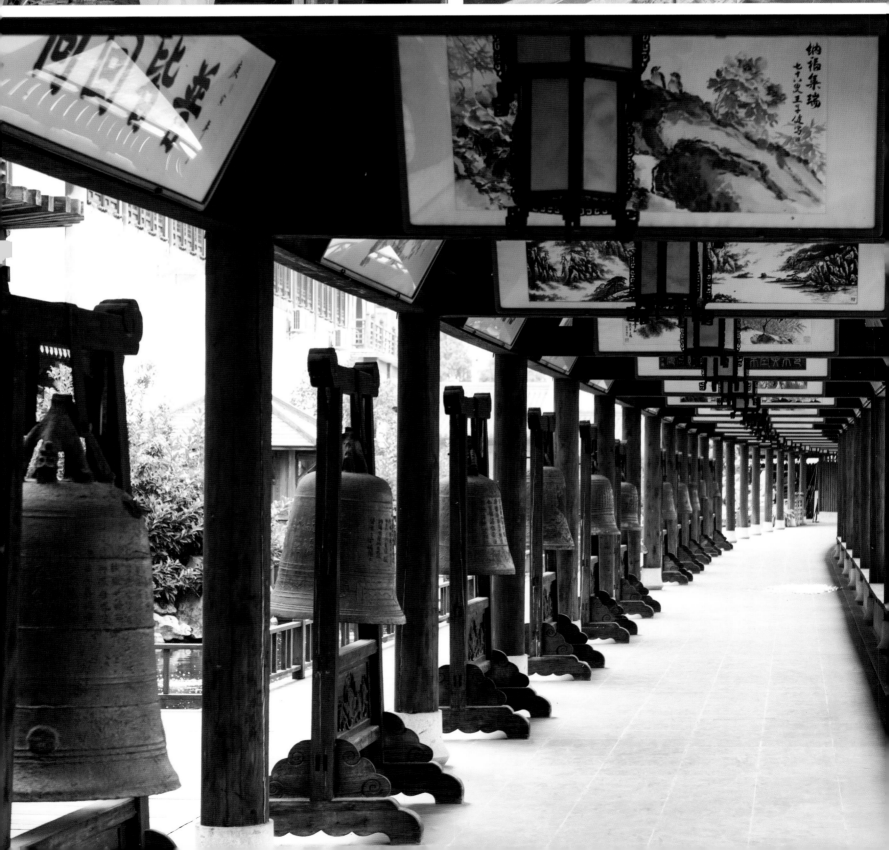

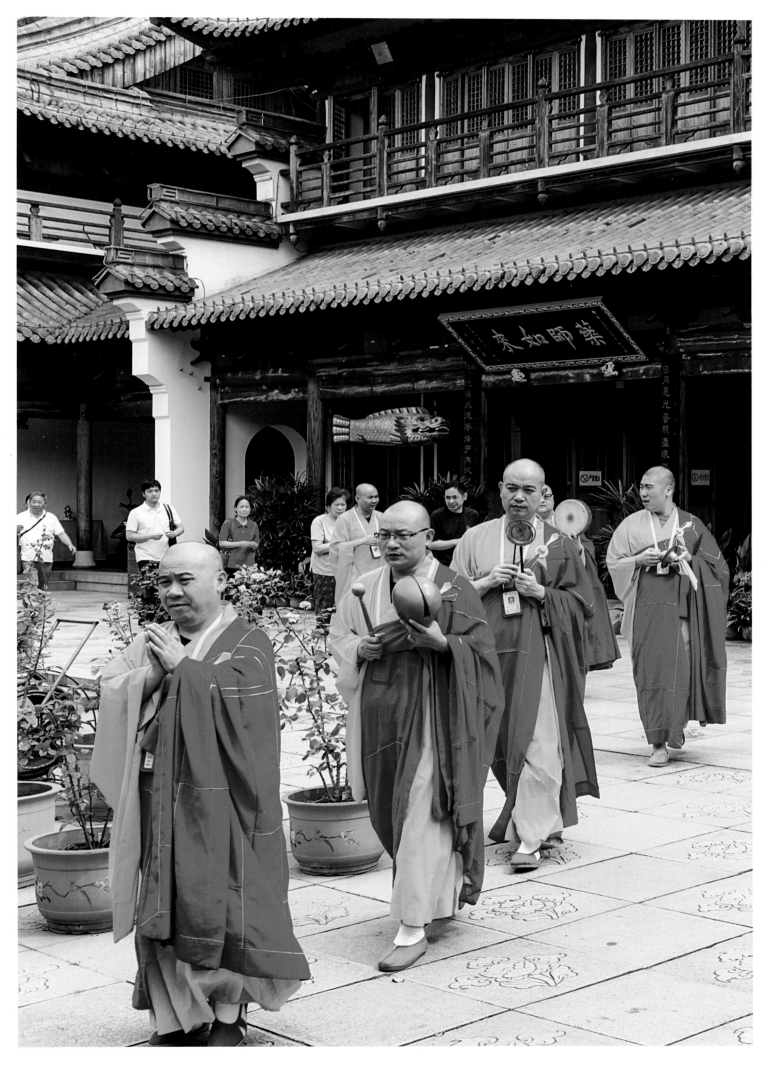

Zhenru Temple ❋ Shanghai ❋ China ❋ Sacred sites of Mahayana

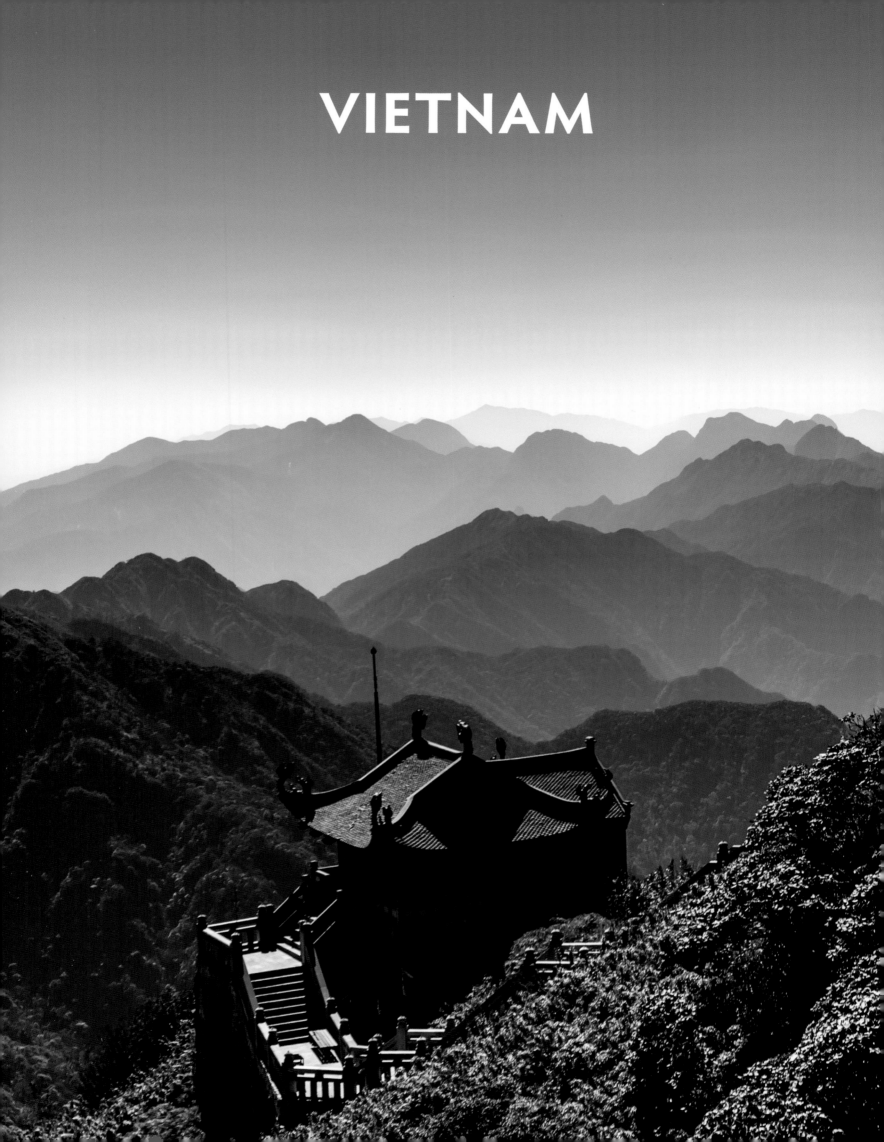

VIETNAM

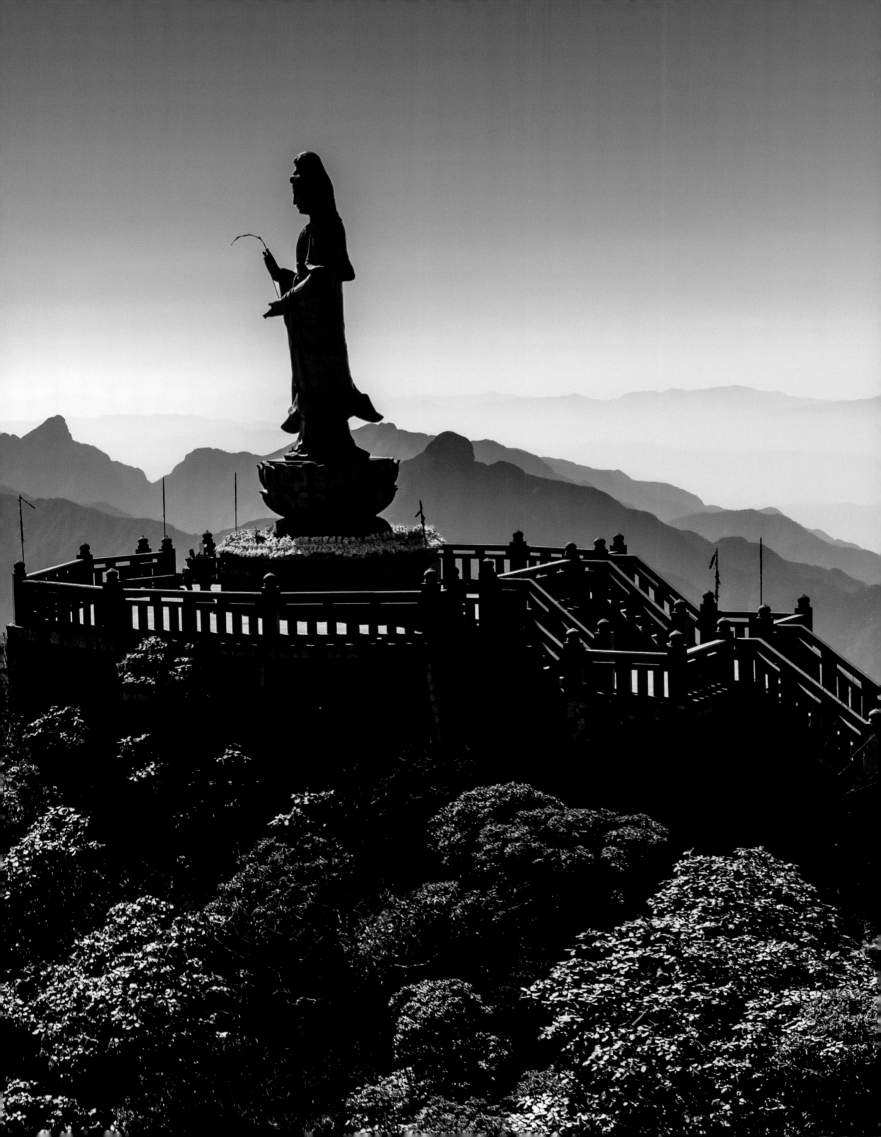

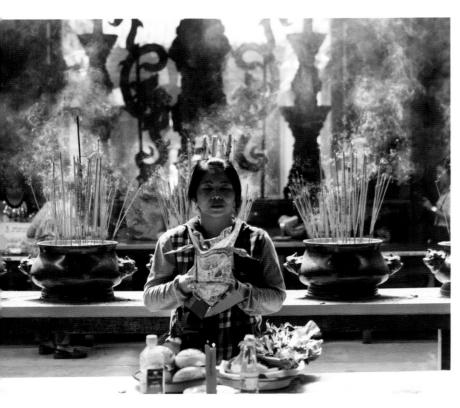

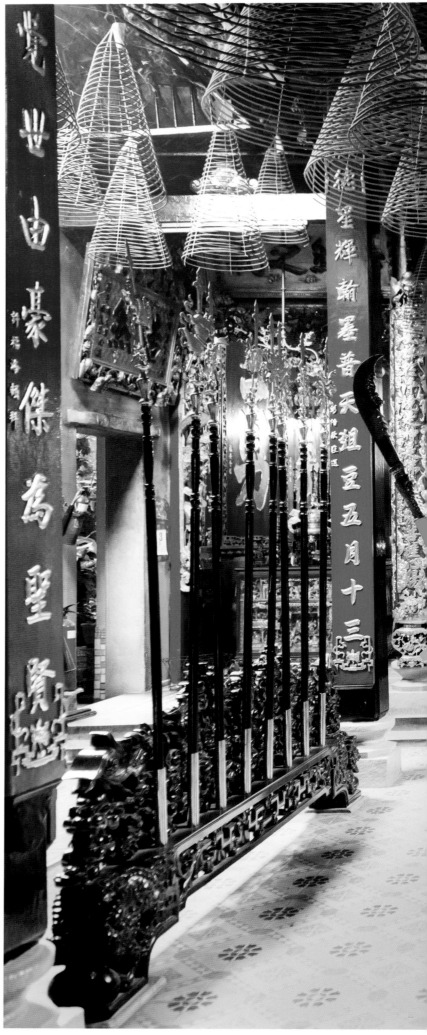

Situated in Cholon, Ho Chi Minh City's Chinatown, the Quan Âm Pagoda is dedicated to the goddess of mercy, Quán Thế Âm Bồ Tát, or Quán Âm for short (Guan Yin in Chinese). The numerous weapons are not an expression of any warlike intentions, but rather Buddhist symbols for the destruction of ignorance, the piercing of all false views, and so on.

124

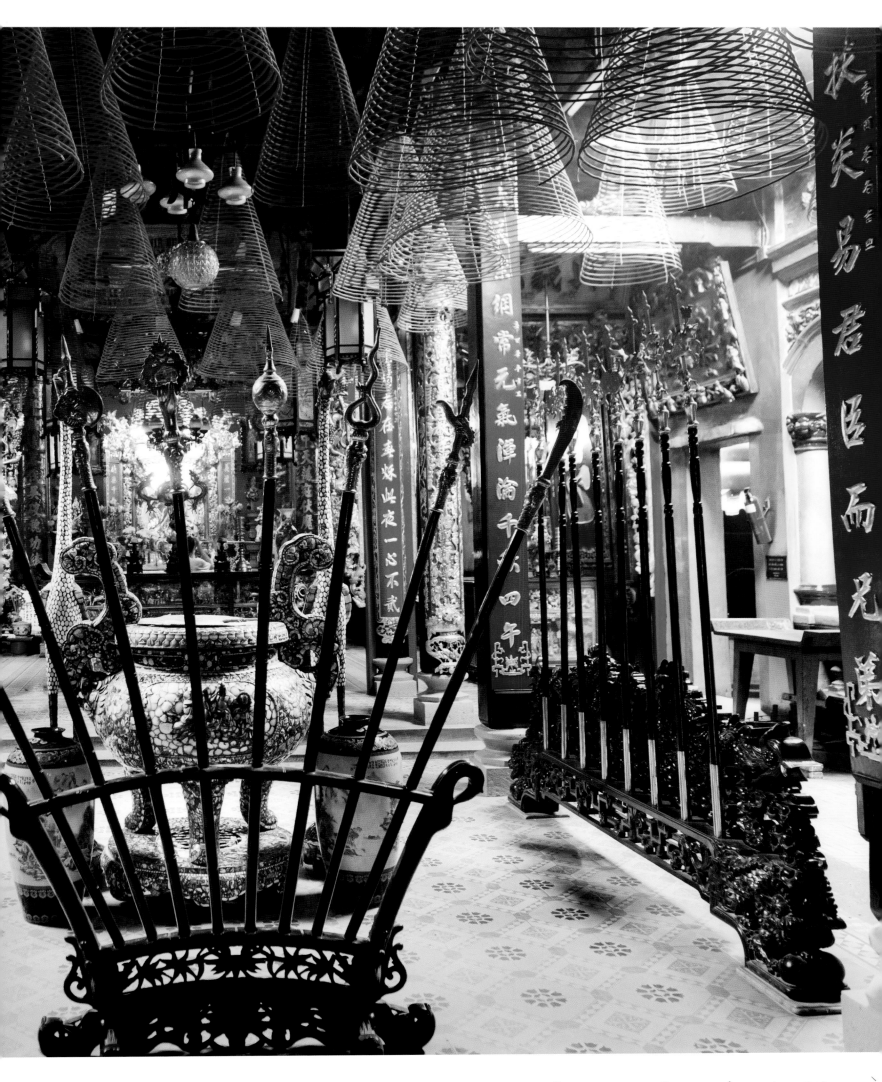

Quan Am Pagoda ❦ Ho Chi Minh City ❦ Vietnam ❦ Sacred sites of Mahayana

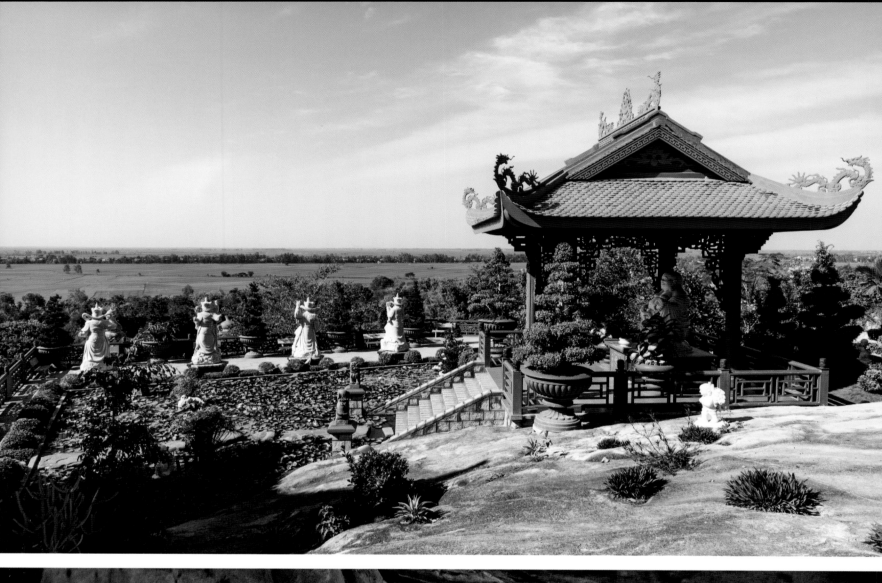
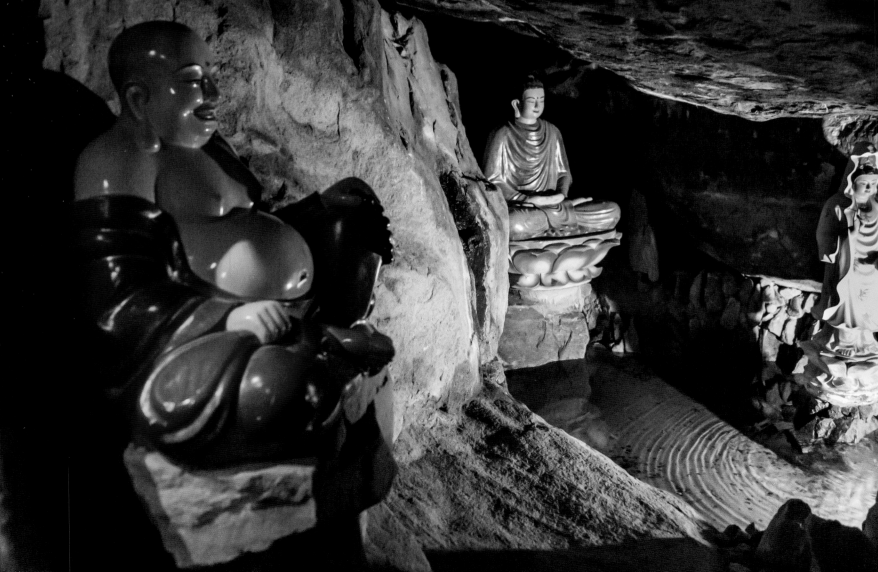

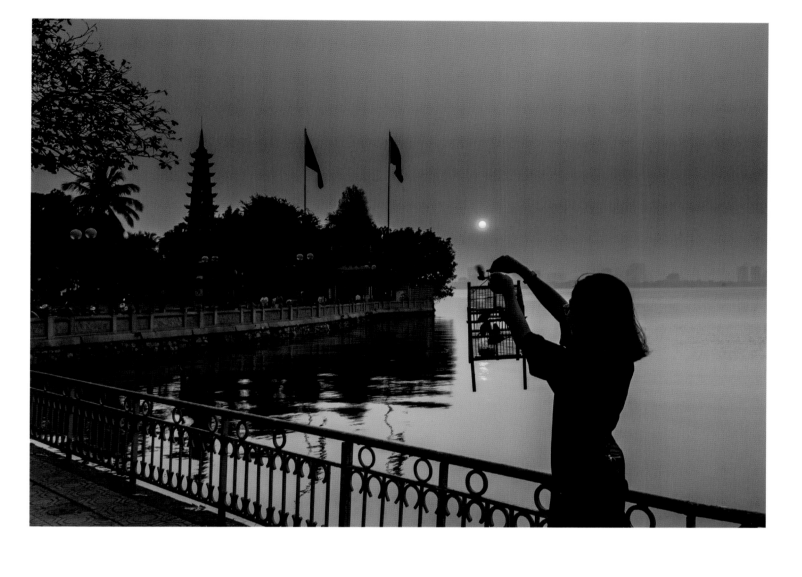

Near the city of Chau Doc, Nui Sam mountain rises
from the rice fields. Burial sites and shrines are scattered
all over the hill area. The mountain is also home to Chua
Hang cave (Hang Pagoda), in which a seamstress named
Le Thi Tho once meditated and is said to have converted
two snakes who lived there. Releasing birds is a popular
ritual after visiting holy sites and is believed to be good
for your karma.

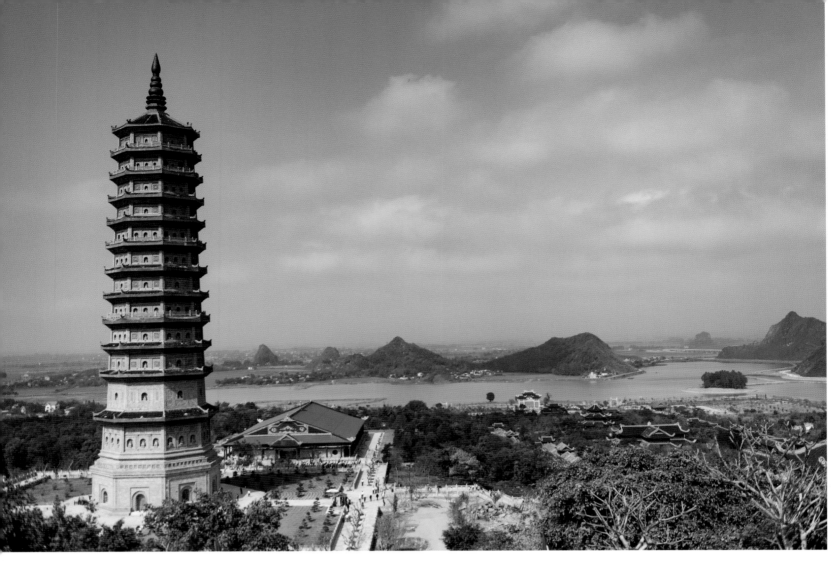

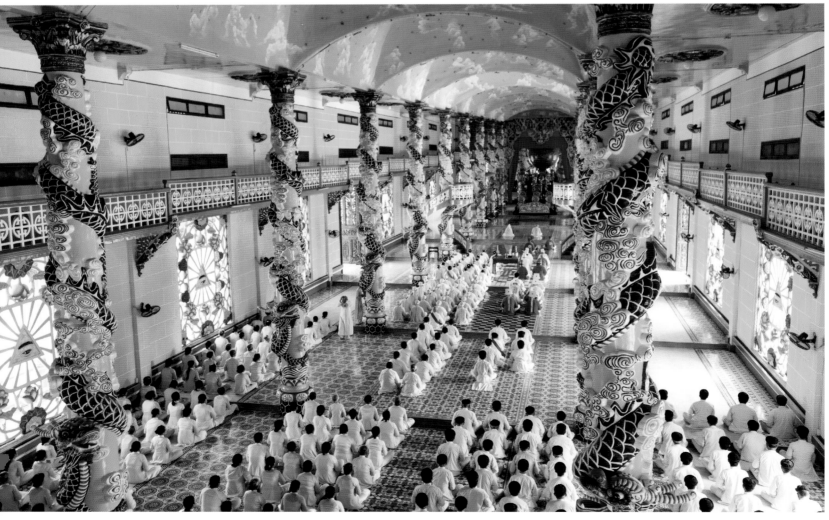

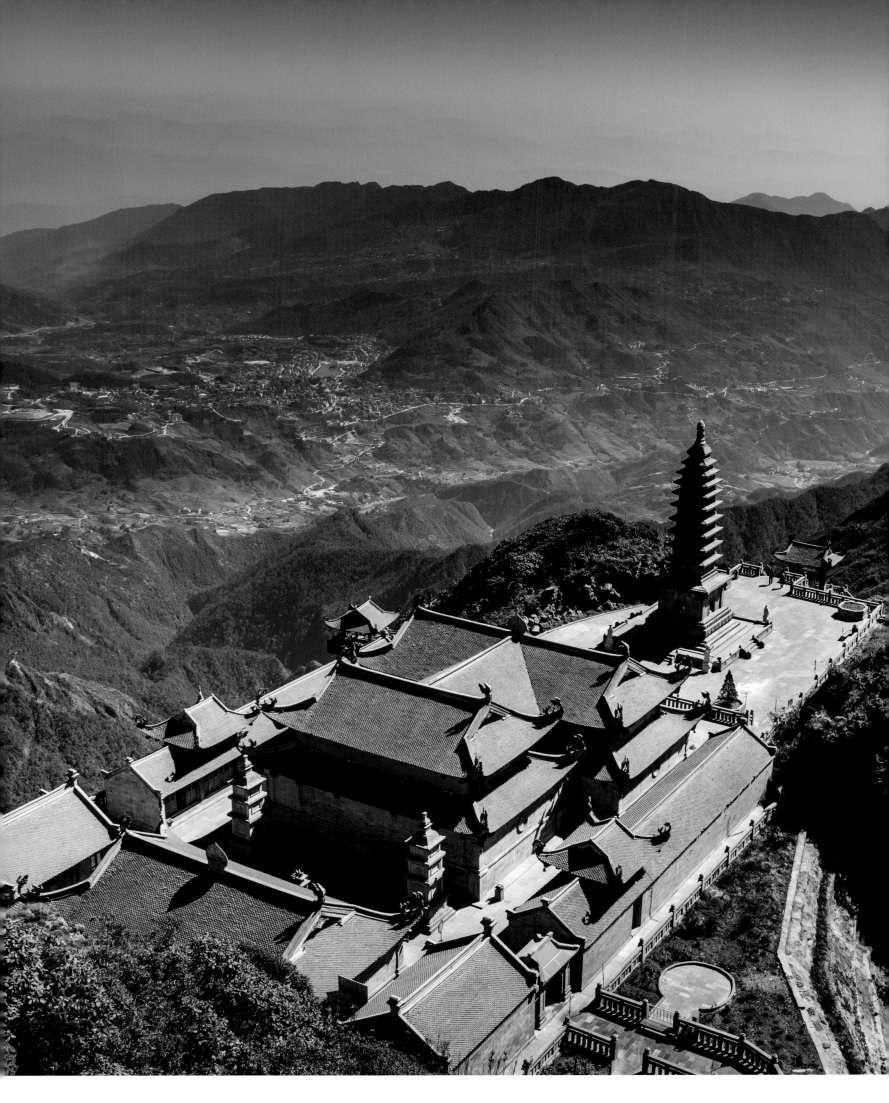

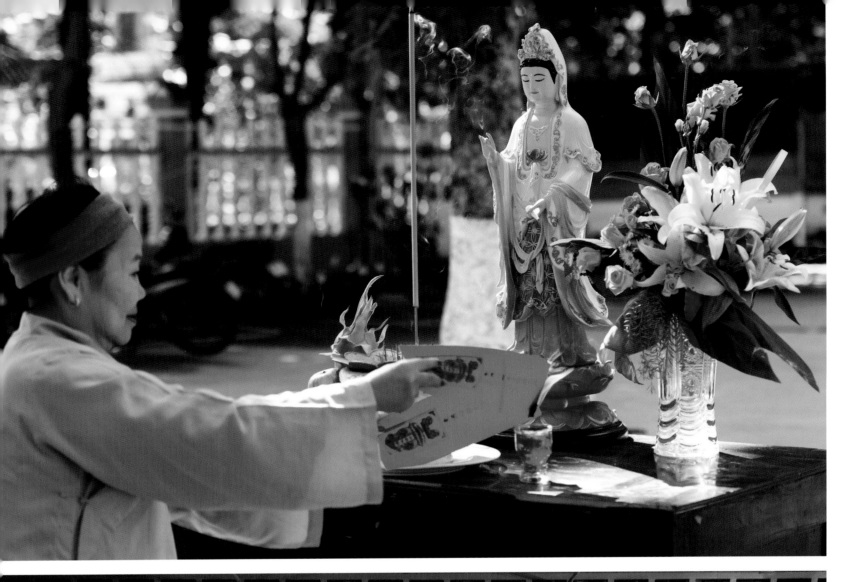

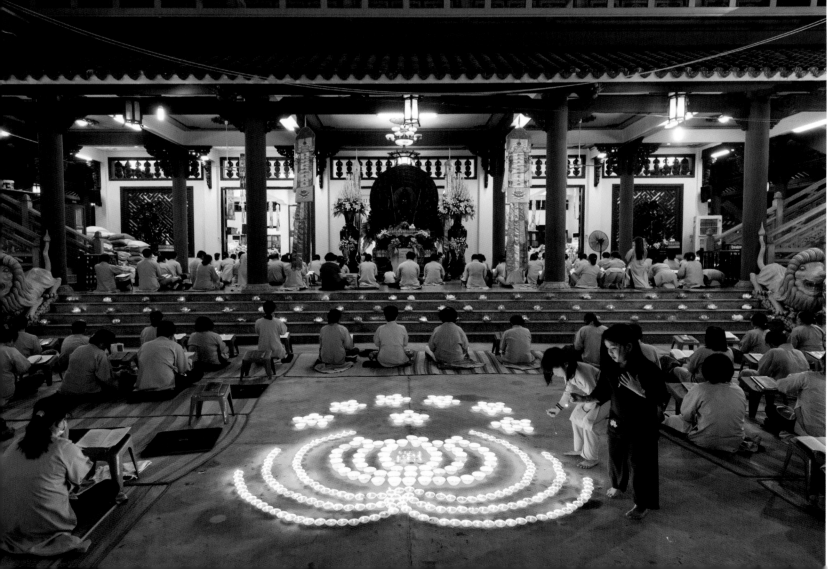

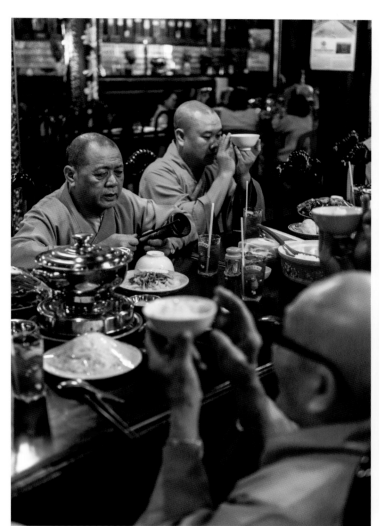
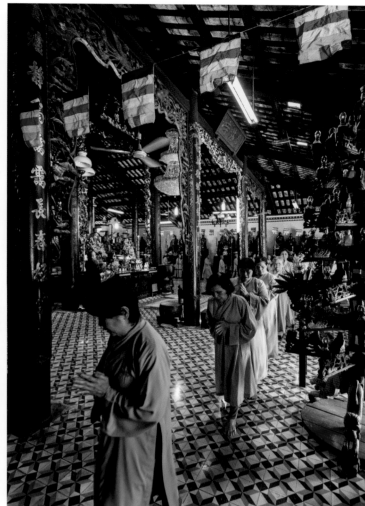

Salvation always involves the liberation from suffering and the healing of the soul. You might say that Bhaisajyaguru is the psychologist among the Buddhas. He is the loving friend who is called upon in times of sickness and need. It is said that he once took a vow to rid the world of its spiritual suffering. The Via Phat Duoc Su ceremony is held in his honor every year at the Giac Lam Pagoda in Ho Chi Minh City.

Giac Lam Pagoda ❁ Ho Chi Minh City ❁ Vietnam ❁ Sacred sites of Mahayana

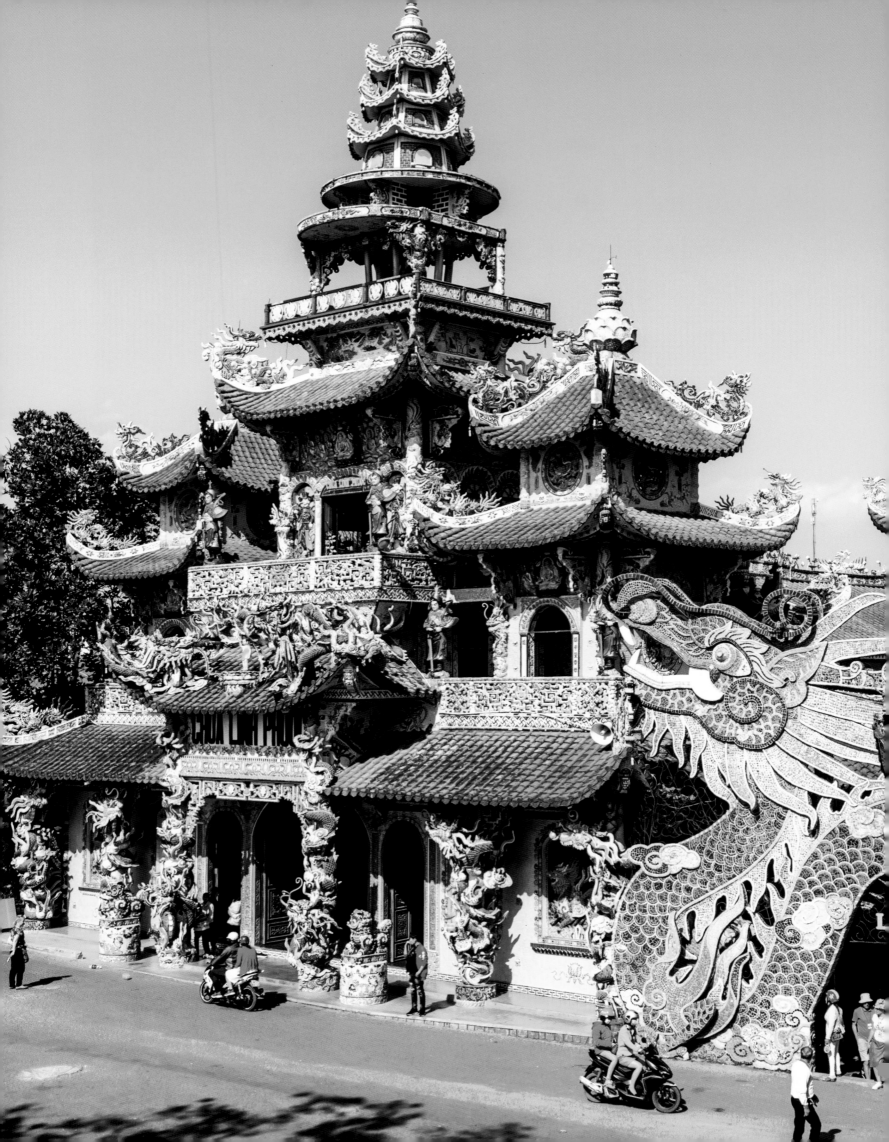

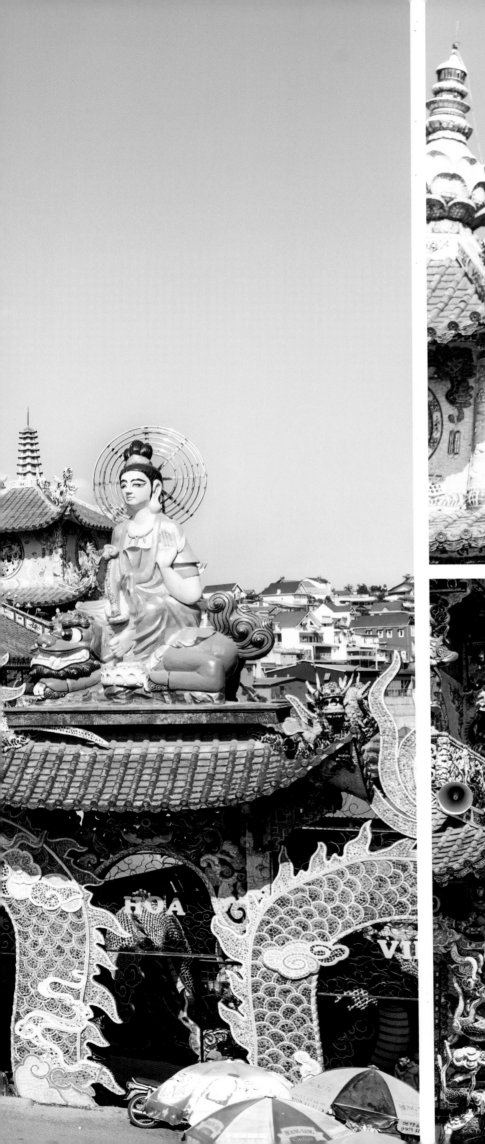
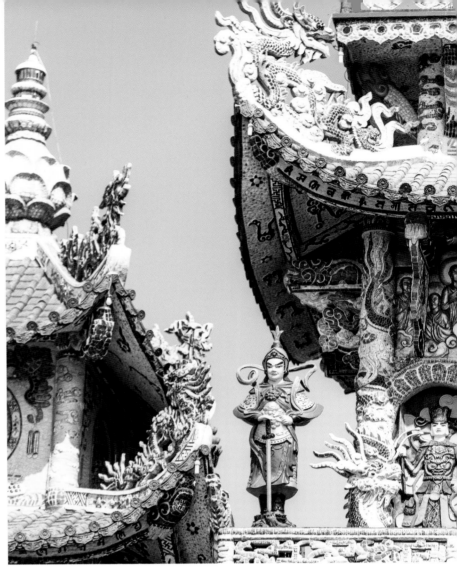
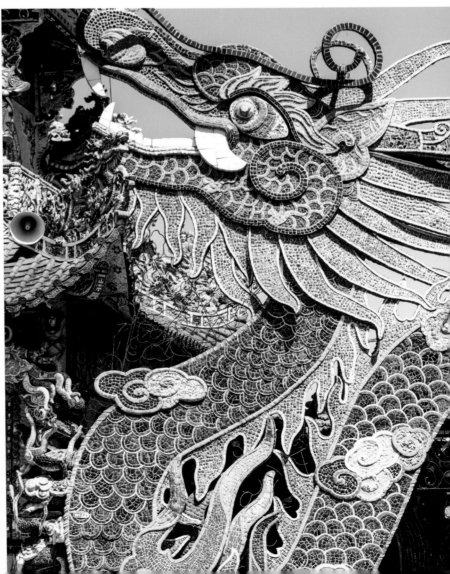

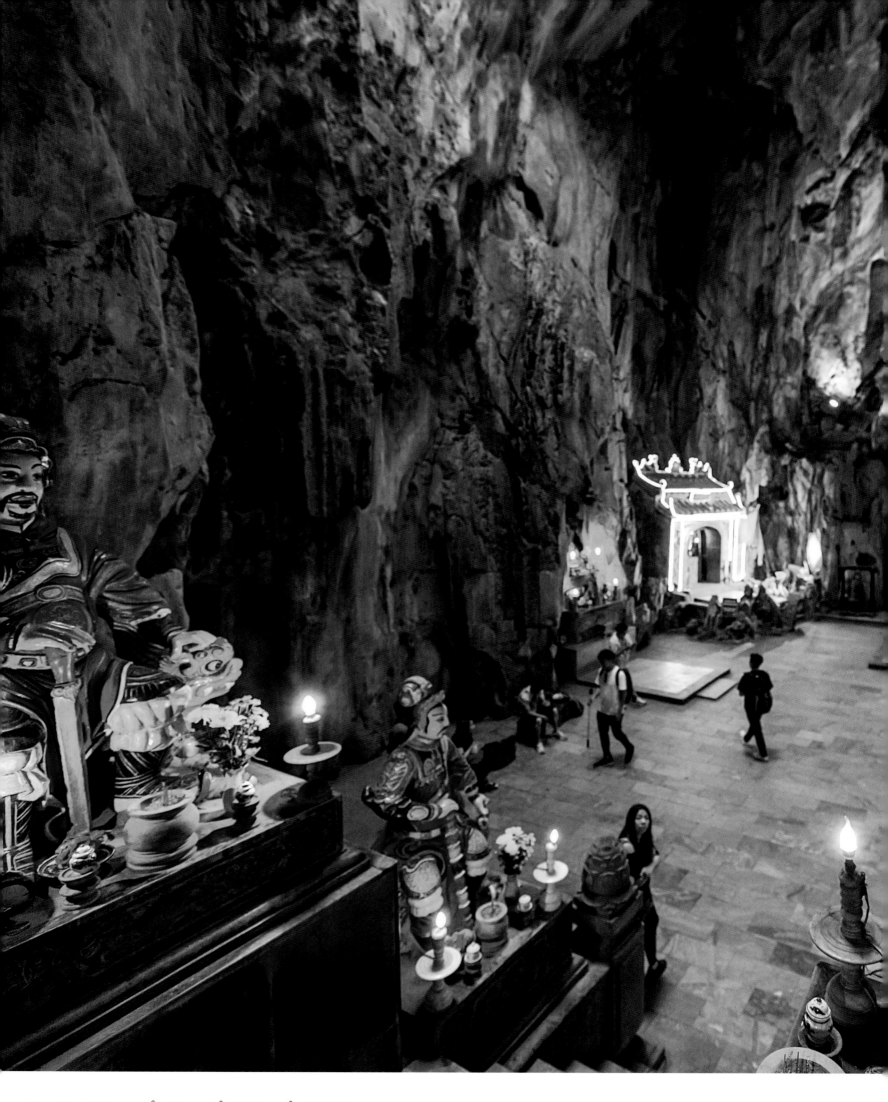

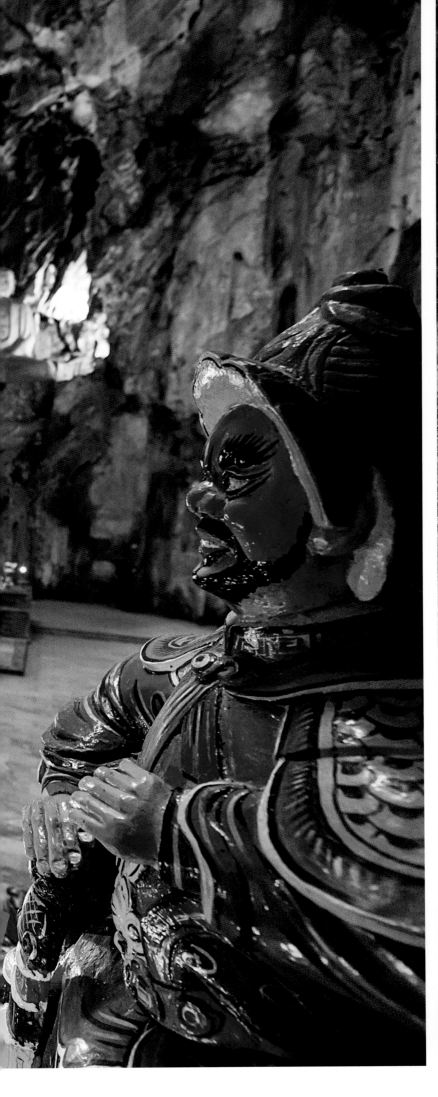
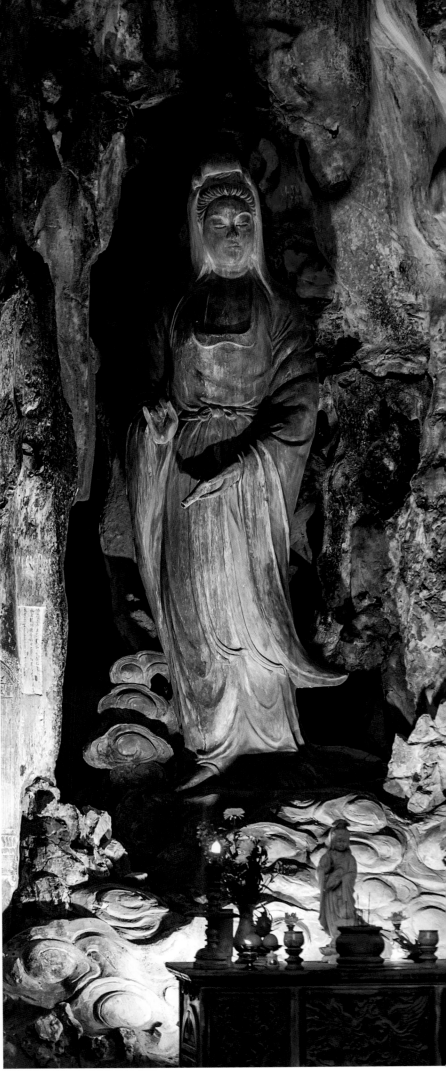

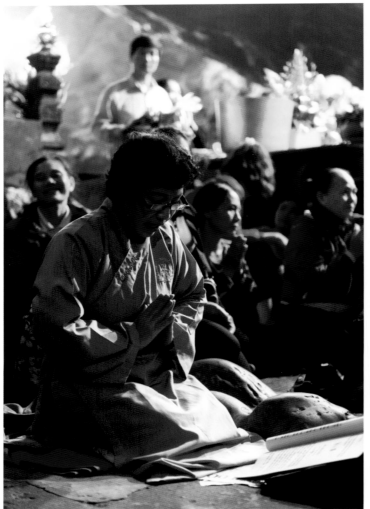

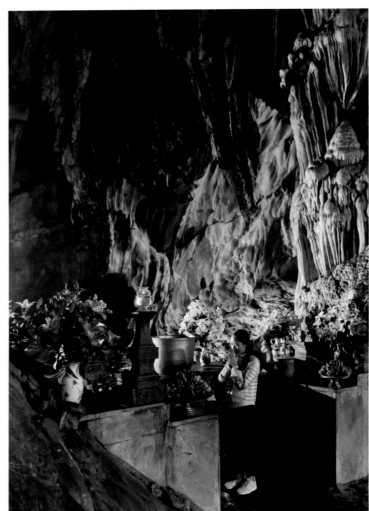

The Chua Huong perfume pagoda is located in the heart of the Huong Tich ("traces of fragrance") limestone mountains. Situated southwest of Hanoi, Chua Huong is one of the most important Buddhist pilgrimage sites in Vietnam. The three-month pilgrimage season begins after the Vietnamese New Year festival of Tet. On this occasion, many people, including poets, painters, and other artists, make a pilgrimage to this place in search of inspiration.

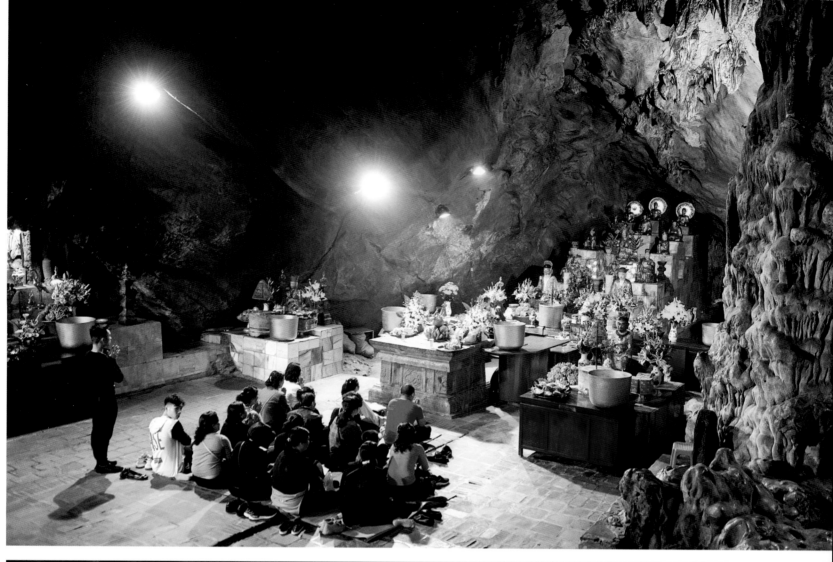

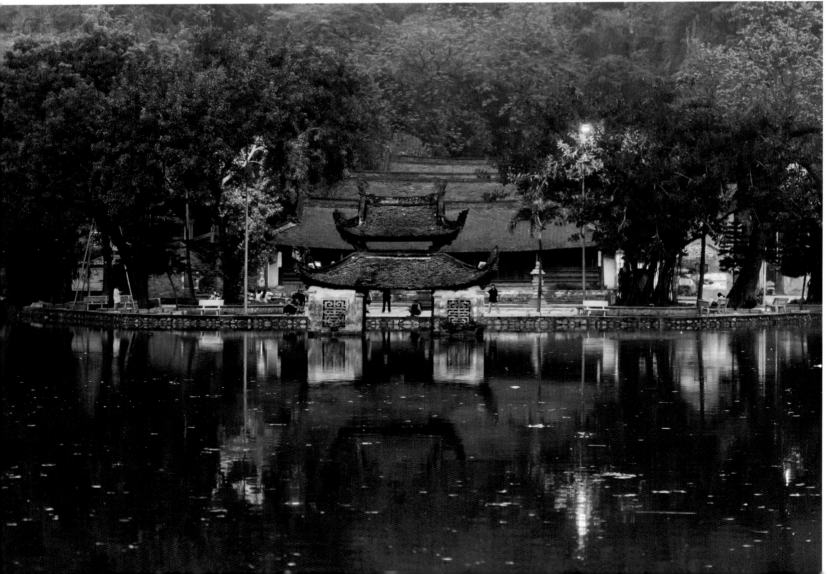

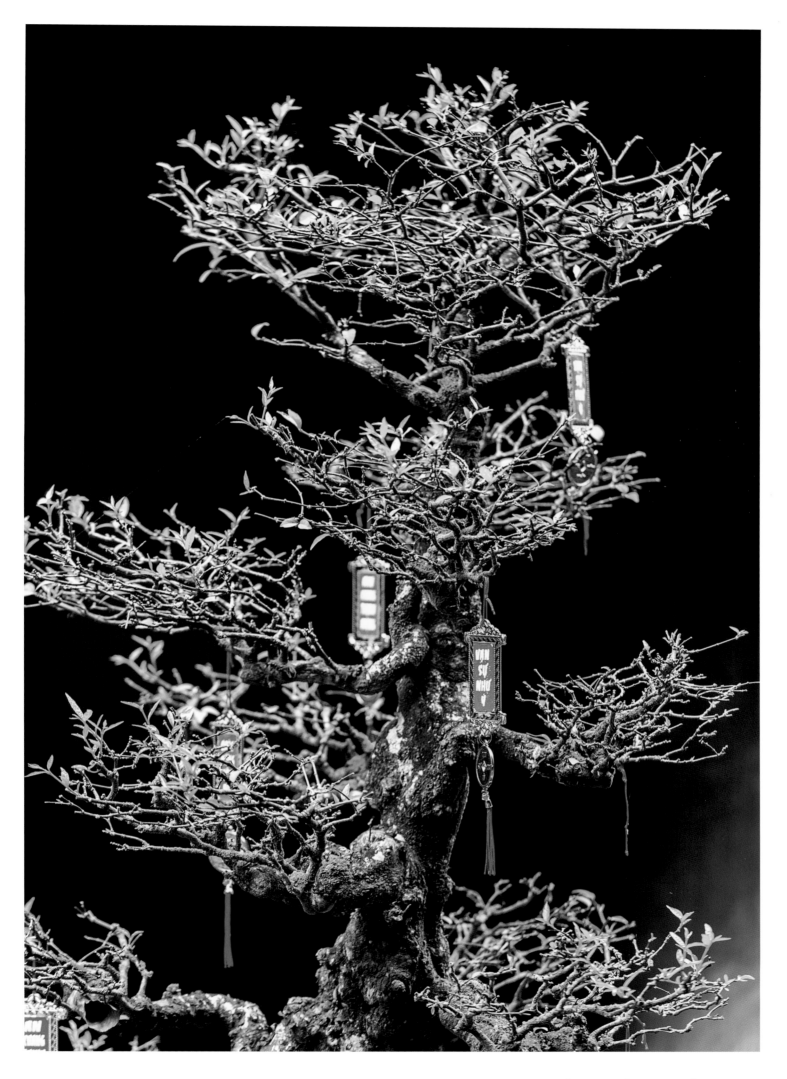

Tay Phuong Pagoda ❁ Hanoi ❁ Vietnam ❁ Sacred sites of Mahayana

SACRED SITES OF

VAJRAYANA

Hemis, Phyang, Thikse, Chemrey,
Zanskar (Karsha, Lungnak valley, Sani, Zangla)

Pokhara, Lalitpur, Kathmandu,
Pharping, Bhaktapur

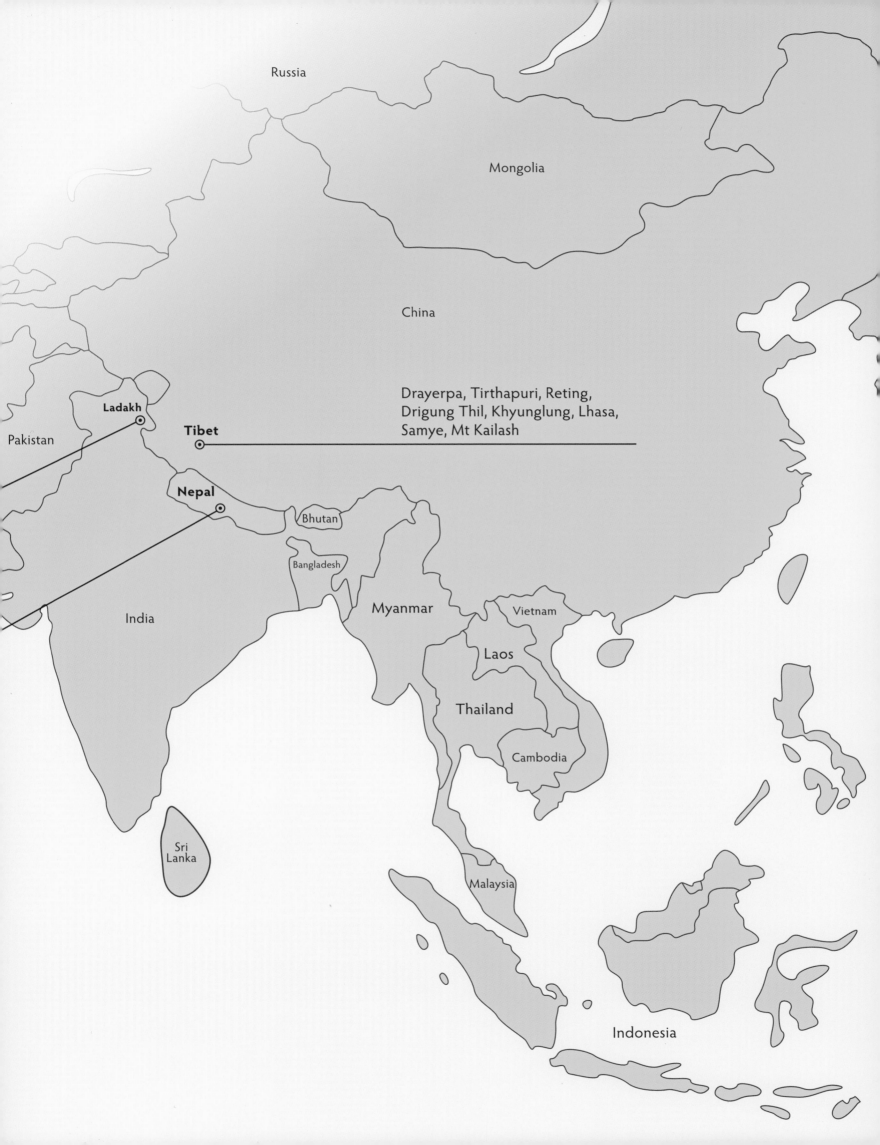

Sacred sites of
VAJRAYANA

Buddha reputedly said: "Do not give up just because things get hard." That quote comes to mind as I battle a severe headache; after all, a journey in the footsteps of Padmasambhava is an ordeal in and of itself due to the enormous altitude of the highlands. I set off from Tradun heading west with my Tibetan guide, Tashi. My first destination is Mount Kailash, the holiest mountain in Buddhism. From there, we want to continue on to Tirthapuri, the place where Padmasambhava started his missionary work in Tibet. Before he could get started, however, Padmasambhava had to contend with considerable resistance.

When Trisong Detsen (r. 755–797), the second Dharma King after Songtsen Gampo, ascended the throne, the Tibetan Empire was at the height of its power. Tibetan forces controlled large parts of Central Asia, and in 763 Trisong Detsen's armies even briefly captured the Chinese capital of Chang'an. As had Songtsen Gampo, Trisong Detsen tried to use religion to legitimize his immense power. Not truly persuaded by Buddhism, he gathered the most important representatives of the Bon religion, whose followers are called *Bonpo*, and pitted them against representatives of Buddhist doctrine in a dispute that played out in public. The Bonpo were defeated and exiled, and Buddhism became the new religion of Tibet.

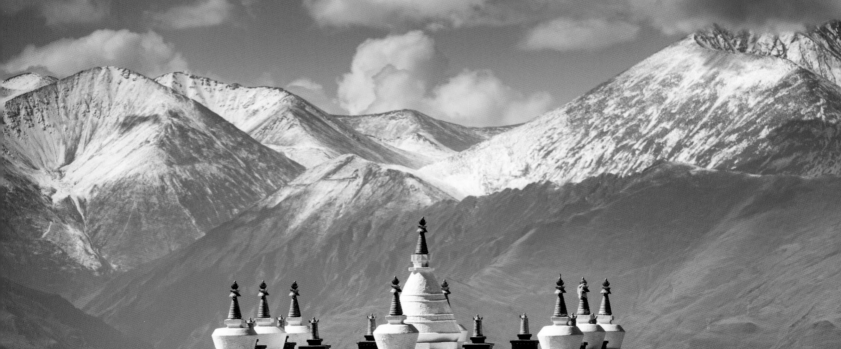

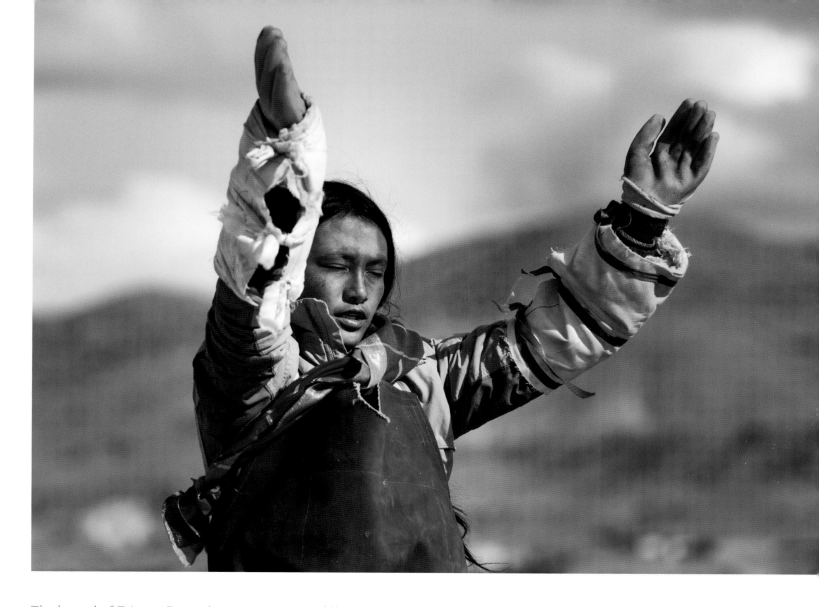

The legend of Trisong Detsen's conversion to Buddhism, however, is a much more dramatic read. To learn more about this religion, the king had invited the Indian scholar Shantarakshita (c. 723–787) to Tibet. Shantarakshita's efforts to convince Trisong Detsen were initially unsuccessful, and so he invited the Indian sage Padmasambhava to Tibet to assist him. Not far from Samye in central Tibet, Trisong Detsen and Padmasambhava met for the first time. The king, however, refused to pay homage to the great scholar, whereupon Padmasambhava caused five flames to flare up from his fingertips. Trisong Detsen, now completely awestruck, prostrated himself before Padmasambhava. To commemorate this event, Trisong Detsen had five stupas built, which can still be seen today about three miles (five kilometers) west of Samye.

There were no architects at work here; in the case of Mount Kailash, nature itself has created a place of spiritual dignity.

Whether Padmasambhava was actually a historical figure is a matter of some debate. In the cultural memory of Tibetans, who call him *Guru Rinpoche* ("precious master"), however, he has become the cultural hero who is credited with making Tibet, with its human and demonic inhabitants, a Buddhist country.

After two days of travel, we reach our destination—a very special kind of holy place. There were no architects at work here; in the case of Mount Kailash, nature itself has created a place of spiritual dignity. It is one that

is regarded as the holiest of all places for Buddhists, Hindus, Jainas, and Bonpos and serves as a link between their spiritual and physical worlds. It is not the size that is so impressive—the mountain measures just 22,028 feet (6,714 meters)—but the location. Everything here is gigantic and mysterious, infinite and moving, a boundless landscape that forms the natural backdrop for Vajrayana and its rites and demons.

In the cosmology of India and Tibet, Mount Kailash represents the earthly manifestation of Sumeru, or the very center of the world. Hindus, Buddhists, and Bonpos consider Mount Kailash to be a "self-created temple," a natural shrine of gigantic proportions that towers in the middle of the mighty 621-mile-long (1,000-kilometer-long) Gangdise mountain range. A number of major rivers originate on its outskirts: the Indus, Sutlej, Karnali (a tributary of the Ganges), and the Yarlung Tsangpo, which becomes the Brahmaputra in India. From the sacred headwaters, they spread out in all four directions. As these rivers progress, they supply vital water to a populated area comprising about one fifth of humankind.

For the Tibetan Buddhists, Mount Kailash represents a mandala, in the center of which—on the summit—the deity Chakrasamvara is enthroned. Chakrasamvara is both the tantric embodiment of the Buddha as well as a "divine" manifestation of wisdom and compassion of all enlightened beings. His name means that he is the one who stops the wheel (*chakra*) of rebirth (*samvara*). Buddhists who walk around the mountain are convinced that they can immerse themselves in Chakrasamvara's sphere of influence and thus accumulate a great deal of good karma and purify negative karma.

There is another special meaning that mountains have as the center of the world. They symbolize an *axis mundi*, or a world axis, and hence the center of the universe. The *axis mundi* is a type of ceremonial and conceptual center, a navel of the world and the intersection of the four compass points. A classic

144

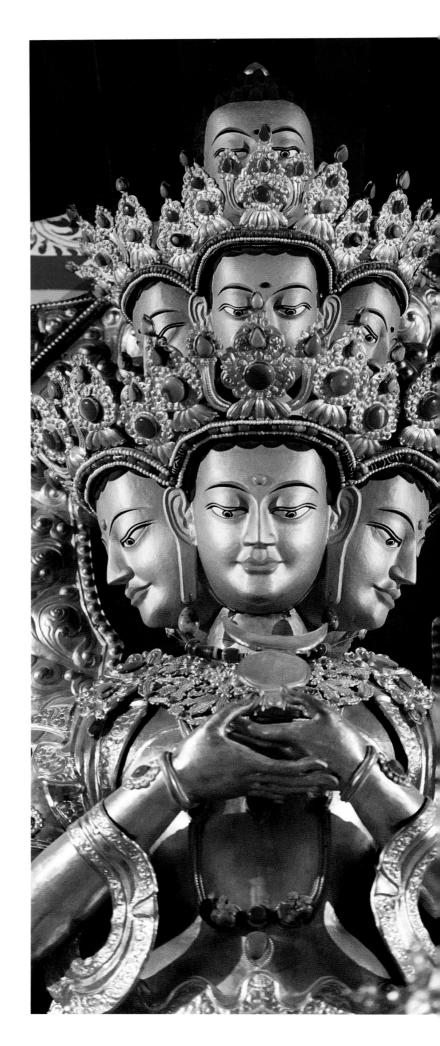

example is the mythical Mount Meru in Hinduism and its Buddhist counterpart, Sumeru, both of which are represented in the physical world by Mount Kailash in western Tibet. The basic pattern is always the same—a vertical axis connecting the three worlds: the underworld of the deceased, the middle level of humankind, and the heavenly sphere.

Padmasambhava "tamed" the local deities and the demons and incorporated them into an ever-expanding pantheon of gods.

Not far from Mount Kailash and situated on the northern bank of the Sutlej is Tirthapuri, the third major sacred site visited by pilgrims after Mount Kailash and the holy lake Mapham Yutso (Manasarovar). The name Tirthapuri probably derives from the Sanscrit word Pretapuri and means "city of death." According to ancient legends, this is where the dead and spirits dwell. However, this place owes its holiness to Padmasambhava, who is said to have prepared here for his missionary work in Tibet and meditated together with his companion, Yeshe Tsogyel. It is hardly a coincidence that the great Buddhist scholar and tantric master chose this of all places, because in order to be successful, he first had to tame Tibet's spirits and demons and make them subservient to Buddhism.

Padmasambhava did in fact manage to align the down-to-earth cults with their magical practices and their beliefs in spirits and magic with the high philosophy of the Buddha and the mindfulness training he aspired to. He "tamed" the local deities and the demons and incorporated them into an ever-expanding pantheon of gods. In the end, he is said to have named the god Pehar as the patron deity for all of Tibet. With this step, the gods and demons were placed in the service of Buddhism and nothing else stood in the way of further missionary work.

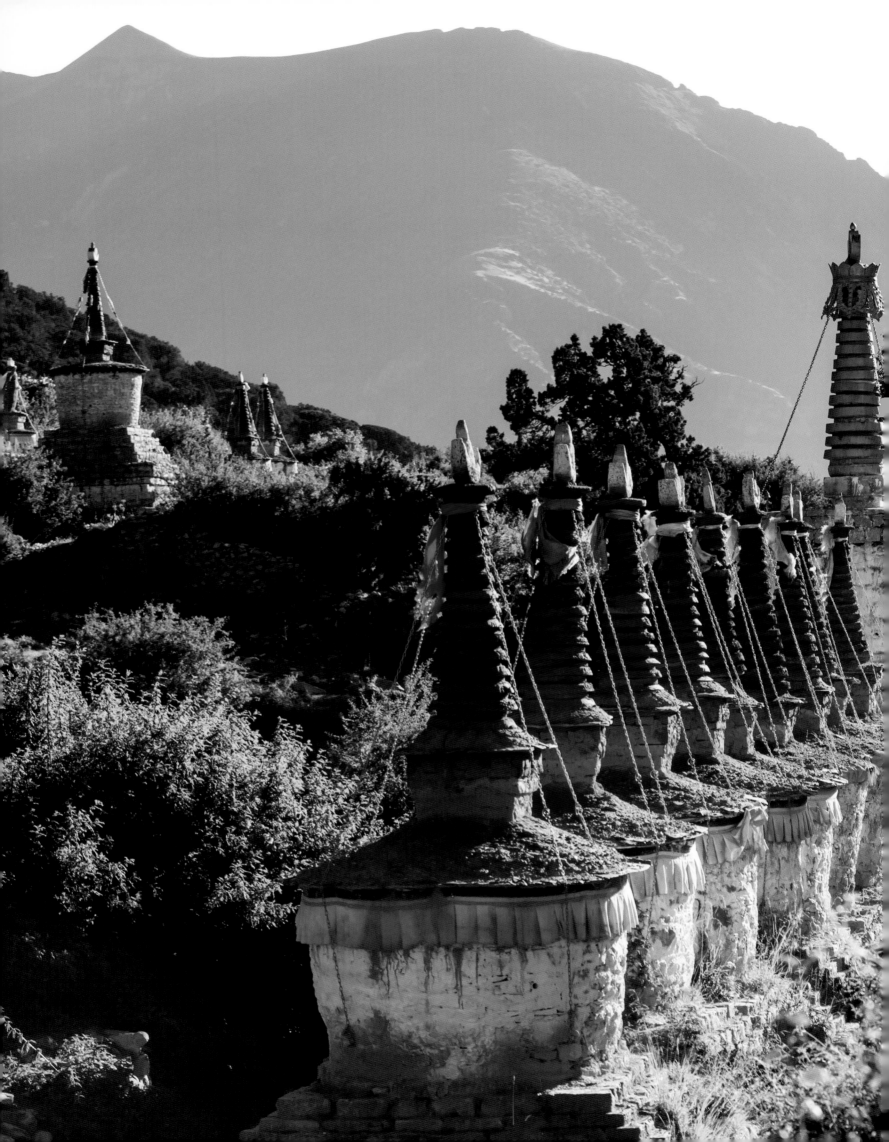

TIBET

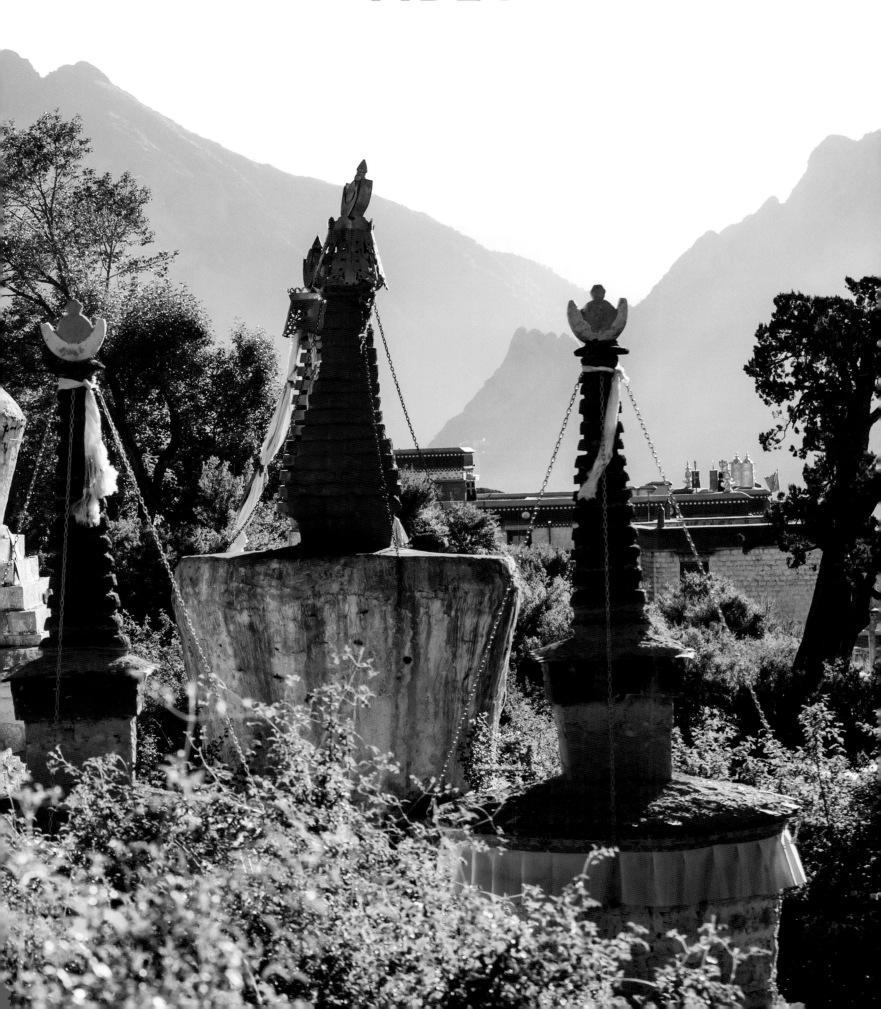

This double-page spread:

Reting Monastery with the golden wheel of teaching and the brilliant victory banners (*dhvajas*) stands in the middle of the largest juniper forest in Tibet. The Dhvajas symbolize the victory of Buddhism over the demons as well as the victory of Buddha over all types of anger and hate. The rare and ancient juniper trees are considered to be a symbol of the special sanctity of this place.

Next double-page spread:

Drigung Thil is the most famous monastery in Tibet for traditional sky burial ceremonies. Light offerings, a symbol of Buddha's enlightenment, are made before the burial. Traditional Tibetan woodwind instruments called gyalings are always played in pairs during the ceremony. The goal of this type of ritual music is to gain insight into a deeper, absolute reality.

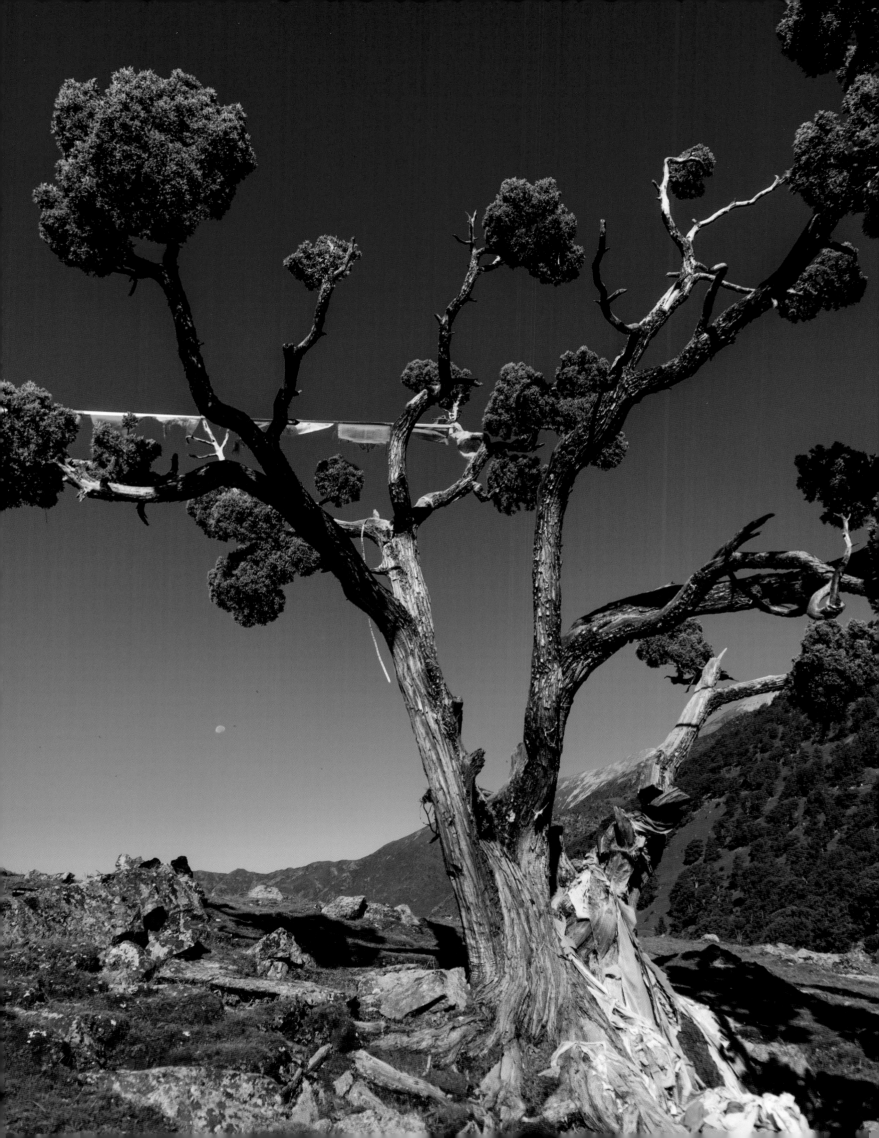

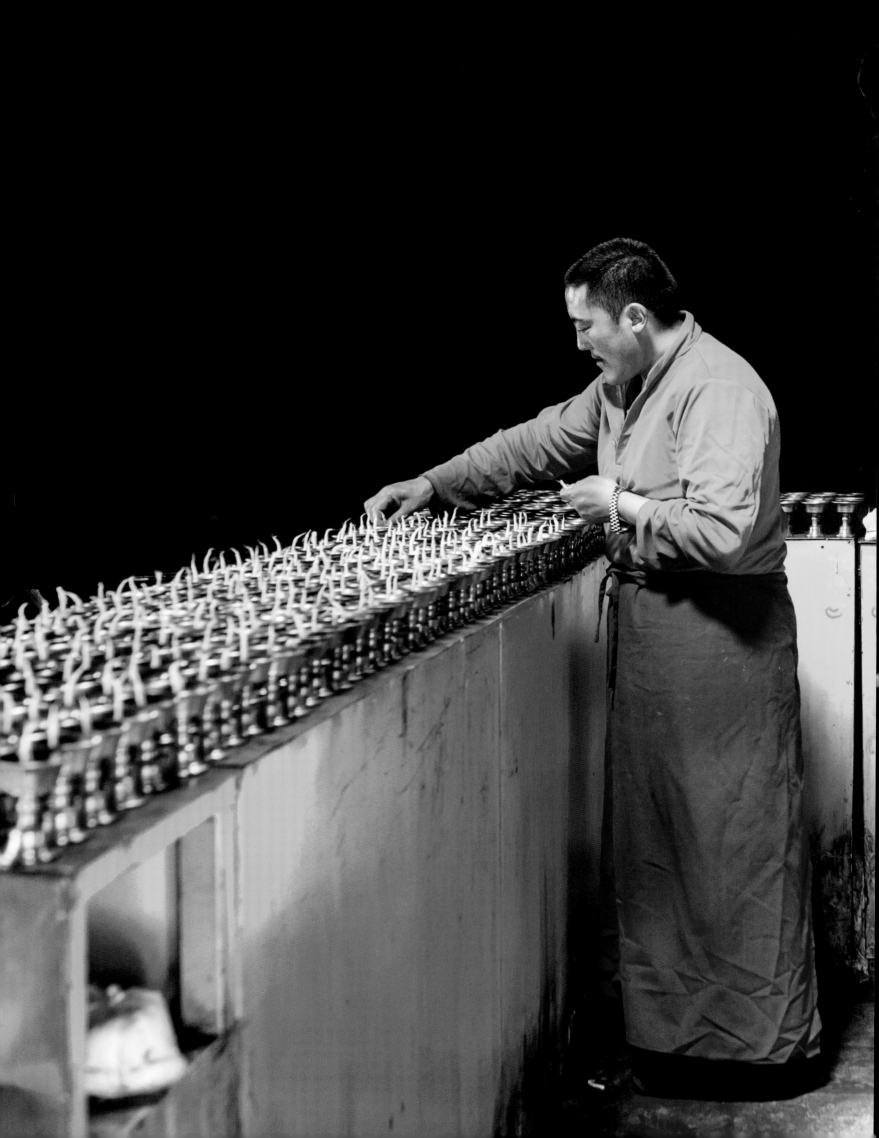

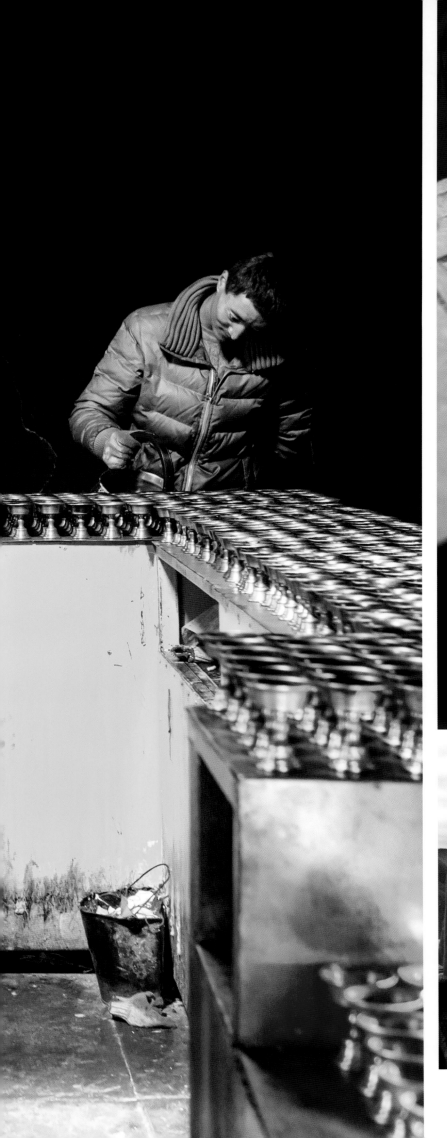

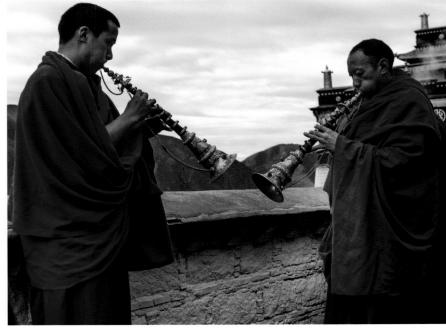

Drigung Thil Monastery 卍 Lhasa 卍 Tibet 卍 Sacred sites of Vajrayana

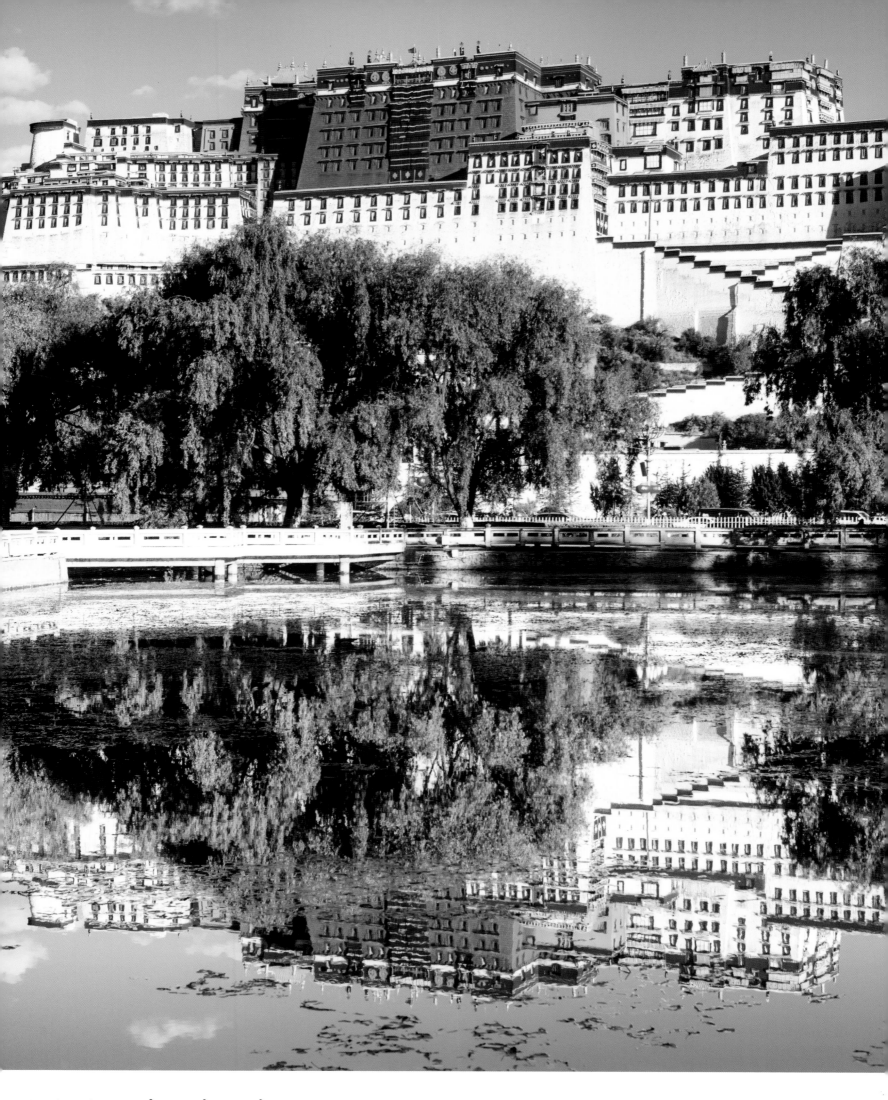

Sacred sites of Vajrayana ❁ Tibet ❁ Lhasa ❁ Potala Palace

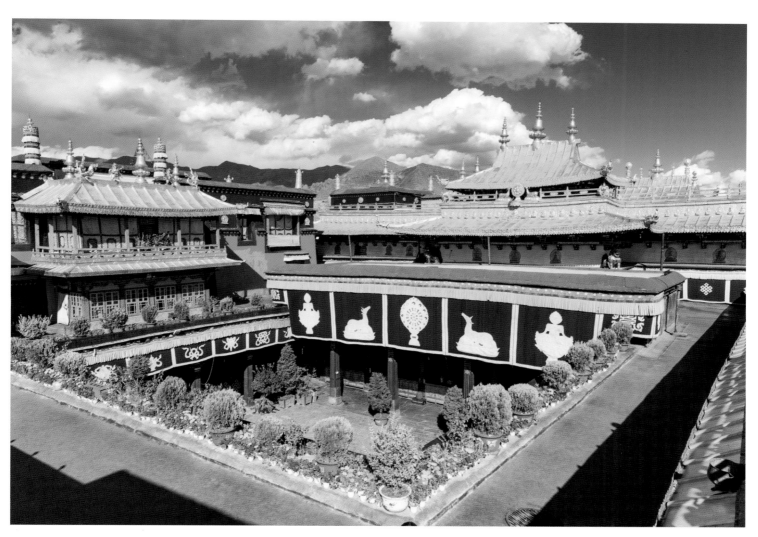

153

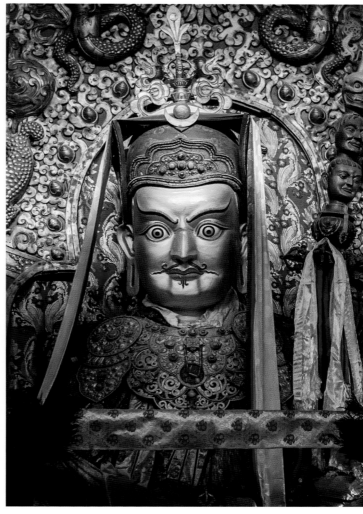

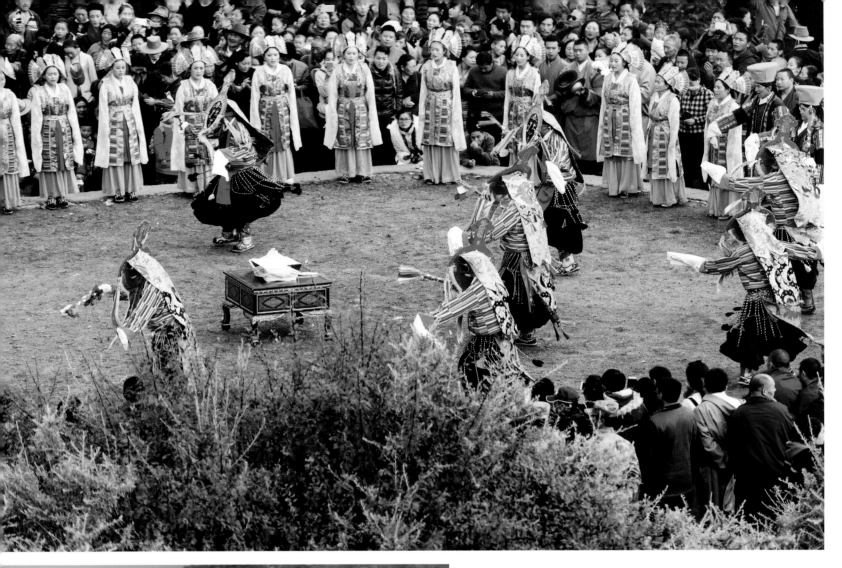

The Thangka festival is one of the most important celebrations held at the Drepung Monastery in Lhasa. The highlight is the unrolling of a giant thangka, which is accompanied by cham or mask dances. These dances are meant to drive away all evil demons. At Samye Monastery on the right, built as a three-dimensional mandala representing the Buddhist cosmos, the decision was made in 794 to establish Tantric Buddhism as the state religion.

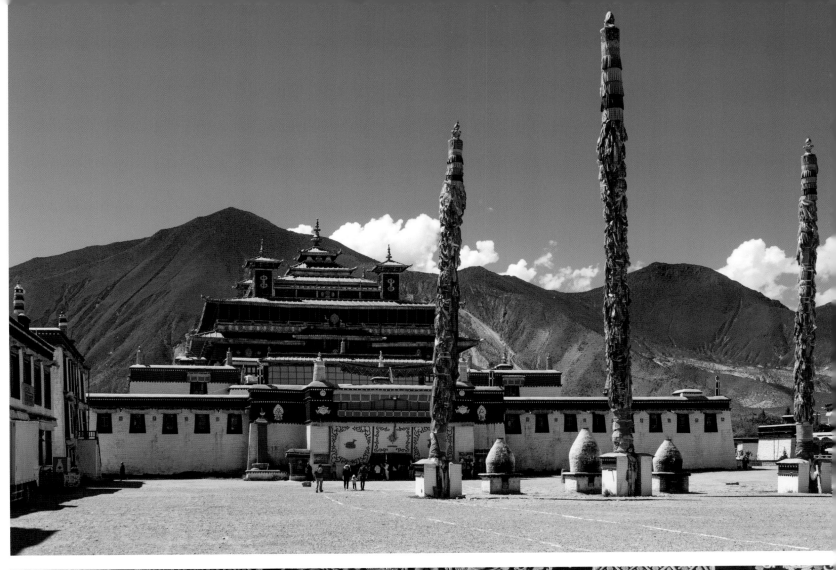

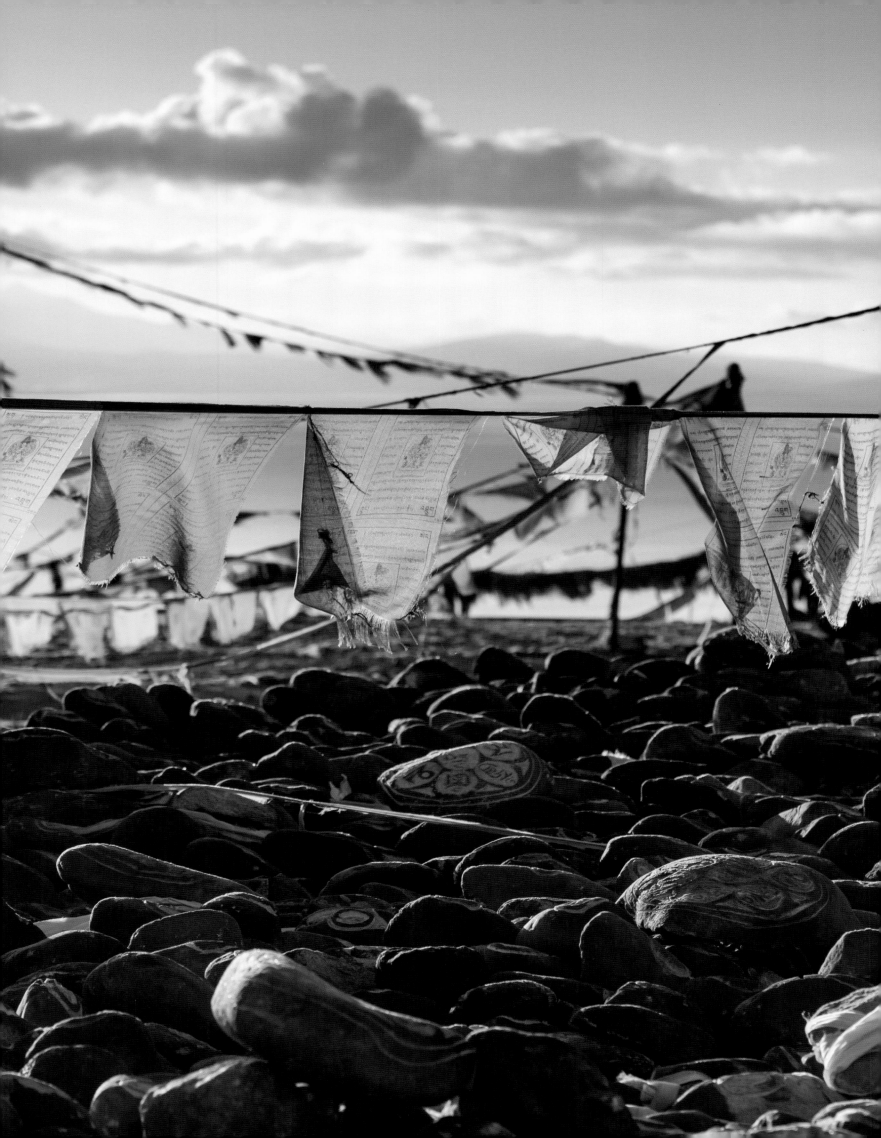

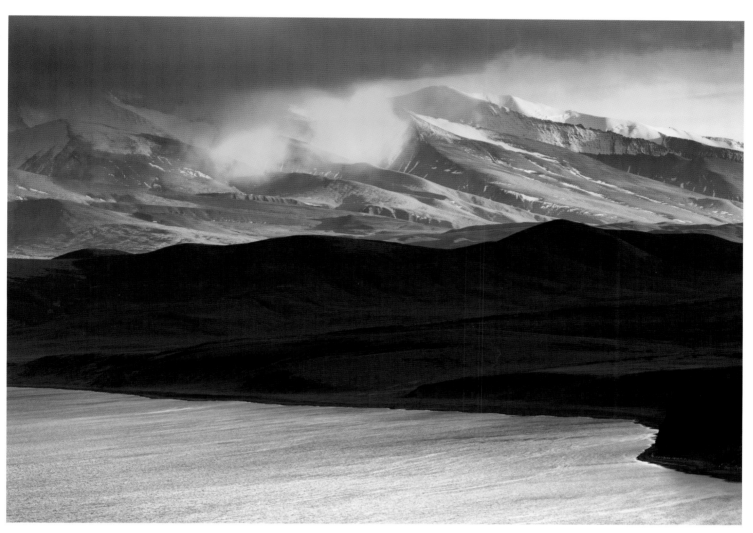

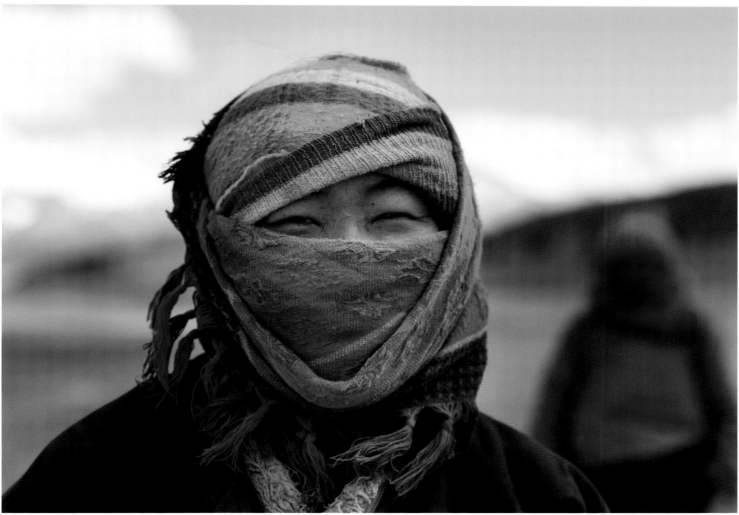

Lake Manasarovar 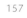 Tibet 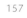 Sacred sites of Vajrayana

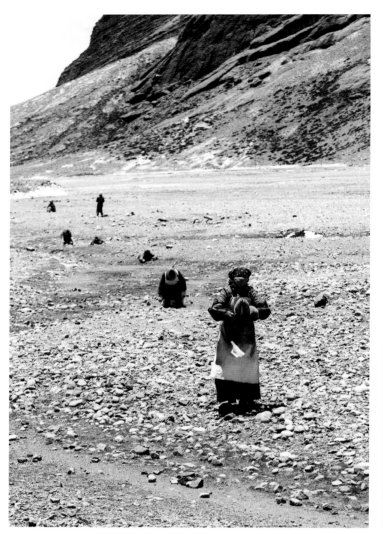

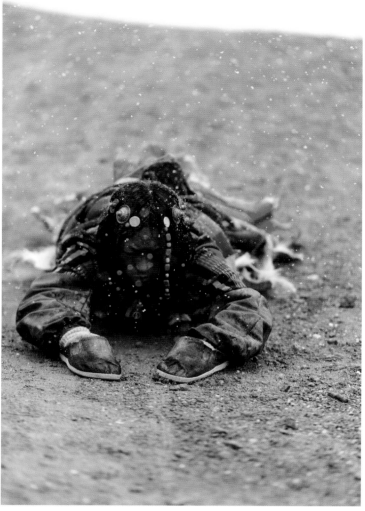

Previous and this double-page spread:
Dominated by Gurla Mandhata, an icy
mountain peak towering 25,243 feet (7,694 meters)
high, Lake Manasarovar (known by Tibetans as
Mapham Yutso) symbolizes the sun, the
masculine, consciousness, and the forces of
light. Before undertaking a *kora* of Mount
Kailash, or walking the circuit around it,
pilgrims drink some lake water, which is
believed to cleanse them of the sins of one
hundred rebirths. Many also place a mani stone
inscribed with the Bodhisattva Avalokitesh-
vara's mantra "om mani padme hum."
Afterwards, they set out on their holy circum-
ambulation of Mt Kailash, which takes about
three days. However, those who choose to
complete a kora around the holy mountain by
means of full-body prostrations, considered
more meritorious, will often require weeks.

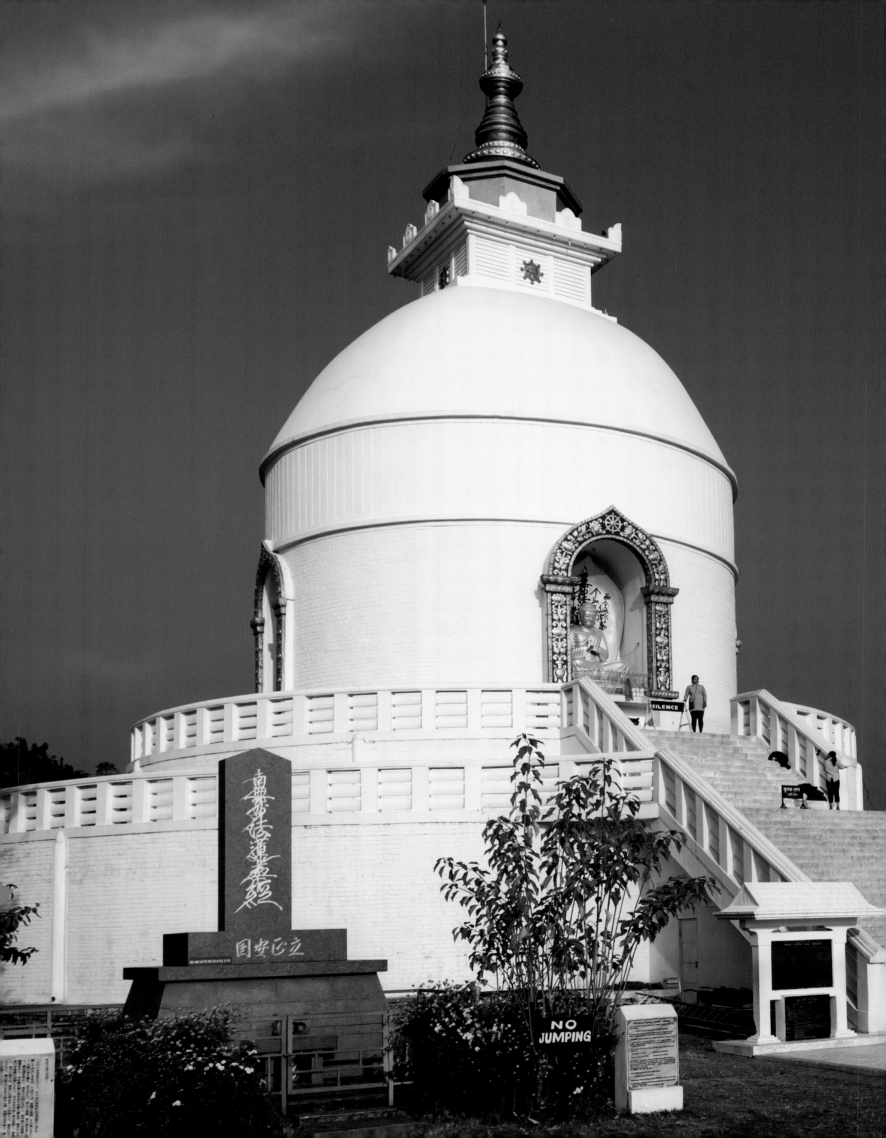

NEPAL

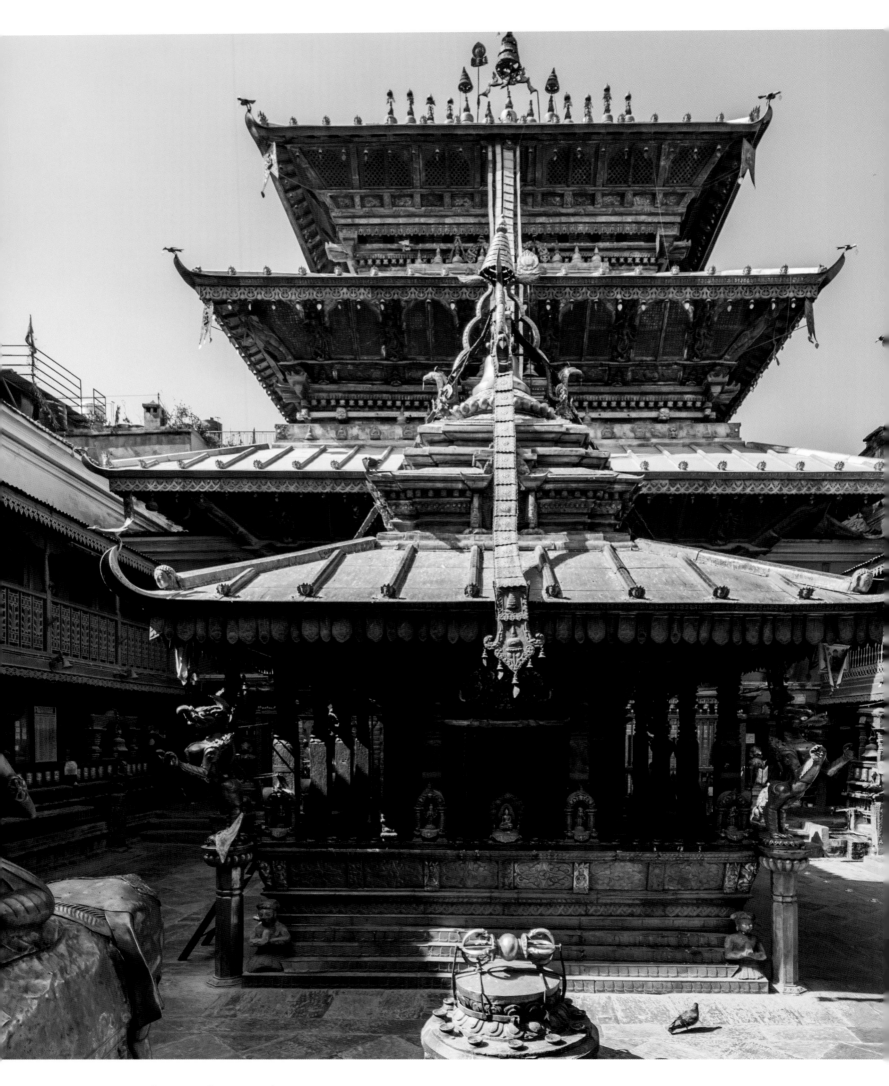

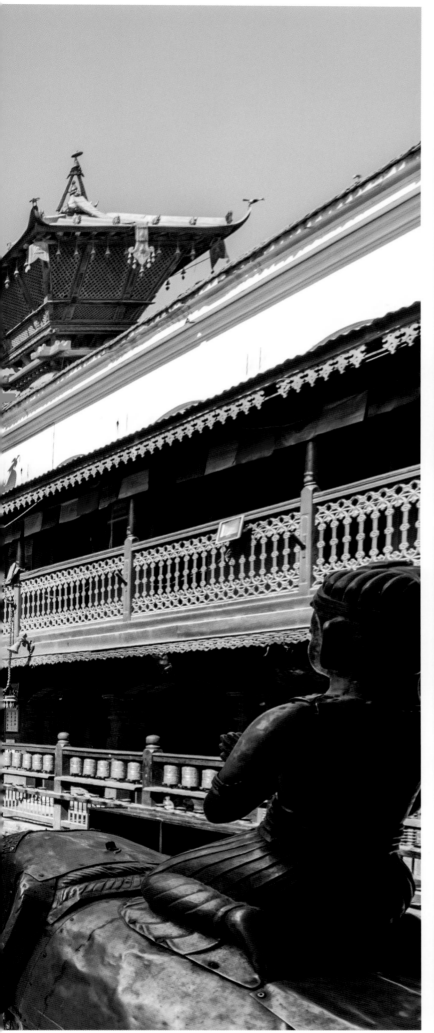

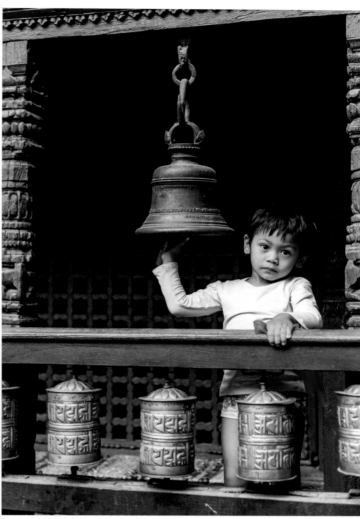

163

Hiranya Varna Mahavihar (The Golden Temple) ✿ Lalitpur ✿ Nepal ✿ Sacred sites of Vajrayana

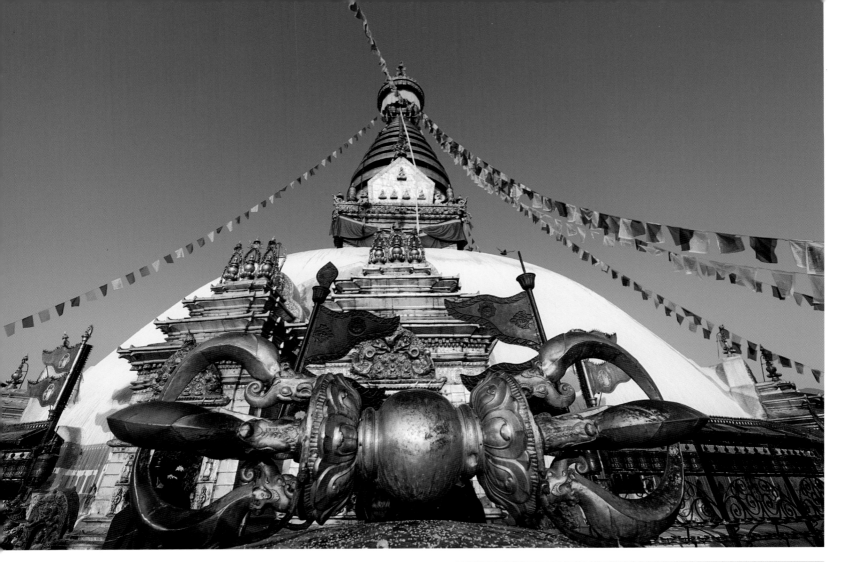

Swayambhunath is considered the most important center of power in Kathmandu Valley. The diamond scepter (*vajra*) in front of the stupa is the symbol of the indestructible path of Vajrayana. In Buddhism, the numerous monkeys that live here represent the so-called "monkey mind," a term for the mind that finds it difficult to concentrate on one thing. The "all-seeing eyes of Buddha" on many stupas are a device intended to make the abstract meaning of the stupa as the spirit of Buddha more accessible to believers.

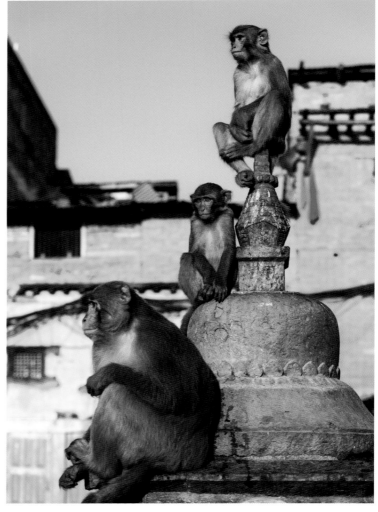

 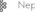

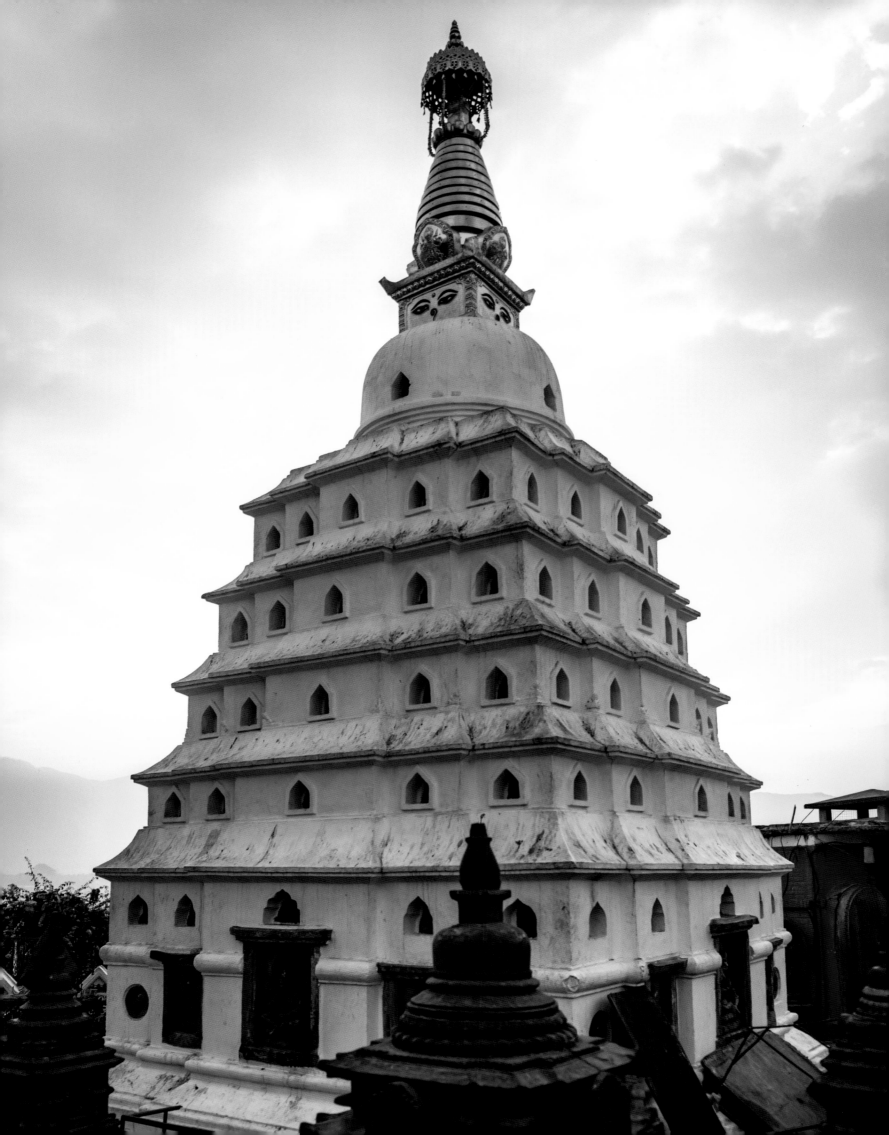

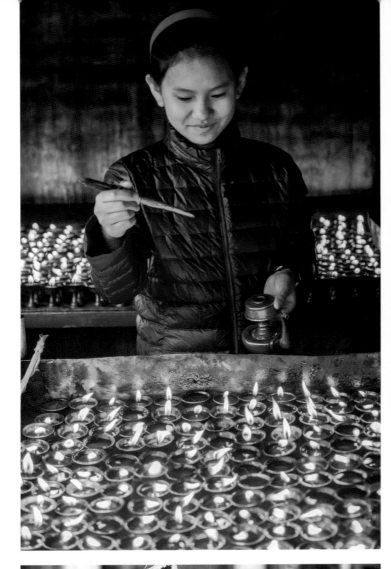

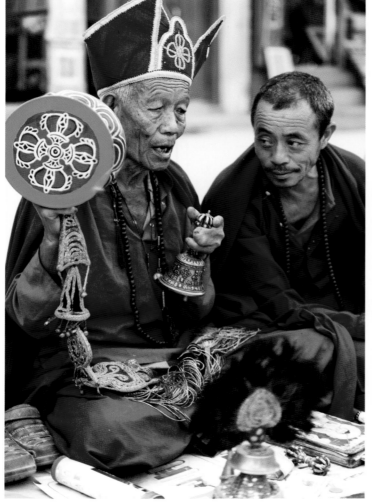

166

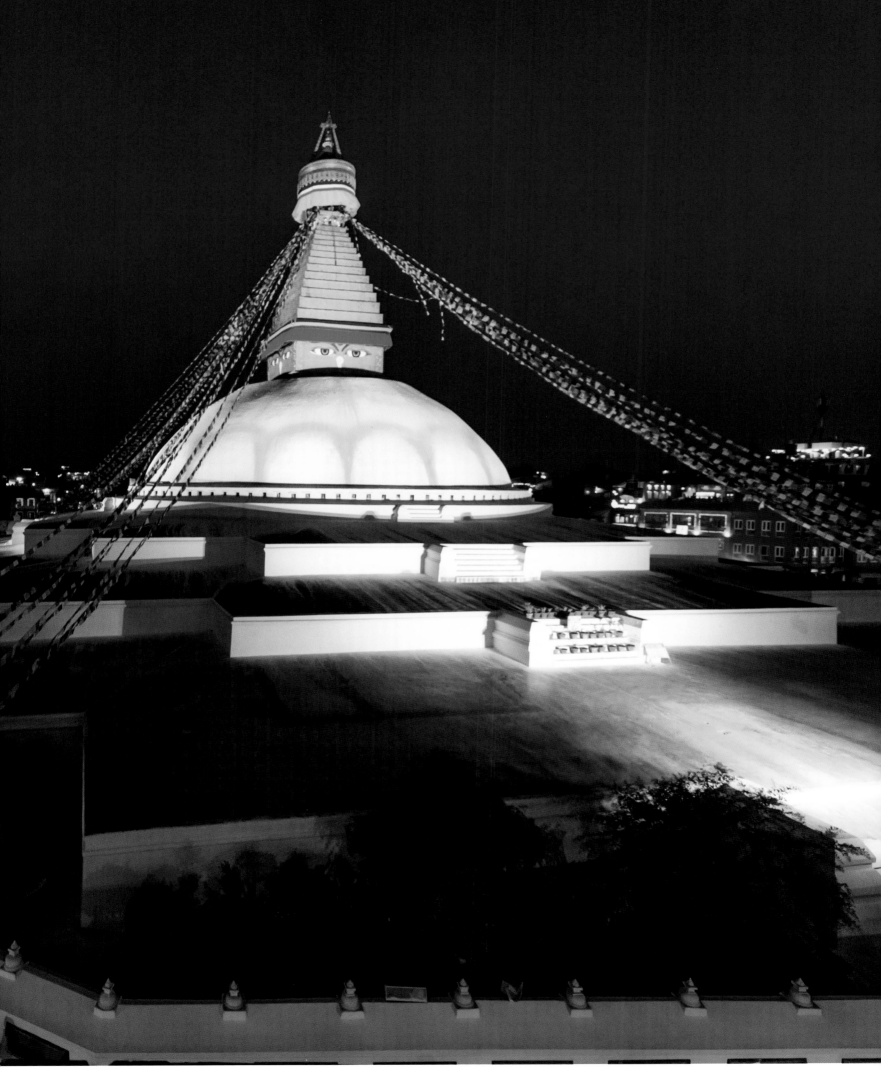

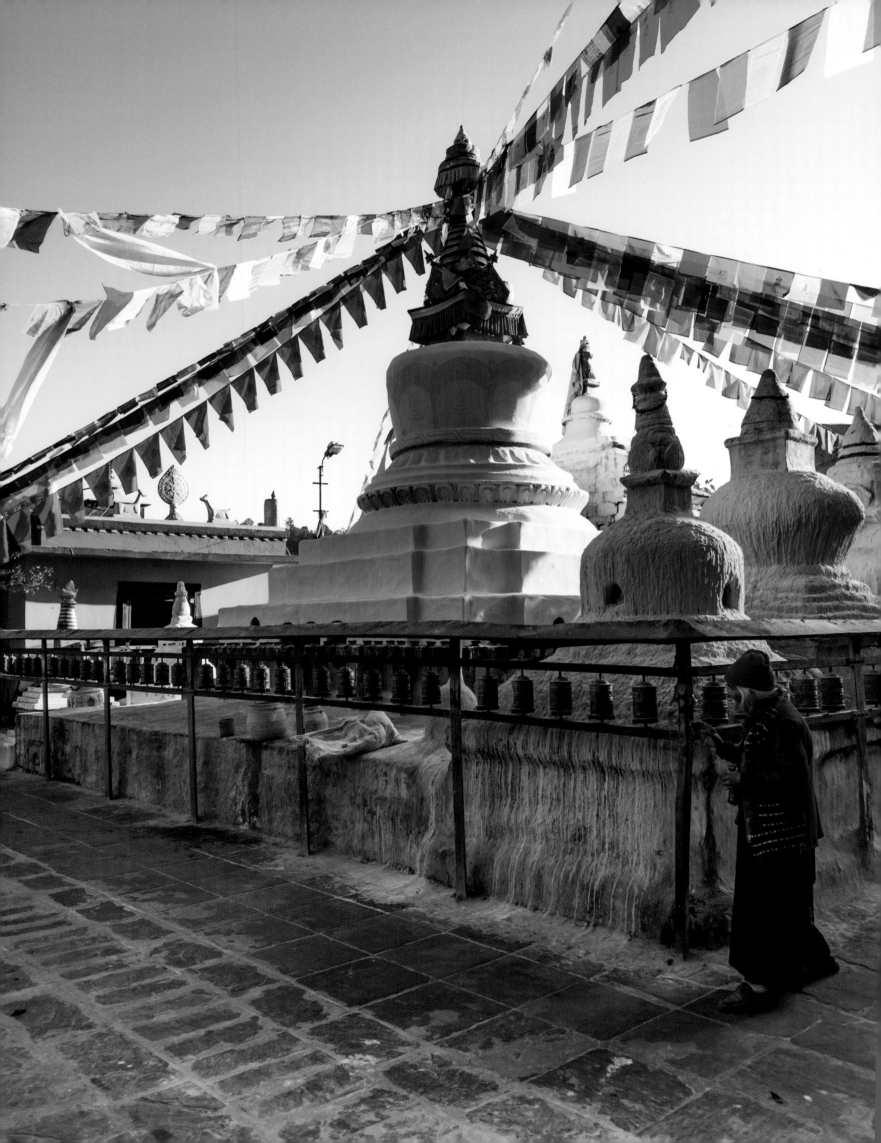

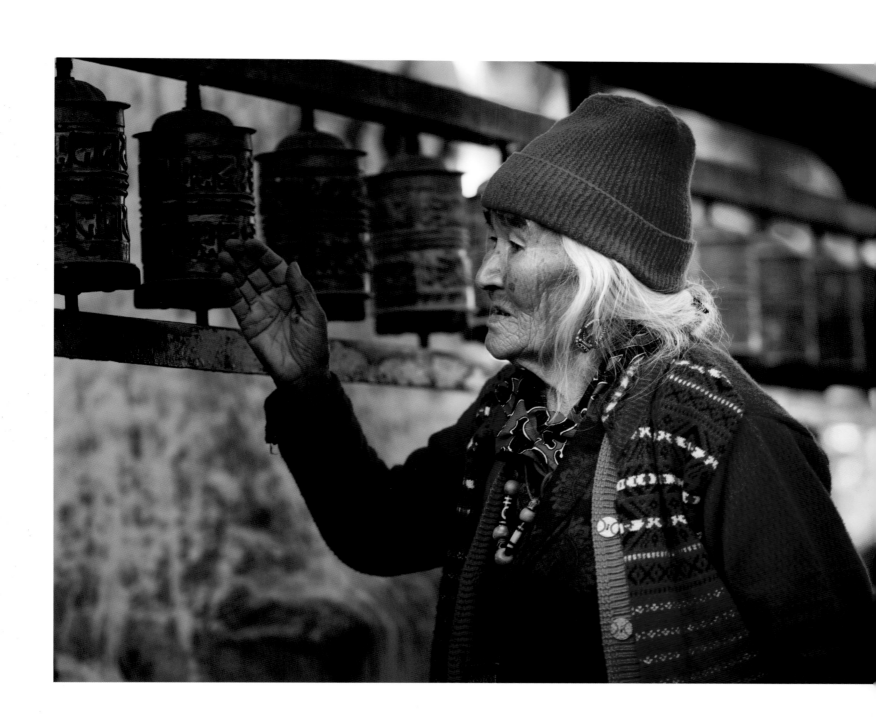

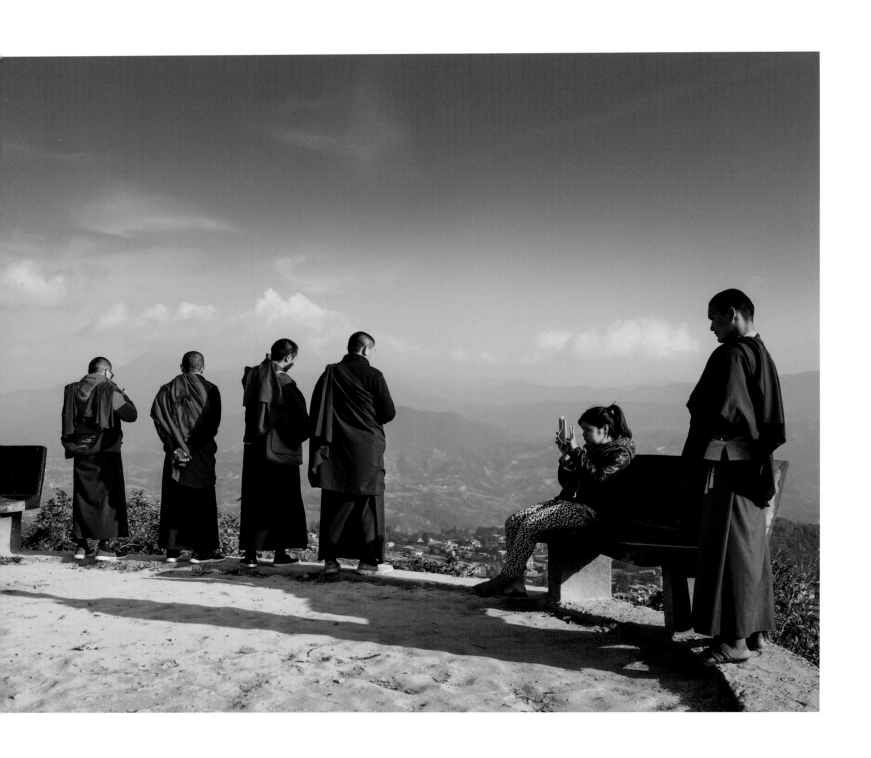

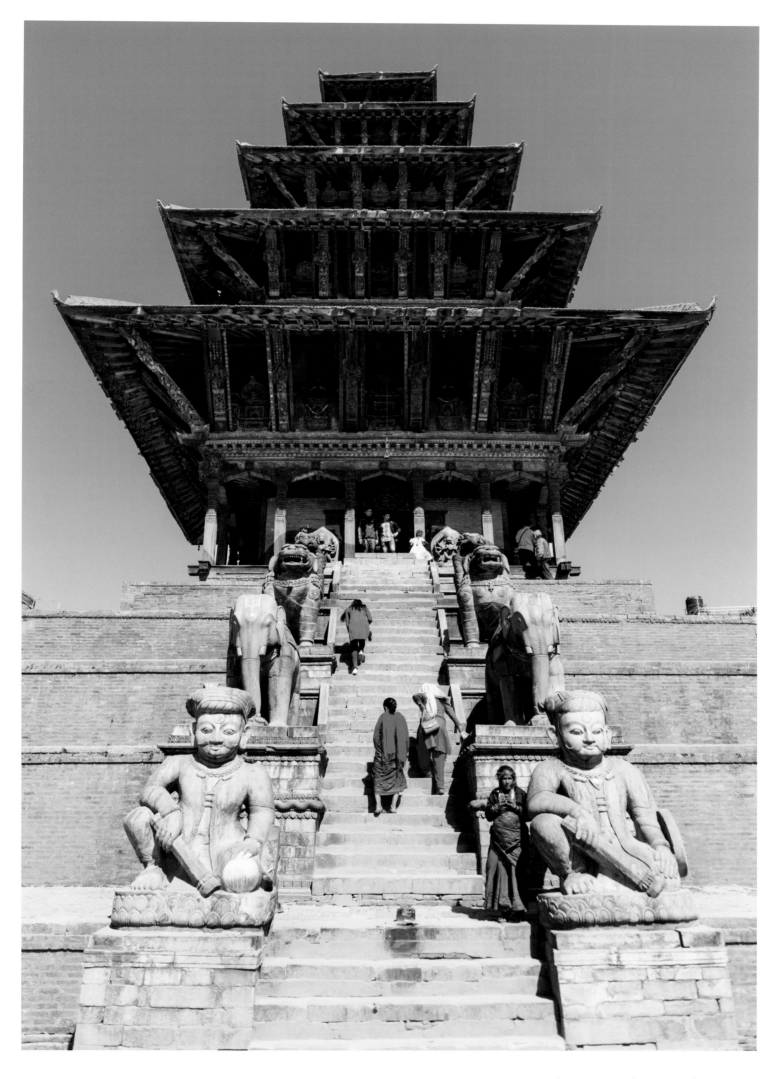

Nyatapola Temple ❈ Bhaktapur ❈ Nepal ❈ Sacred sites of Vajrayana

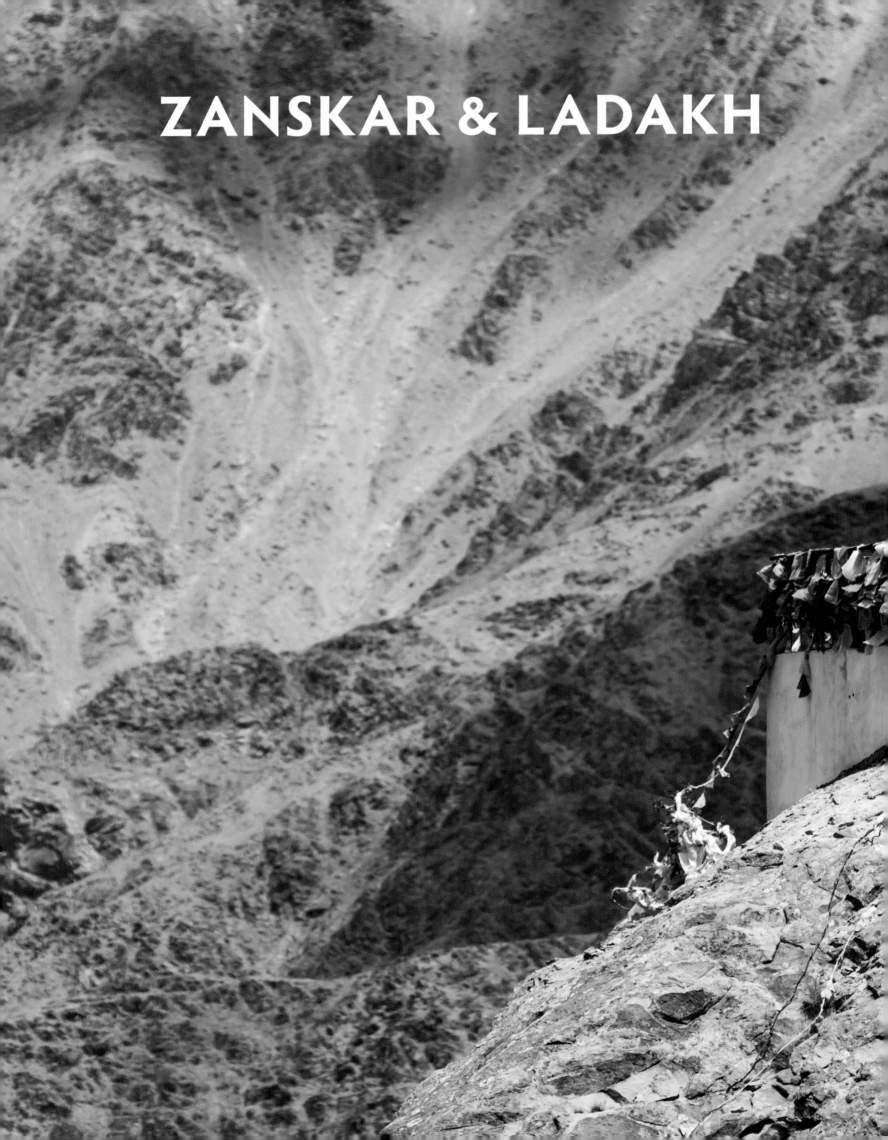

ZANSKAR & LADAKH

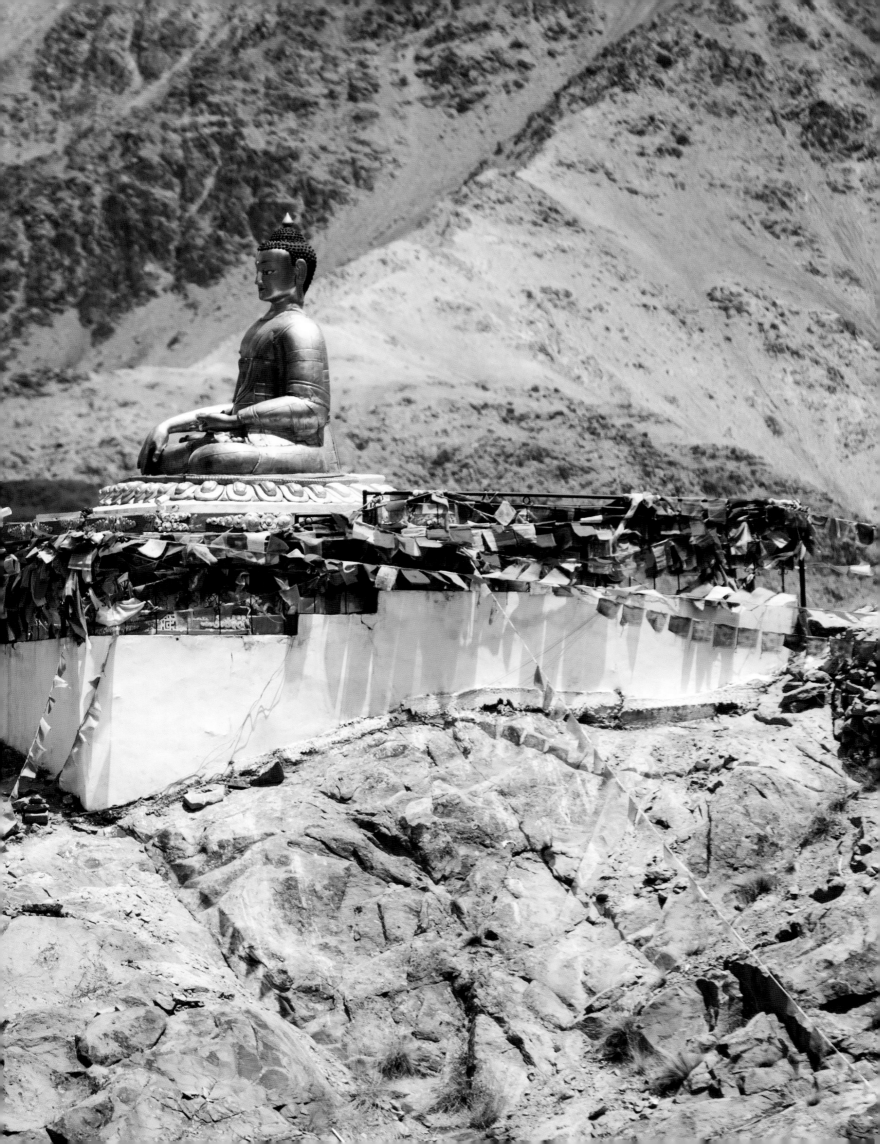

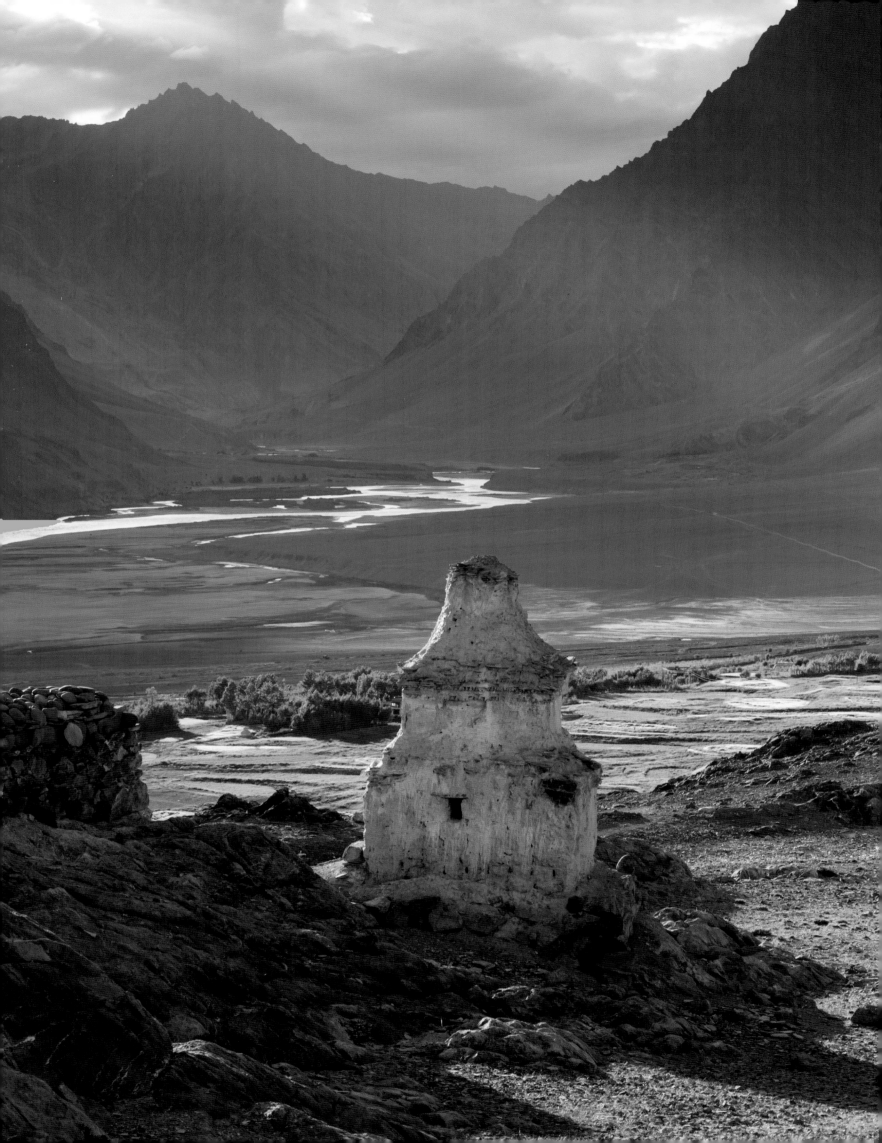

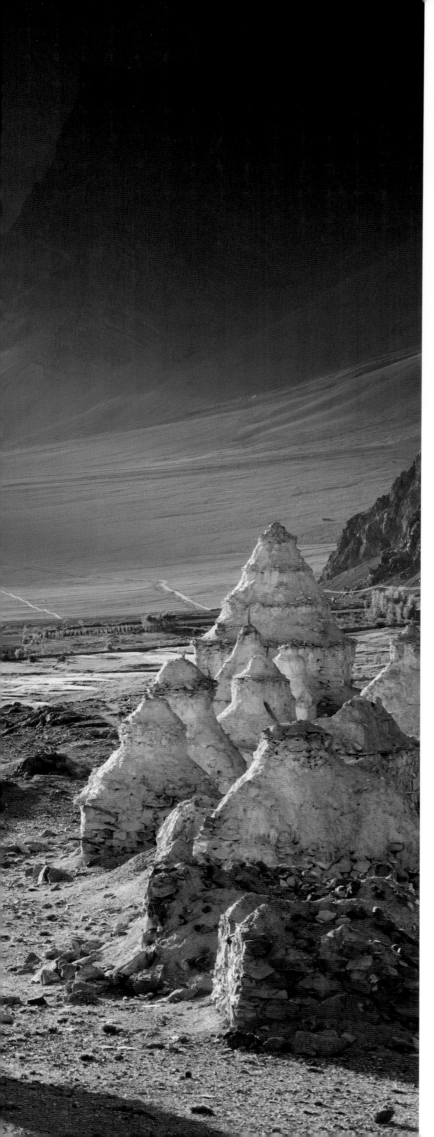

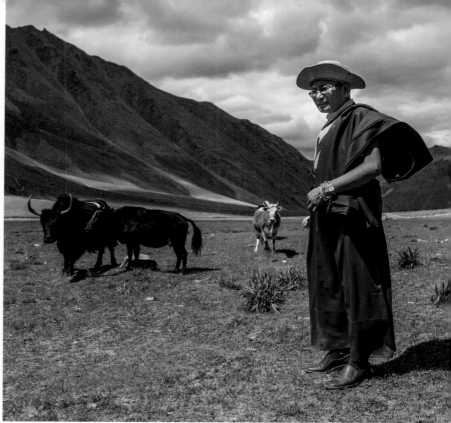

This double-page spread:
Over the course of millions of years, the Zanskar River has created a wide and fertile valley, which is overlooked by the Karsha Monastery. The largest monastery complex in Zanskar is known for its library, which is home to the 225 volumes of the Tanjur. Together with the 108 volumes of the Kanjur, the Tanjur constitutes the canonical scripture of Tibetan Buddhism.

Next double-page spread:
Padmasambhava is said to have meditated for five years in Sani (Zanskar), where a huge statue was erected in his honor. According to legend, he then transformed into eight manifestations and set out to Tibet for missionary work. Tucked away in a side valley, Phugtal Monastery clings to the rocky slopes of Zanskar high above the Tsarap River.

175

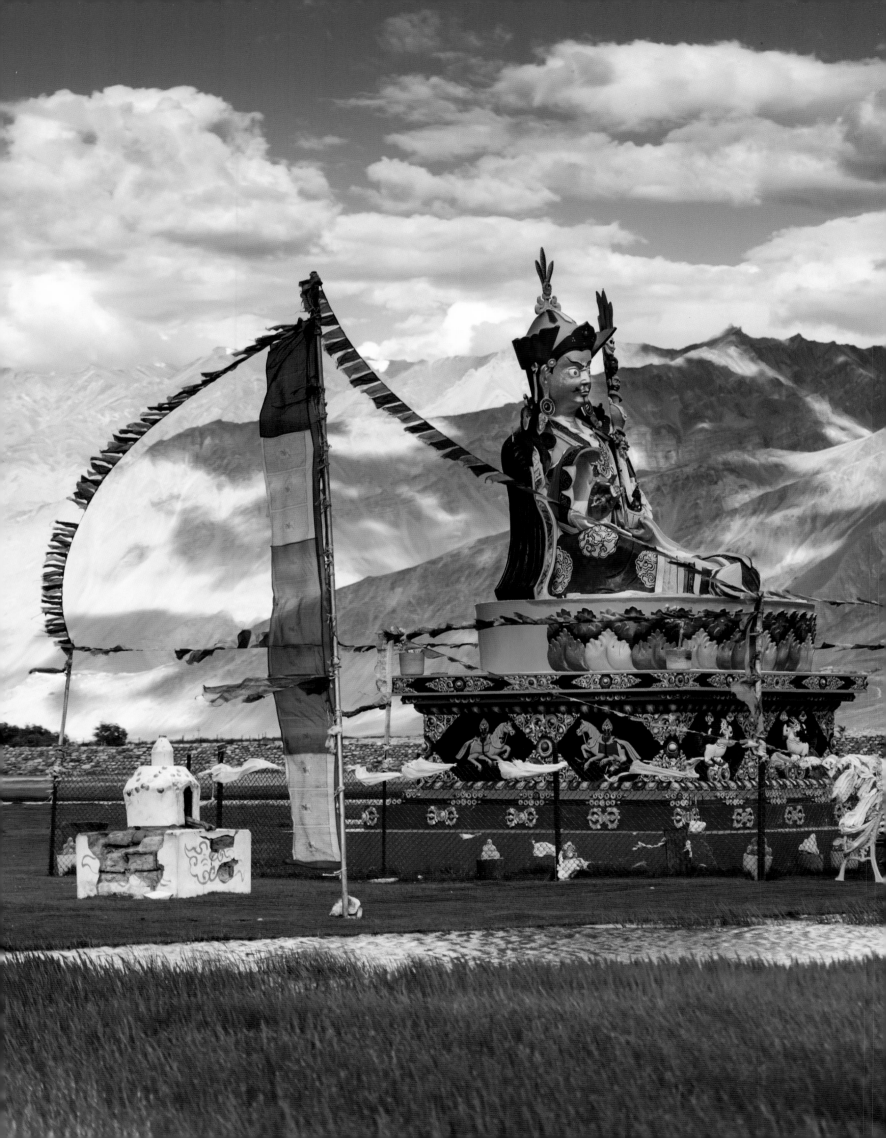

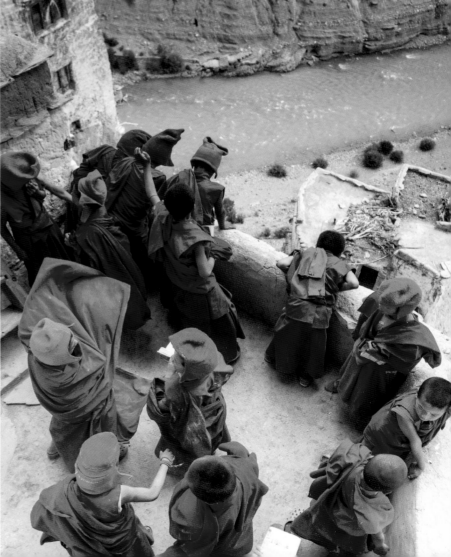

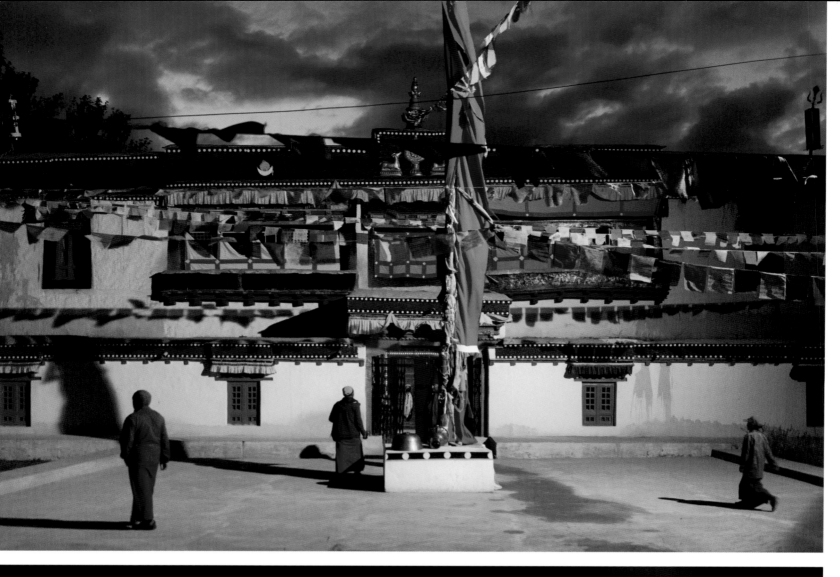
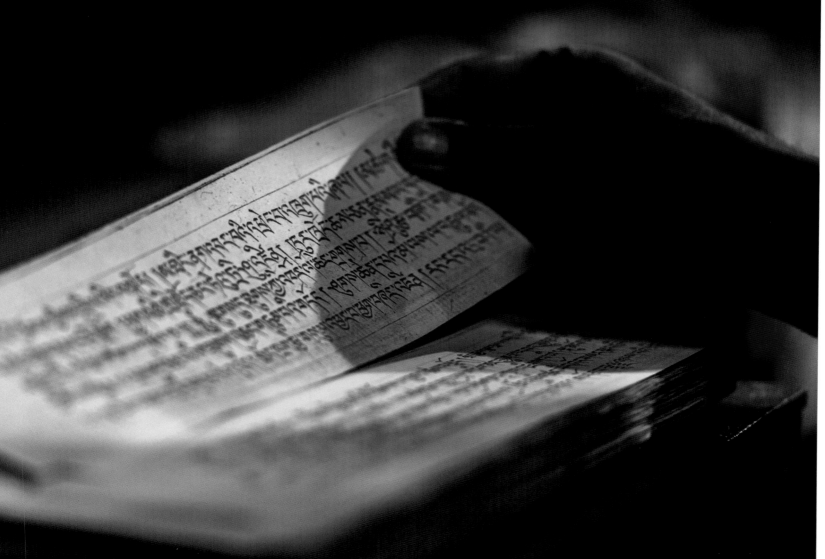

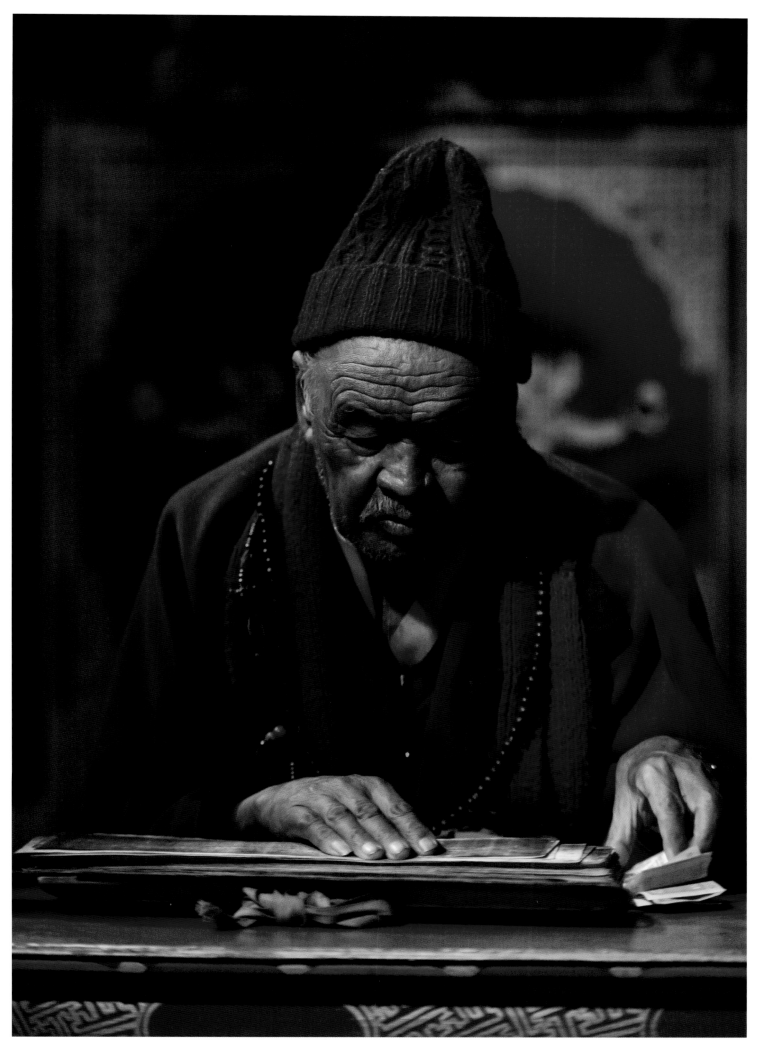

Sani Monastery ✿ Zanskar ✿ India ✿ Sacred sites of Vajrayana

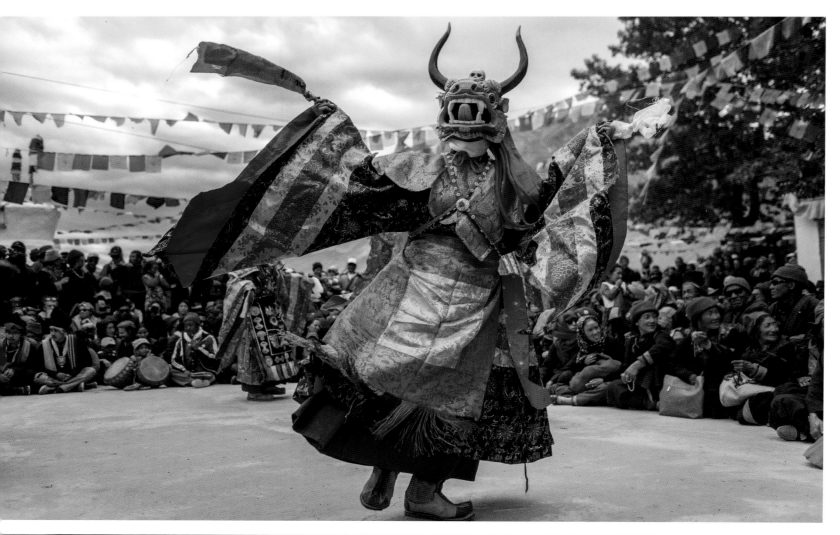

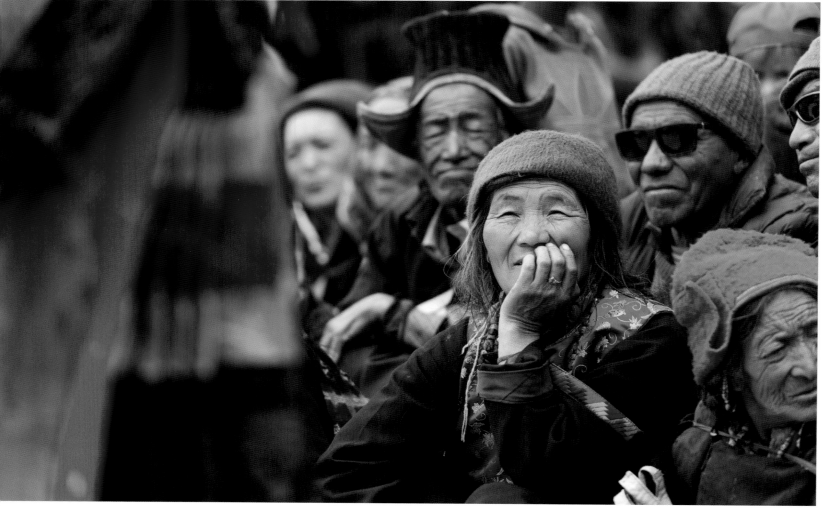

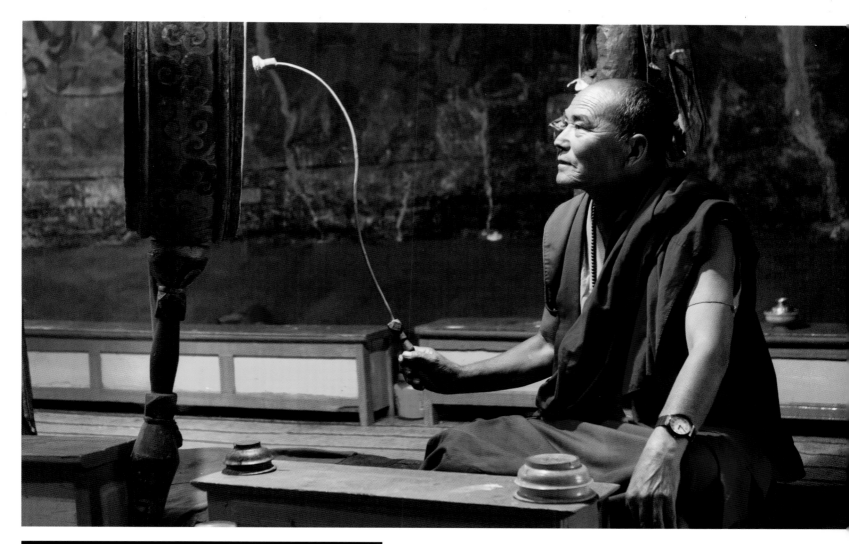

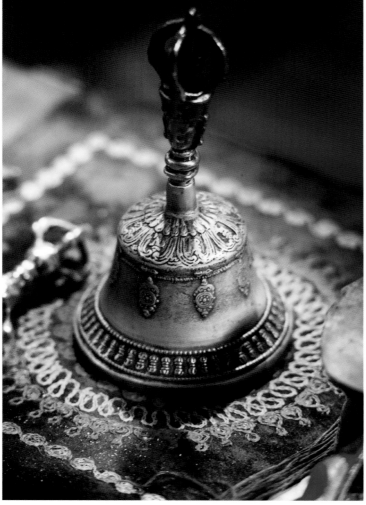

Cham dances teach spectators about the transience of earthly things. The aim of the dances is always to drive out the negative in people and encourage them to be virtuous. The frame drum above is beaten in a steady rhythm during the recitations to attract the attention of a deity. Another ritual instrument is the combination of bell and vajra, a symbol that heralds the path to enlightenment.

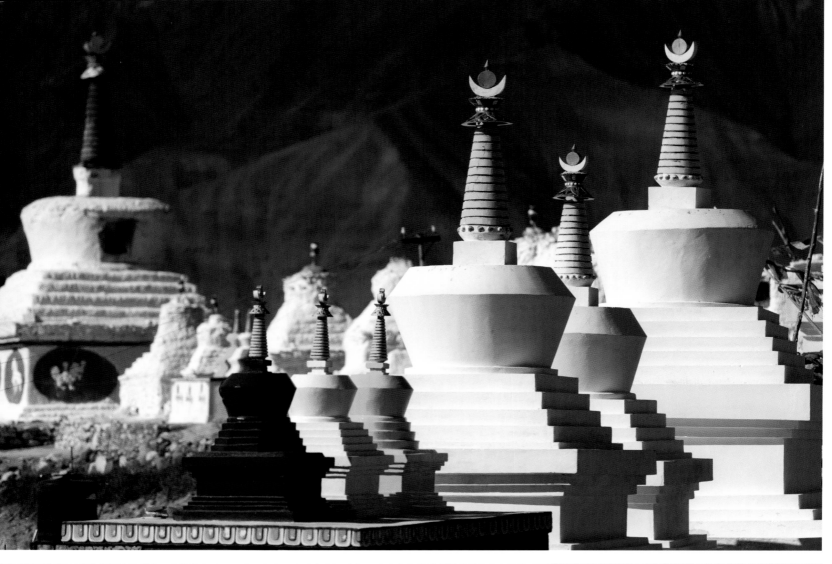
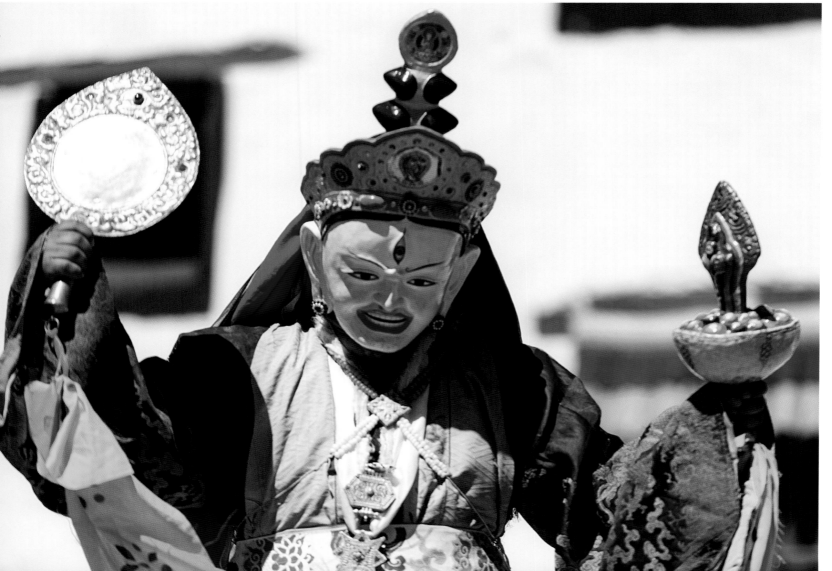

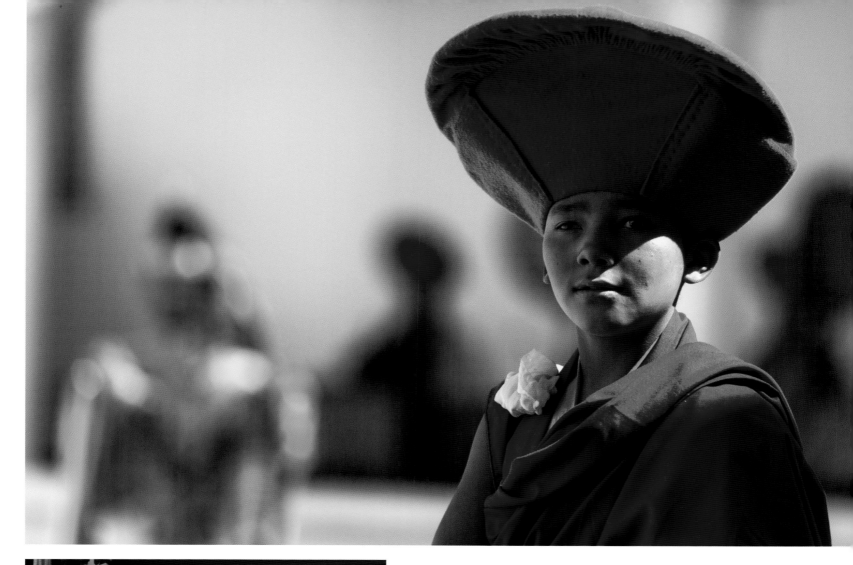

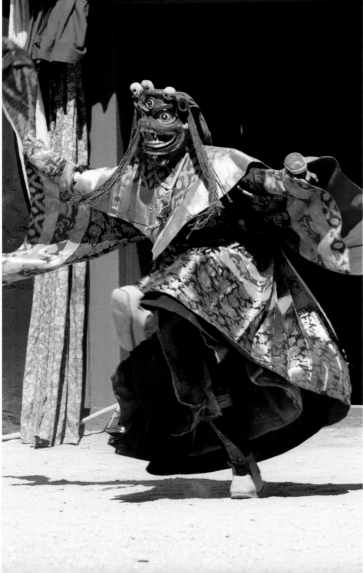

Phyang Monastery in Ladakh is considered one
of the meditation places of Padmasambhava.
Pre-Buddhist spirit cults are said to have been
strongly entrenched here until his arrival.
The core theme of the mask dances here is
thus the subjugation of demons by Padmasam-
bhava and the victory of Buddhism over
ancient folk beliefs.

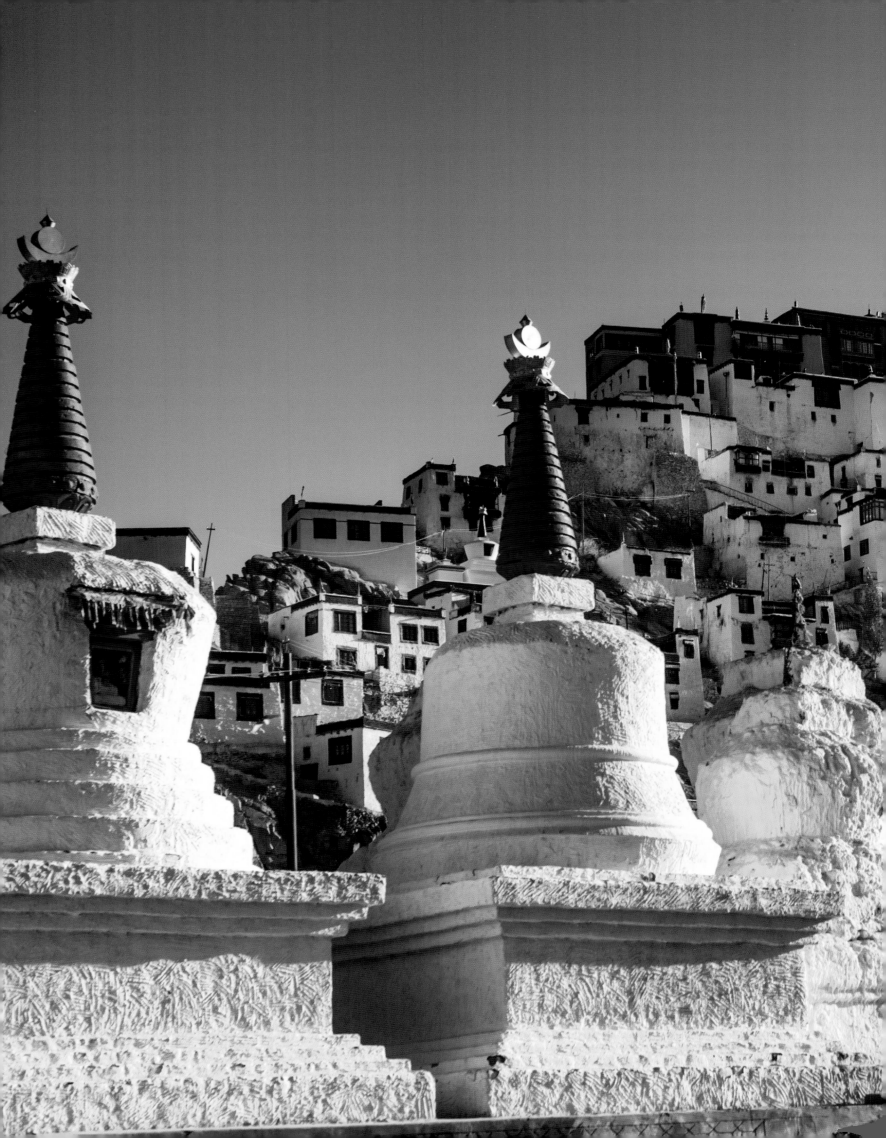

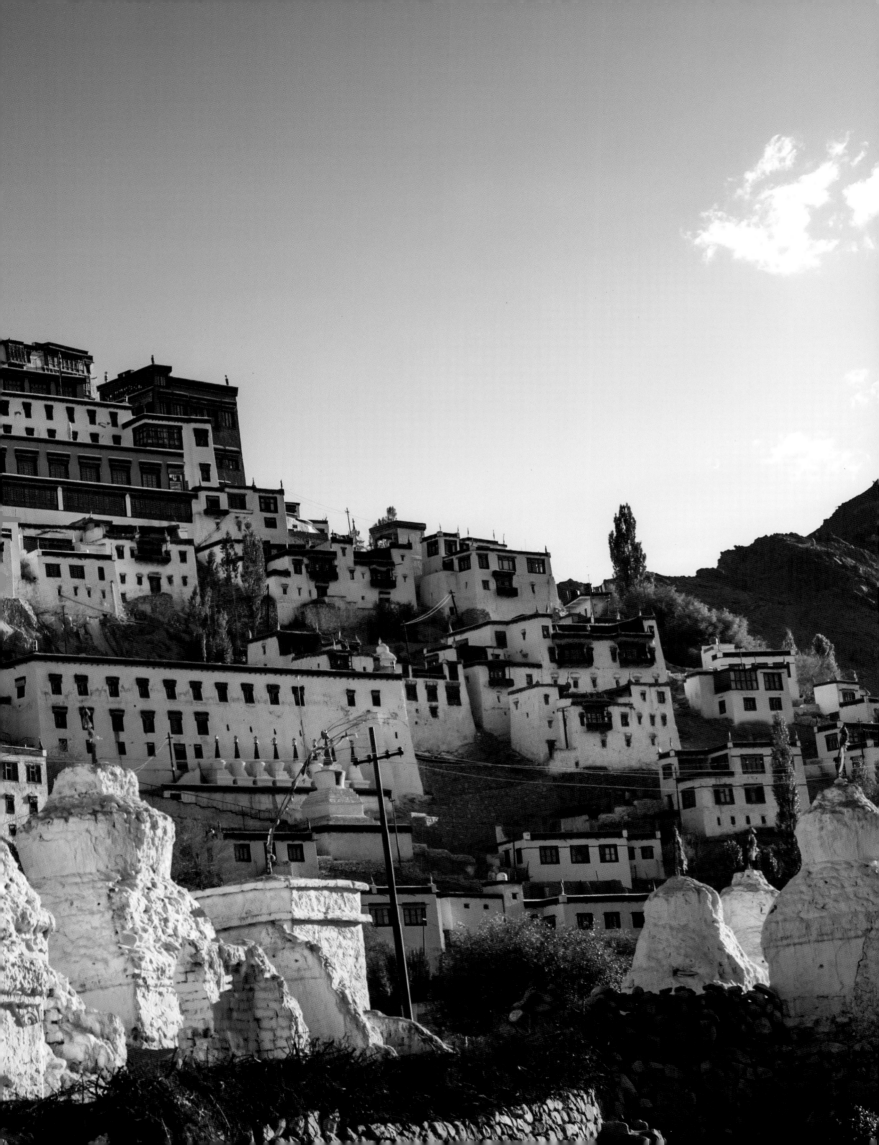

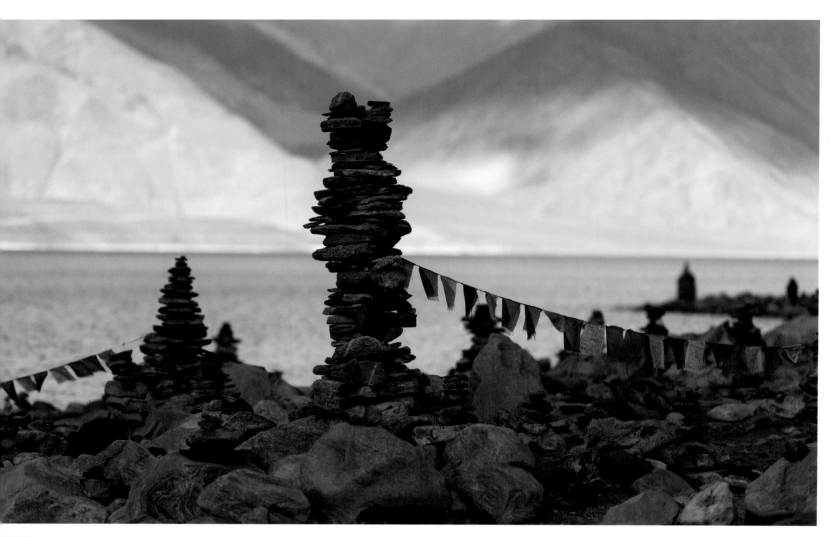

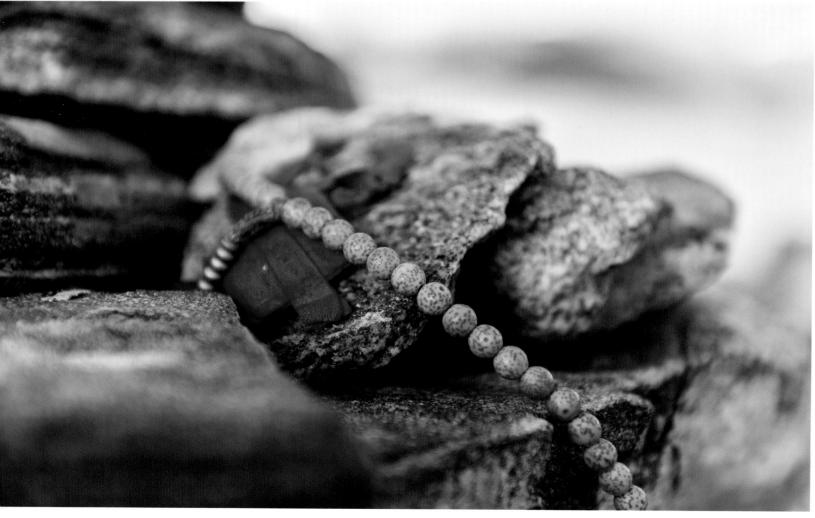

Sacred sites of Vajrayana India Ladakh Lake Pangong

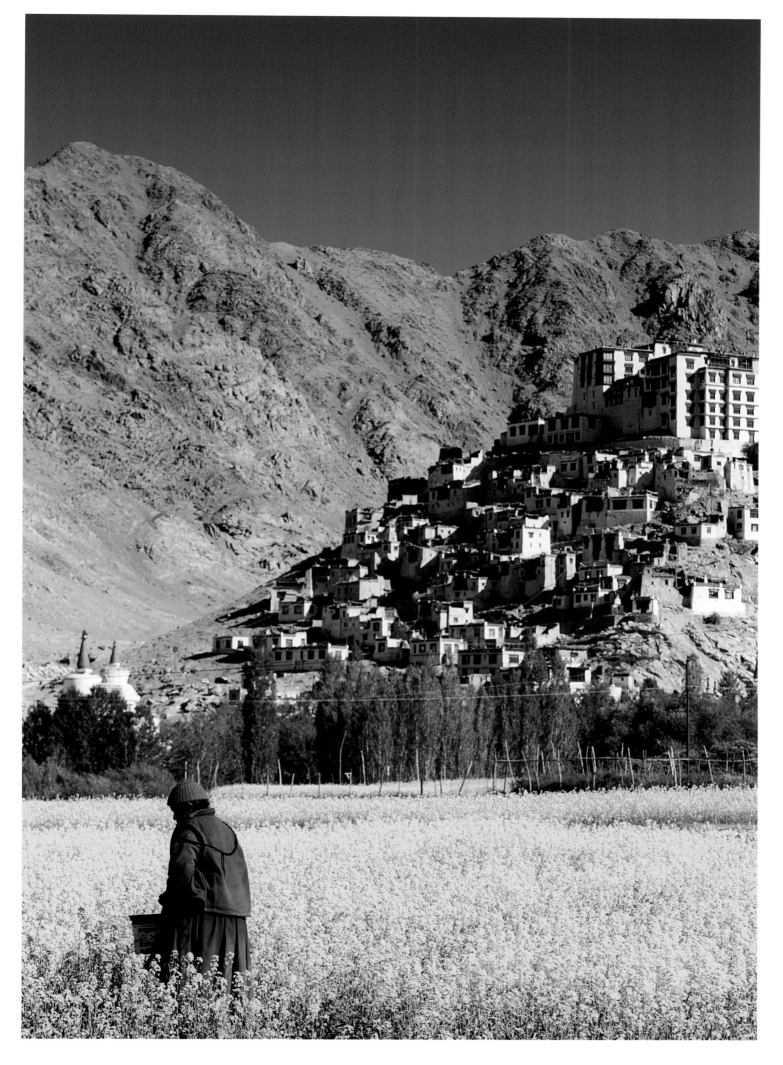

Chemrey Monastery ❁ Ladakh ❁ India ❁ Sacred sites of Vajrayana

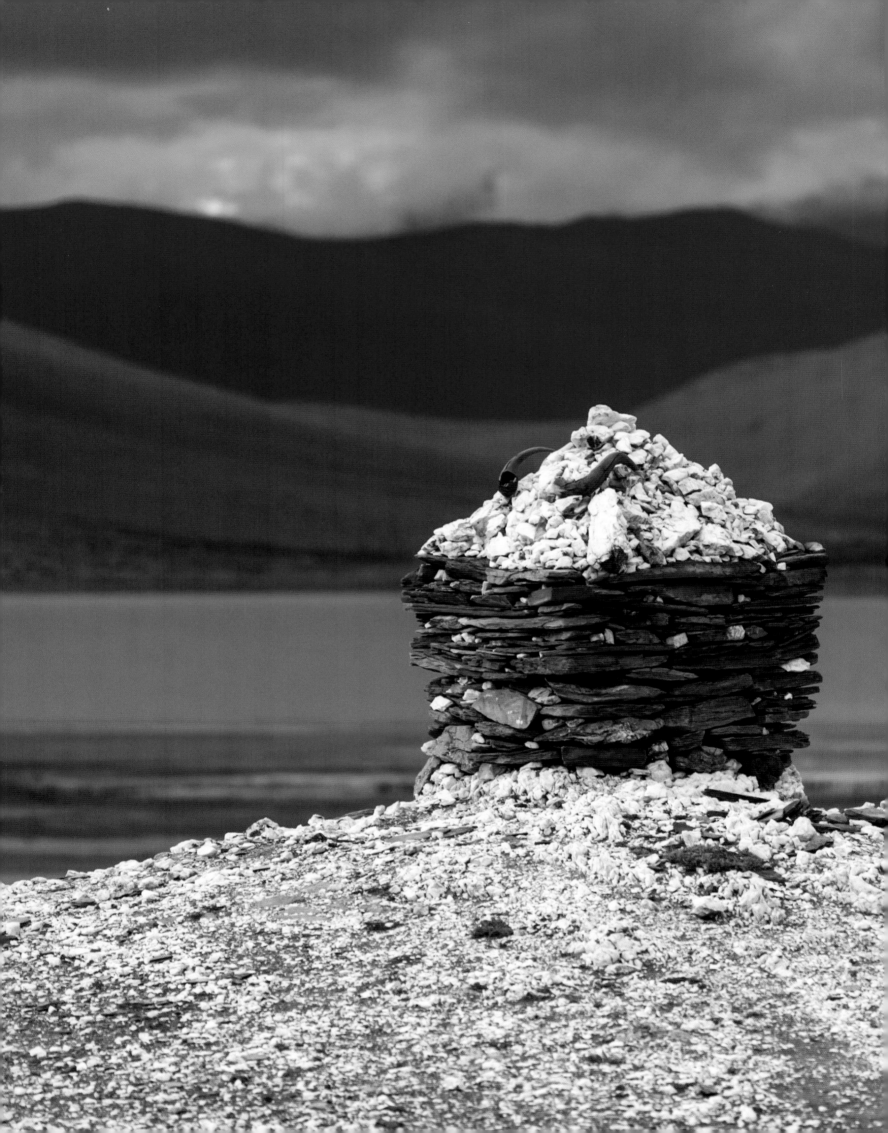

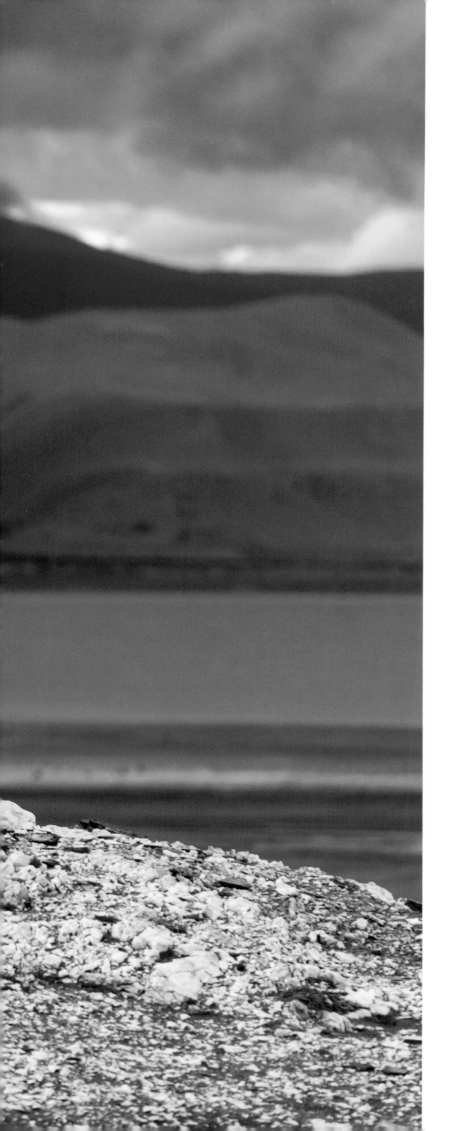

Lake Moriri Ladakh �֎ India ✖ Sacred sites of Vajrayana

INDEX OF SITES

BIOGRAPHIES

Christoph Mohr works as a portrait, documentary, and landscape photographer. In his photography, he focuses on Asia as well as on Africa, where he captures the country and its people in impressive snapshots and is always on the lookout for special atmospheric lighting and colors.

www.christophmohr-fotografie.de

Oliver Fülling is a freelance author, editor, and tour guide specializing in China and Asia. In 1985 he traveled for the first time to Tibet, which was still medieval at the time. Since then the Himalayas have never left him, and he still travels regularly to the roof of the world, always in search of new mysteries in the region.

IMPRINT

© 2021 teNeues Verlag GmbH

Photographs: © 2021 Christoph Mohr.
All rights reserved.
Texts: Oliver Fülling

Map: Olivera Ilic/Shutterstock
Icons:
Dharmachakra (p 26) by Ayub Irawan from the
Noun Project
Dharmachakra (p 36) by Anthony Ledoux from the
Noun Project
Lotus by mikicon from the Noun Project
Vajra by Christopher J. Fynn, CC BY-SA 4.0,
via Wikimedia Commons

Editorial Coordination and Proofreading
by Nadine Weinhold, teNeues Verlag
Production by Alwine Krebber, teNeues Verlag
Color Separation by Jens Grundei, teNeues Verlag
Design by Jens Grundei
Translations and Copyediting by WeSwitch GmbH,
Heather Bock, Romina Russo Lais

ISBN: 978-3-96171-311-0
Library of Congress Number: 2020935970
Printed by PBtisk a.s. in the Czech Republic

Bibliographic information published by the
Deutsche Nationalbibliothek:
The Deutsche Nationalbibliothek lists this publication in
the Deutsche Nationalbibliografie; detailed bibliographic
data are available on the Internet at dnb.dnb.de.

Published by teNeues Publishing Group

teNeues Verlag GmbH
Werner-von-Siemens-Straße 1
86159 Augsburg, Germany

Düsseldorf Office
Waldenburger Straße 13
41564 Kaarst, Germany
e-mail: books@teneues.com

Augsburg/München Office
Werner-von-Siemens-Straße 1
86159 Augsburg, Germany
e-mail: bbarlet@teneues.com

Berlin Office
Lietzenburger Straße 53
10719 Berlin, Germany
e-mail: ajasper@teneues.com

Press department Stefan Becht
Phone: +49-152-2874-9508 / +49-6321-97067-99
e-mail: sbecht@teneues.com

teNeues Publishing Company
350 Seventh Avenue, Suite 301
New York, NY 10001, USA
Phone: +1-212-627-9090
Fax: +1-212-627-9511

teNeues Publishing UK Ltd.
12 Ferndene Road, London SE24 0AQ, UK
Phone: +44-20-3542-8997

www.teneues.com

teNeues Publishing Group
Augsburg/München
Berlin
Düsseldorf
London
New York

teNeues